MOMENTS

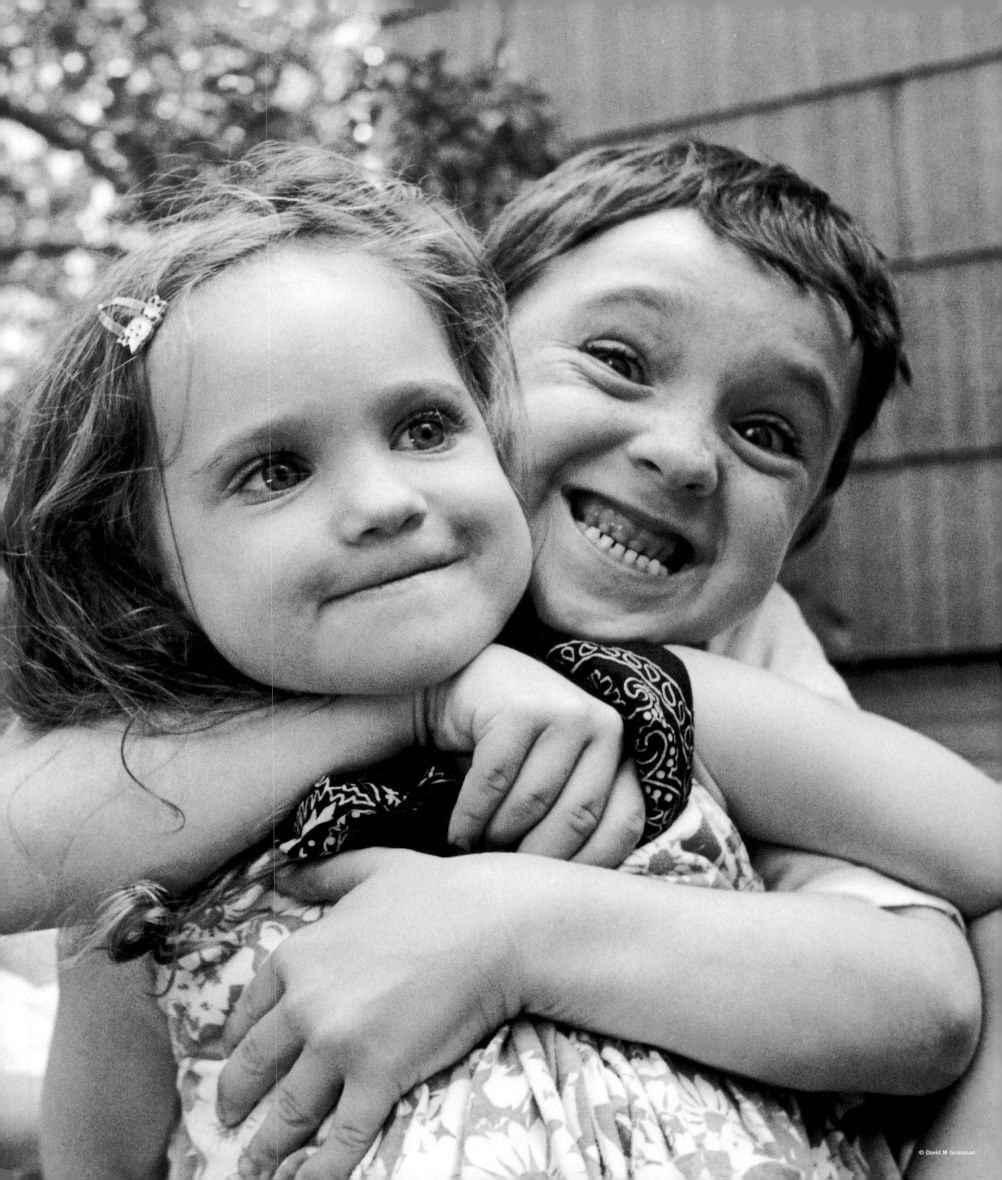

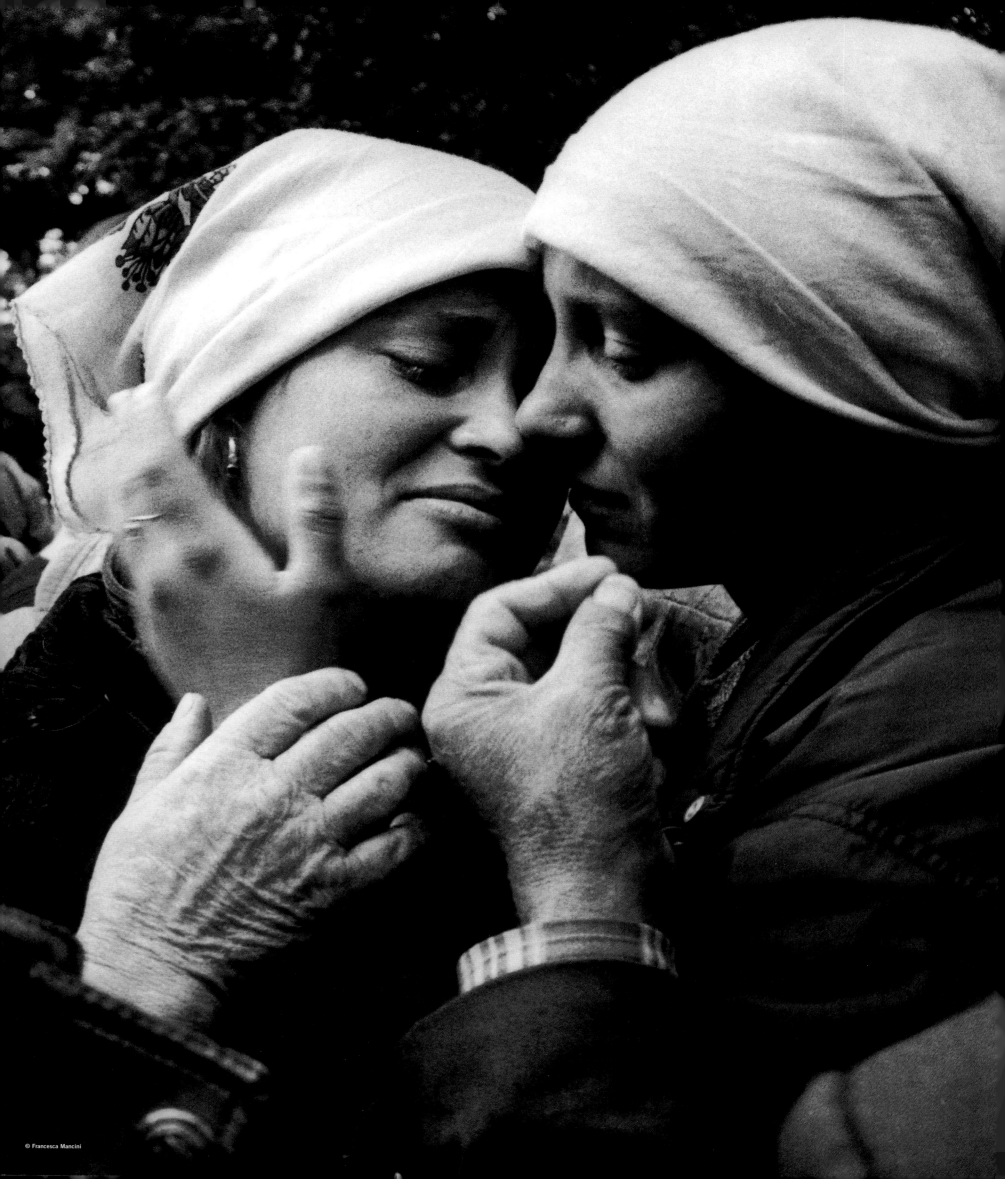

INTIMACY

LAUGHTER

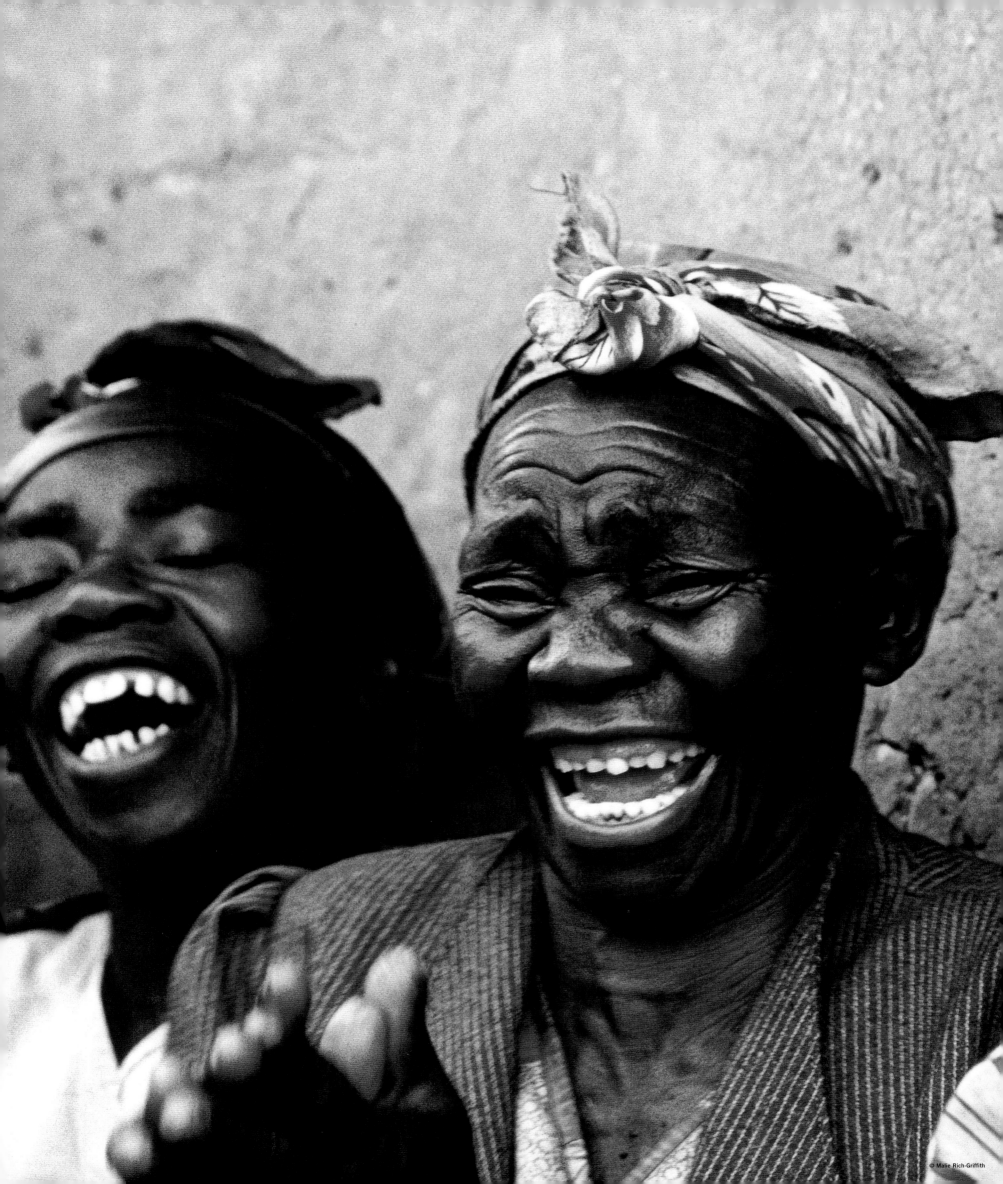

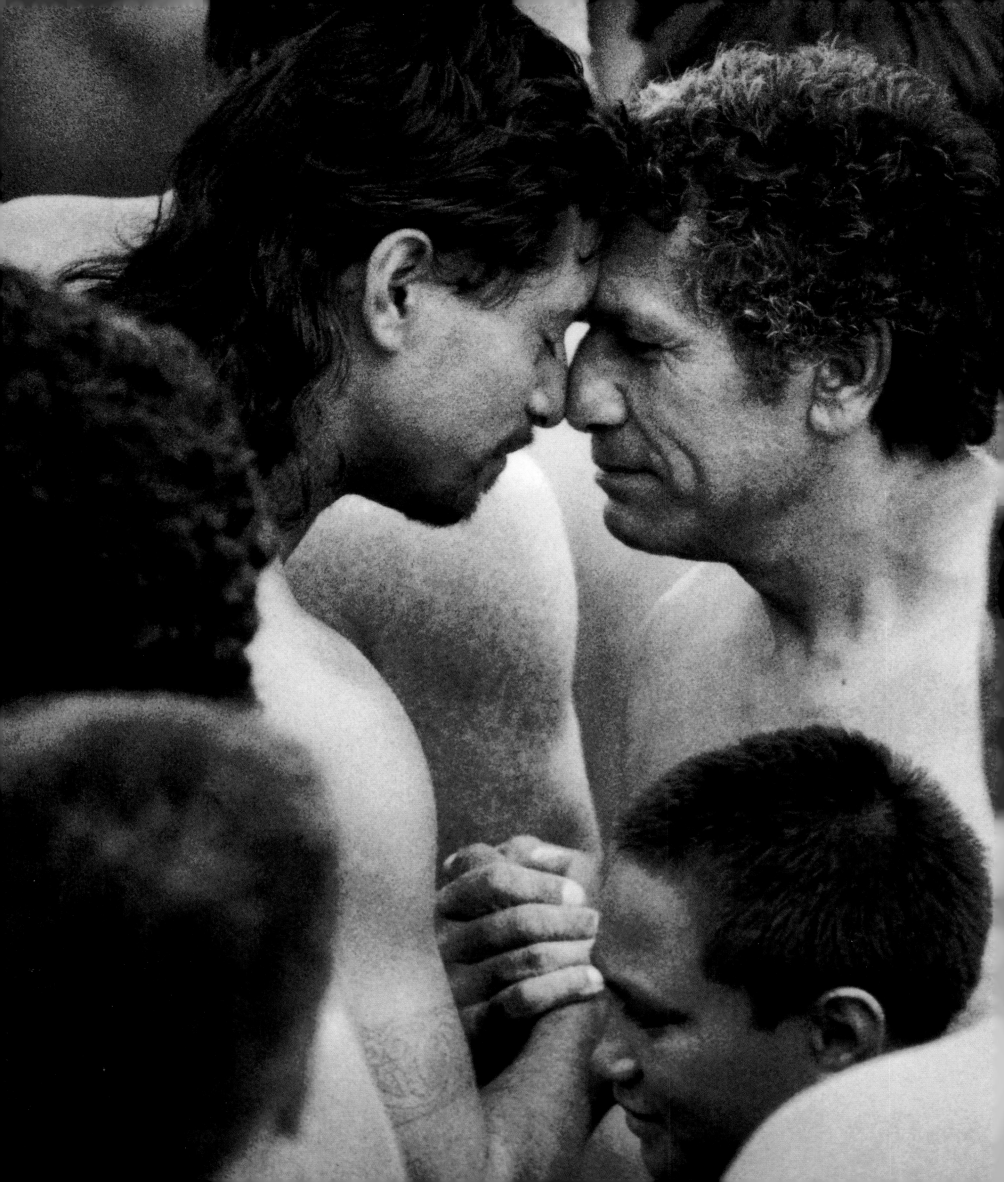

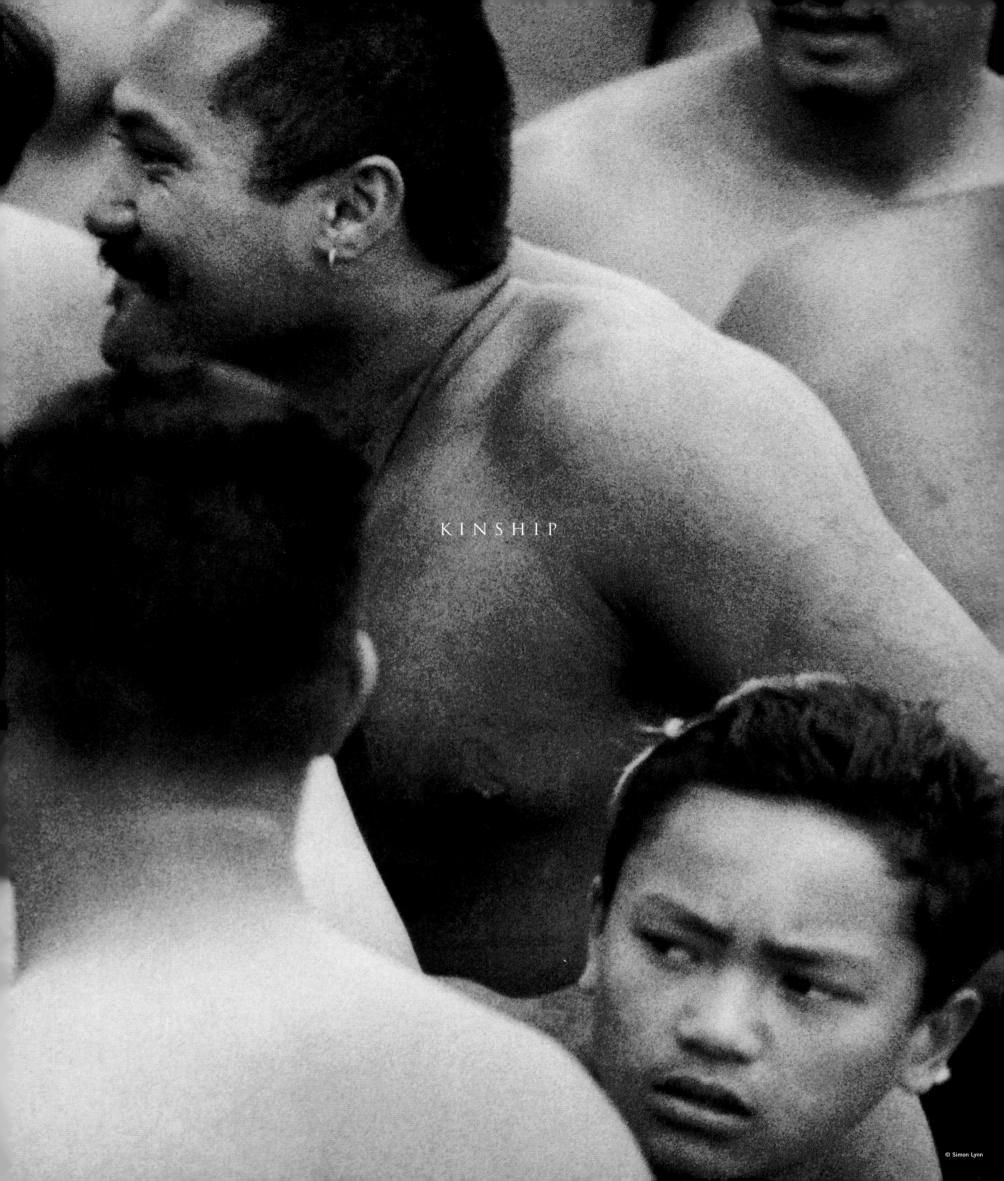

KINSHIP

FRIENDSHIP

a celebration of humanity

WILLIAM MORROW

75 YEARS OF PUBLISHING

An Imprint of HarperCollinsPublishers

M·I·L·K

MOMENTS OF INTIMACY, LAUGHTER AND KINSHIP

Many people will walk in and out of your life,

but only true friends will leave footprints in your heart.

[ELEANOR ROOSEVELT]

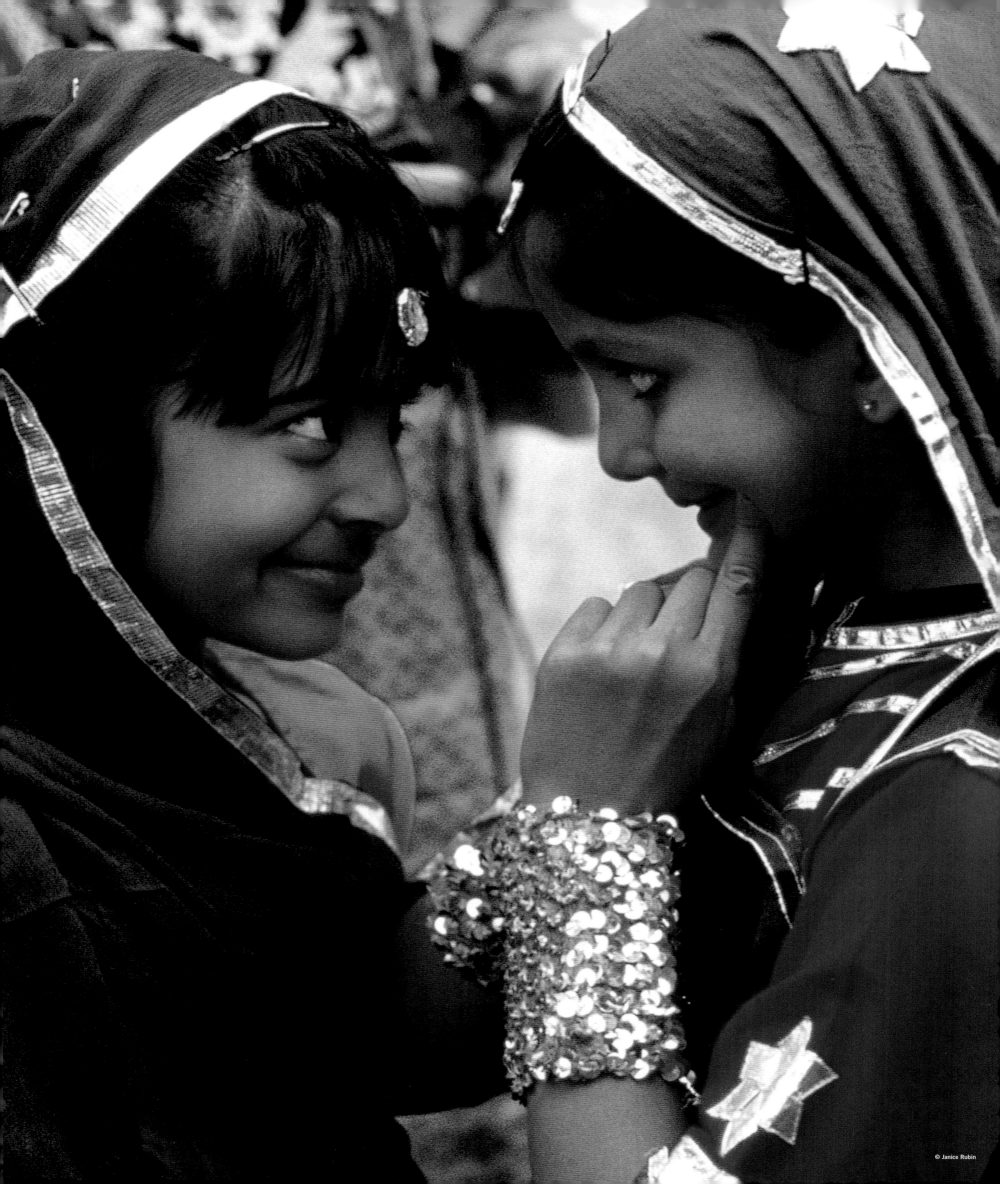

M.I.L.K. began as a dream,
became an ambitious adventure,
and gathered strength as it grew.
We see now that it took on a life of its own,
ceased to be a project and became instead

a gift.

a celebration of humanity

The M.I.L.K. Collection is the result of an epic global search for 300 extraordinary and geographically diverse photographs of family life, friendship and love.

This "epic search" took the form of a photographic competition – probably the biggest, and almost certainly the most ambitious of its kind, ever to be conducted. With a world-record prize pool, and renowned photographer Elliott Erwitt as Chief Judge, the M.I.L.K. competition was conceived to attract the work of leading photographers from as many of the world's countries as possible.

We promoted the competition as "the photographic event of our time" and to substantiate this claim set about the exhaustive task of finding and personally inviting photographers to enter from every one of the world's 192 countries.

Our challenge to the photographers was for them to capture and celebrate the essence of humanity, and our judging criteria called for genuine photographic stories conveying real and spontaneous emotion. Ultimately 17,000 photographers from a staggering total of 164 countries participated, among them a myriad of award winners (including at least four Pulitzer Prize winners), professionals and gifted amateurs from six continents. Over 40,000 photographs were submitted – some in lovingly stitched cloth packages, others alongside warm and heartfelt messages of support and encouragement – unforgettable images of human life, from its first fragile moments to its last.

And so the results of this global search are here for you to enjoy. Our hope – that is, the M.I.L.K. team's hope – is that you will look through this *Friendship* collection and recognize the people in it. Their moments are our moments. The instants of their lives, captured here, are universal.

M.I.L.K. began as a dream, became an ambitious adventure, and gathered strength as it grew. We see now that it took on a life of its own, ceased to be a project, and became instead a gift.

Along with our dreams, we had high ideals for this collection; we demanded absolute excellence and integrity in submission and selection. Tolstoy, in attempting to define "art," wrote that the feelings art evokes must be comprehensible by the mass of people and not just a few. We agree. These images speak to all of us with clarity, universality and – to use that elusive and neglected word – joy.

We salute the men and women who have shaped this project. We hand over ownership of the dream to all who have been involved, because it is no longer ours. Ours was a wisp of an idea, which has been replaced by a tremendous, inspiring reality.

To the brilliant photographers, to Tim Hely Hutchinson who shared my vision for the project at the outset, to Elliott Erwitt, to my friend and M.I.L.K. Project Director Ruth Hamilton, and our skilled colleagues, to my generous family and other friends who kept faith along the way – and to you, as you begin your personal journey through these pages – profound thanks. All these moments of intimacy, laughter and kinship belong to you.

Geoff Blackwell Director & Chief Dreamer – M.I.L.K.

prologue by MAEVE BINCHY

On my first day at school a girl asked me to be her best friend. We were five. We both wore brightly colored knitted jumpers and had bows on top of our heads like little cockatoos. "What do I have to do?" I asked fearfully. Too much was already happening that day; I was being very cautious. "I don't know!" she admitted. "But it's meant to be good to have friends."

And wasn't she right? A woman of wisdom already, at five years of age. Her name was Jillyann and, immediately, I called one of our hens after her, as a sign that we were friends and it was a good thing to be. We lived in a suburb of Dublin and in a small garden kept eleven hens, all eventually given names like Jillyann, Celeste, Eunice, Mary and Philippa as a testament to friendship. They clucked their way to a ripe old age. But when, in the fullness of time, they all fell from their perches, the friendships still survived – and lit up my life as friendships have done everywhere.

I honestly don't know how people can exist without friendship. People to share their secrets, hopes and dreams. Also people who will share humiliation, shame and loss.

People who will laugh with us over nothing, sing the same songs, read the same books or tell us what the rest of the world will not tell: that the new hair color was a sad, sad mistake.

How do they live – the people who are happy and proud to be so independent that they claim they don't need a friend? Is it an act, and something born of necessity because they have found themselves friendless? Is it a fear of confiding, of opening up? A fear of being unashamedly natural in a world that seems to insist on role playing and acting as if all was going well even when it obviously is far from well? Is there any dignity at all in being able to manage alone, in trying to be an island that doesn't touch anything or anyone else?

Twenty-five years ago I left an over-inquisitive Irish society, where everyone knew far too much about everyone else, to come and live in the huge anonymous city of London where you could pass millions of people every day without knowing any of them or any of them knowing you. That was startling enough, and it was having great friends in London that made sense of a huge city and kept me sane.

But what I never understood was the way many people seemed to make a virtue out of being friendless. There was a man who lived in the next street. A big man with sad eyes, he walked slowly, his back straight, down the road. He looked neither right nor left, he greeted nobody. I used to talk to him of course, not because I was so kind and generous, but simply because it was the custom where I came from to salute people who lived nearby and have a little chat. He seemed very startled and would look around in case I was talking to someone else, but he was happy to answer what he must have considered my interrogations about whether he liked hot or cold weather, what he watched on television, and how could we make anything grow in the starved city soil of London gardens.

He seemed to answer easily enough once he realised that I was not going to go home and live with him, but he was never so forward as to ask me anything at all about myself. Maybe he lacked the courage, or the interest even? Once I asked him where did his friends live mainly? "Friends?" He said the word as if I had asked him about Martians. I left the subject. He died and there was hardly anyone outside his house the day the undertakers came. I heard his neighbors say that he was a very nice man because he kept himself to himself. I wanted to cry aloud that he may well have been a very good man, but it was not as a result of keeping himself to himself. It was in spite of it.

As a teacher, a traveler and a writer, I have wandered many places in the world, always and everywhere being touched by images of friendship. Tiny children going to school in Bali, picking huge banana leaves to shelter each other when tropical rain storms threatened their immaculate white shirts. They laughed as they ran, escaping the huge drops of hot rain. Two old men in Athens, so lost in their daily chess game that they were unaware of the traffic swirling around and tourists pushing past them… They smiled and pointed at each other as if one or the other had done something cunning. Four enormous mirth-filled women on a beach in Bulgaria, obviously friends for decades past, struggling at the keep-fit exercises amongst a horde of much more lithe females, and feeling no sense of inadequacy, because they were all in it together.

Boys in Scotland who had created a dream stadium and were playing brilliant football in an old yard with their folded jackets serving as the goal posts. Shoppers in New York clutching each other with excitement at the thought of the next bargain possibly around the next

corner. Golfers in Canada endlessly explaining a swing to each other and commiserating when it failed yet again. Two couples, all-time losers in Las Vegas, wiping each other's tears away with big colored handkerchiefs and saying that they must be grateful that they had left their tickets at the airport so that they couldn't cash them in. Young mothers who had been through the whole engagement, marriage, first baby thing together, busily protecting their toddlers from sunburn on Bondi Beach in Australia, each as caring about the other's child as her own.

I have often wished that I could photograph forever something as wonderful and enriching as friendship, so it is a joy to sit and leaf through picture after picture by those who have done so. It proves, if ever it needed to be proved, that friendship need have nothing to do with coming from the same background and sharing all the same interests. A friendship can grow on the most unlikely and barren ground.

When I was a university student, I was very friendly for four years with a man who loved boxing – a sport that I detested. He had never been to the theater, so I took him to "Long Day's Journey into Night" which he said he found interesting, but that he didn't really enjoy it. Why didn't they all cheer up a bit, stop wailing and drinking and just get on with it? So, in fairness, after that I had to go to a boxing match too. I hated it and wondered why they couldn't shake hands, climb out of the ring and go and have a pizza together.

Our friendship survived it because we had so much else in common, the debating society, the games of chess, the detective stories, the importance of teaching, the hatred of puns, and the belief that life would get better instead of worse. He went on to manage a junior boxing team, which I could never enthuse about. I went on to write plays, which he could barely stay awake for. We didn't see all that much of each other when student days were over. But I have met him many times since and the shorthand of friendship is still there, the feeling that there was no need to explain and put things in context. Nothing is better. We were never in love, so there are no recriminations about who left whom.

Friendship in some ways is more pure than "Love" – the committed type of sexual love, which demands we exclude others from the relationship.

I am overjoyed for all my friends to have many, many friends other than me, but I do not offer the same generosity of spirit to my "Love."

I would be greatly disturbed and peeved – not to say distraught – to know that he had any other love at all than me. No wonder friendship

is easier to handle. And while other people's loves can be confusing, mystifying, irritating and ill advised, their friendships are

always touching.

My mother had a friend who was to my mind very odd, and not really nice enough for her. They had been nurses together years ago and

went back a long, long way. This woman was elegant, groomed, and very conscious of her image, while my mother – a large, generous,

jolly woman – was the reverse. My mother's friend would recoil at the thought of a child's sticky hand reaching up in a gesture of affection,

yet my mother treasured her as a friend. Together they would talk about days in the Nurses' Home and studying anatomy on a skeleton

they had bought between them with money they had won on a horse.

Watching them was uplifting because, despite the huge apparent social differences between them, they were only innocent girls at heart

and the lines of middle age seemed to fall from their faces as they talked about the past, the present and the future.

I remember the night my mother heard her friend had died. She never went to sleep. She sat at a window looking out at the night and

wouldn't be consoled by her husband and children who loved her. "She was my friend – we never had to explain anything to each other,"

she said over and over.

Friendships don't have to have started way back – they can be just as exciting when new. Not long ago, eight of us went on a press trip

where everything that could have gone wrong did go wrong, from food poisoning to a car crash, to snake bites, to a Government Minister

in a faraway land taking great offense at something. But we survived it and like survivors of a shipwreck we remain permanently entwined

in a friendship born of terror.

I don't question that friendship is blinder even than love. I have no idea, for example, what my friends look like. If you asked me, I would find it hard to tell you because, if they are friends, all I see are their smiling faces, their eager enthusiasm waiting to hear or say the next thing, their belief that I am good news also. I couldn't say that one was a little fat bald man, or another a stunning elegant woman who looks ten years younger than she is. These things don't enter into it. Just as most of the people in these pictures wouldn't be able to tell you what clothes their friends wore, I would be unable to tell you what my friends wore last time I met them. It's the company, the catching up and the ability to share, the sheer shorthand of it all, which is valuable to me to the point of excluding everything else.

I have been moved to the heart by these pictures of good times made better and bad times forgotten due to the healing magic of friendship. May the joy of their friendships and your own gladden your souls always.

Maeve Binchy [Dublin]

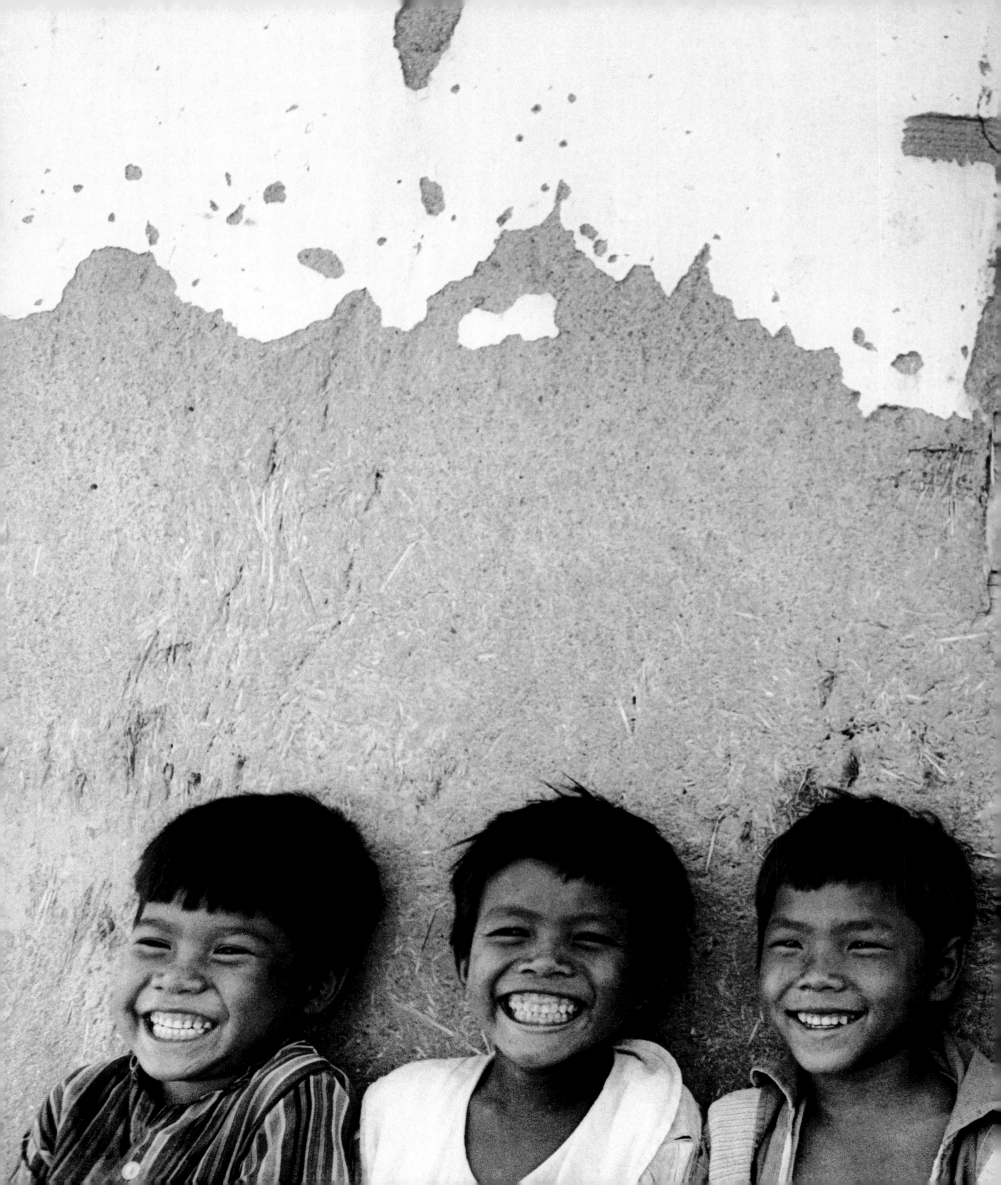

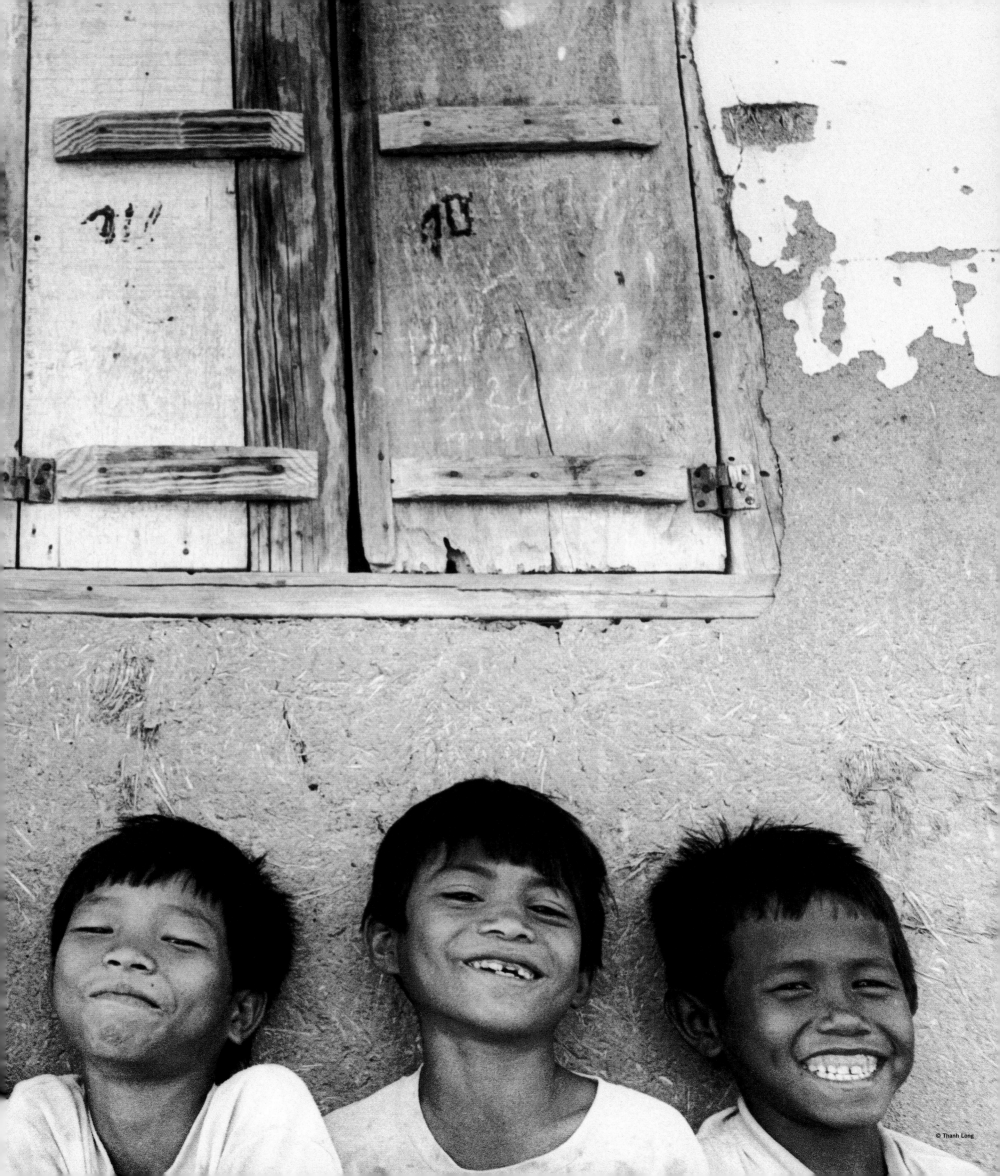

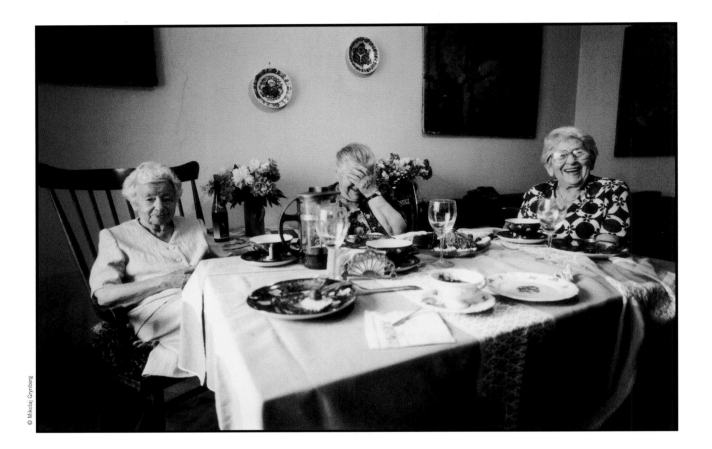

LAUGHTER IS THE SHORTEST DISTANCE BETWEEN TWO PEOPLE.

[VICTOR BORGE]

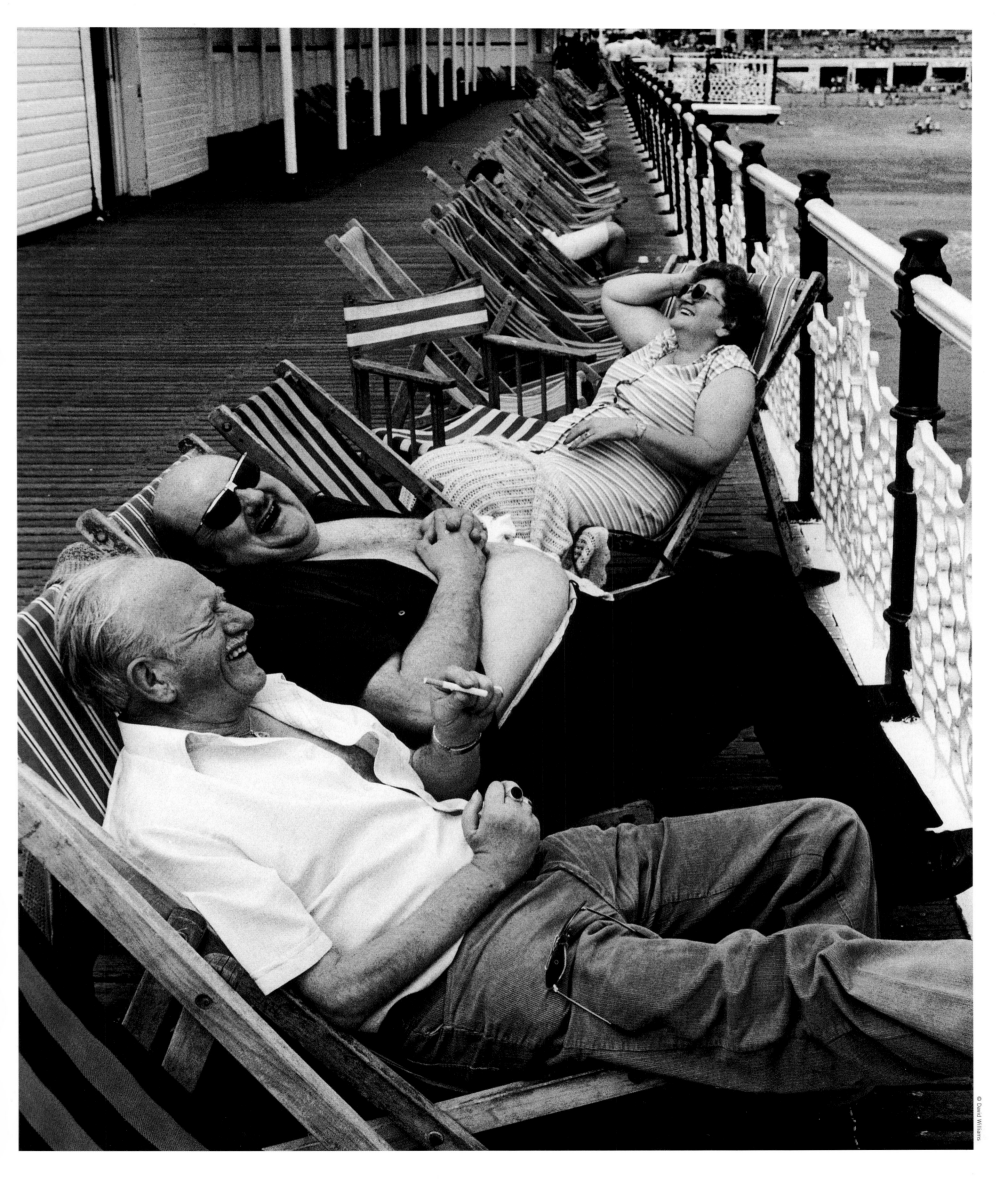

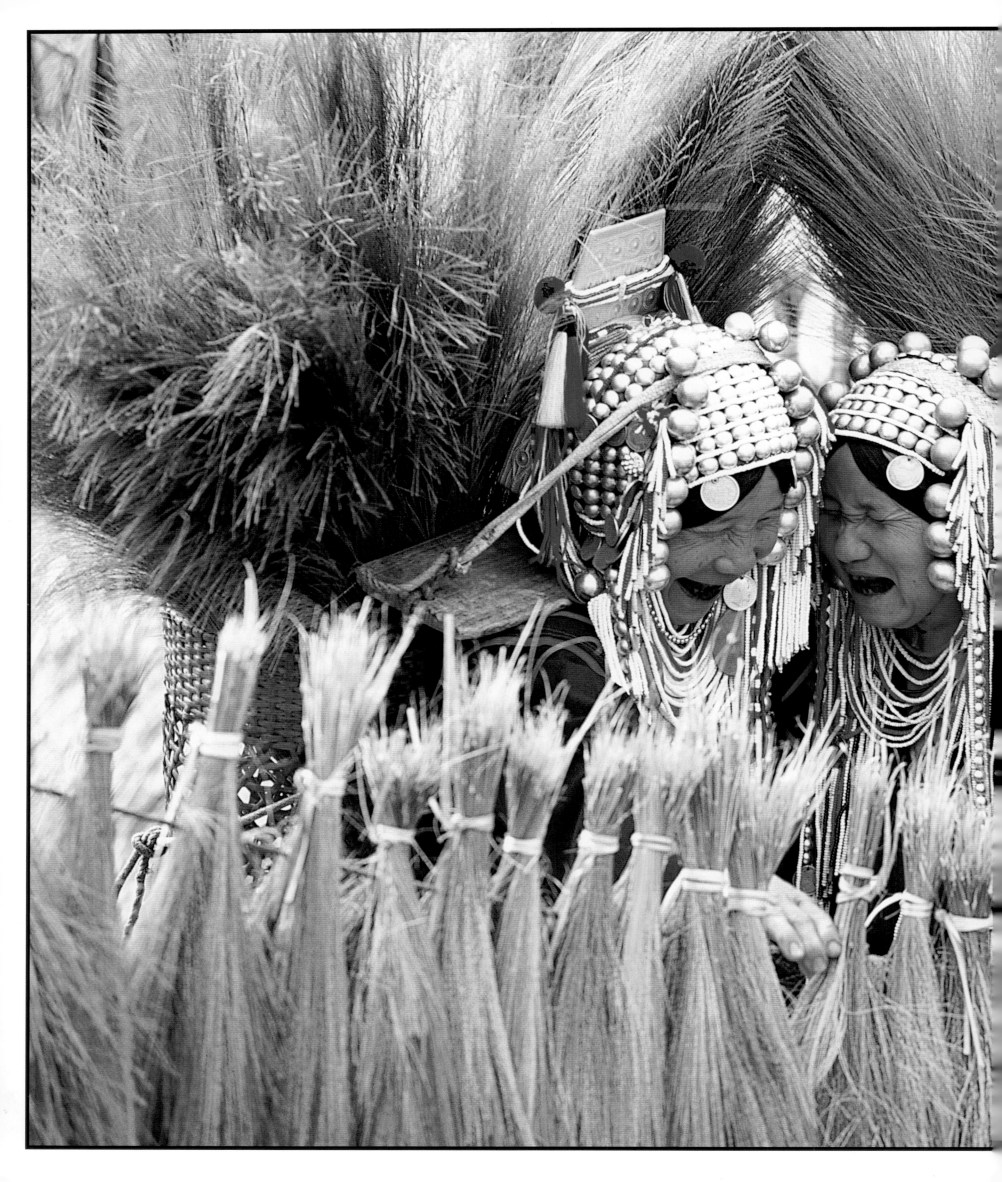

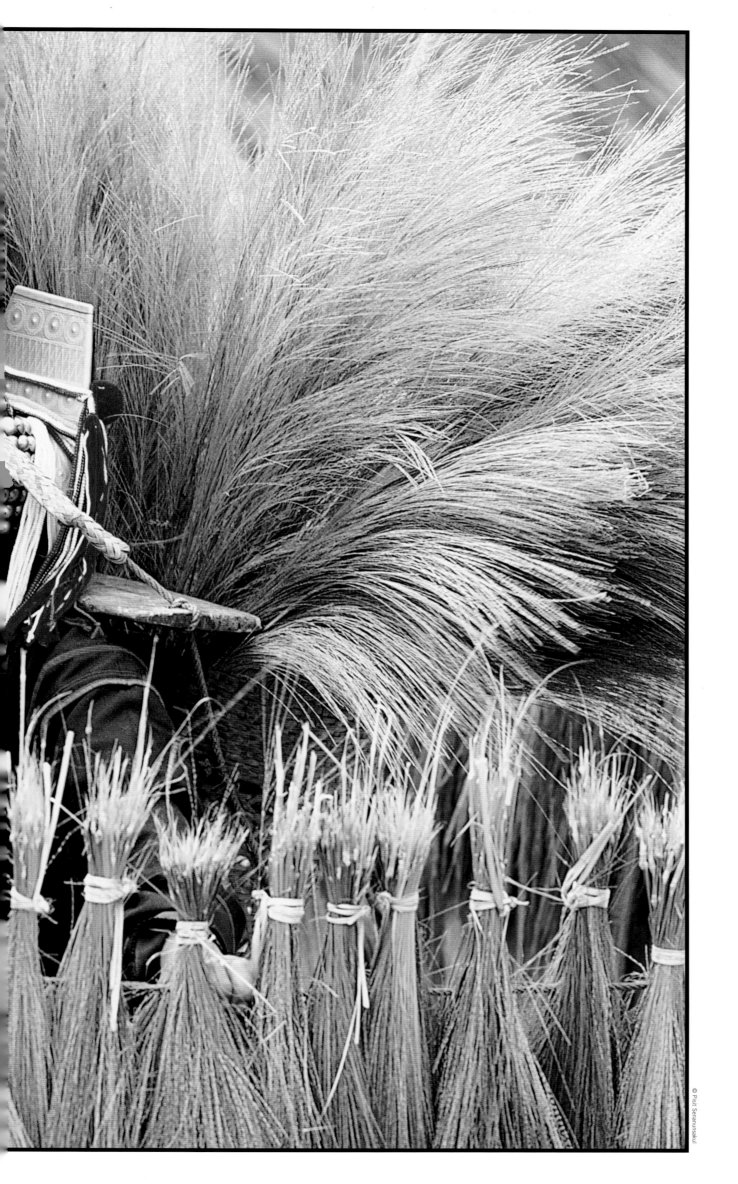

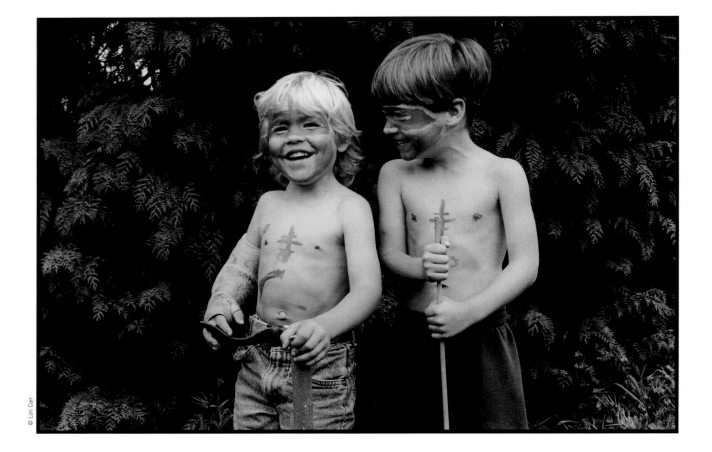

© Lori Carr

A FRIEND IS, AS IT WERE, A SECOND SELF

[CICERO]

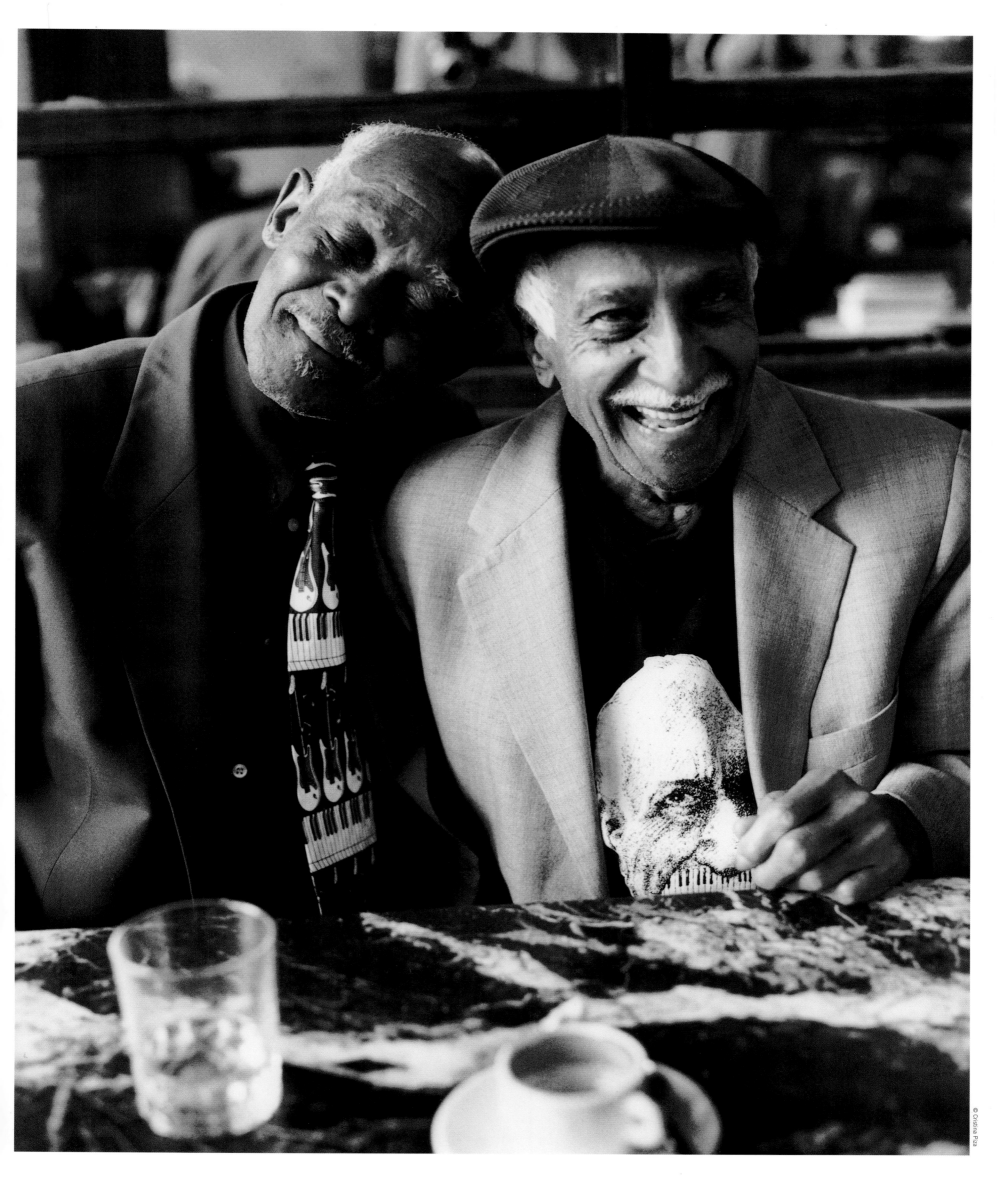

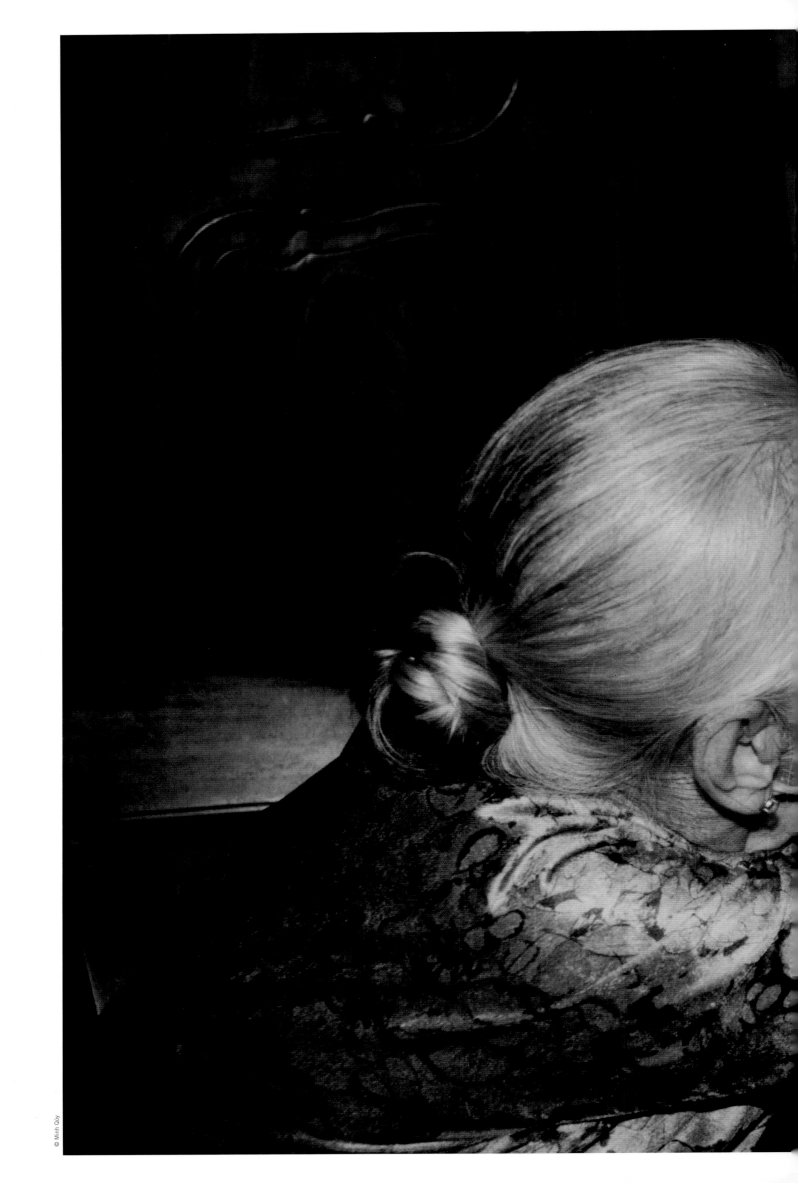

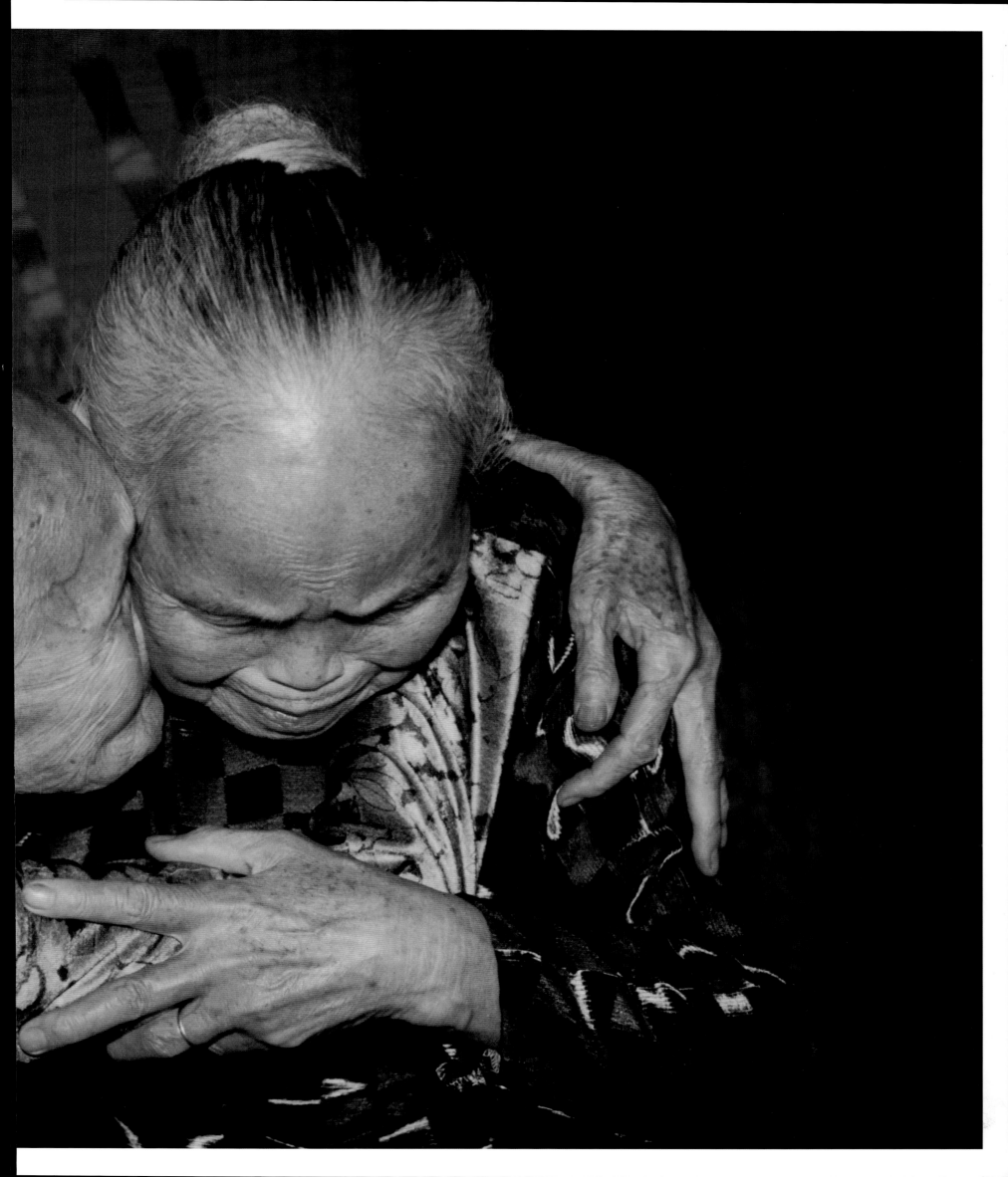

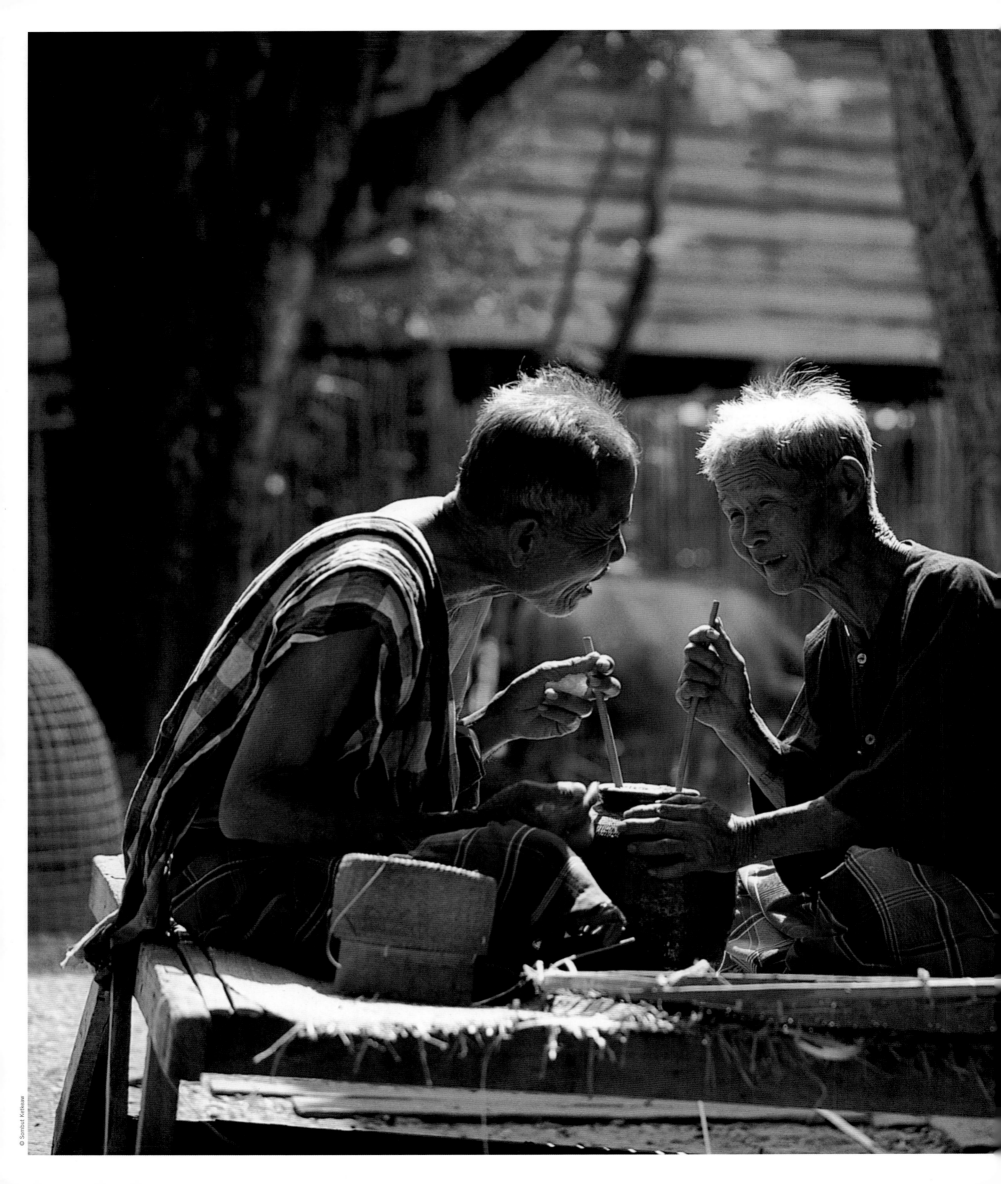

IN THE SWEETNESS OF FRIENDSHIP LET THERE BE LAUGHTER AND

SHARING

OF PLEASURES.

[KAHLIL GIBRAN]

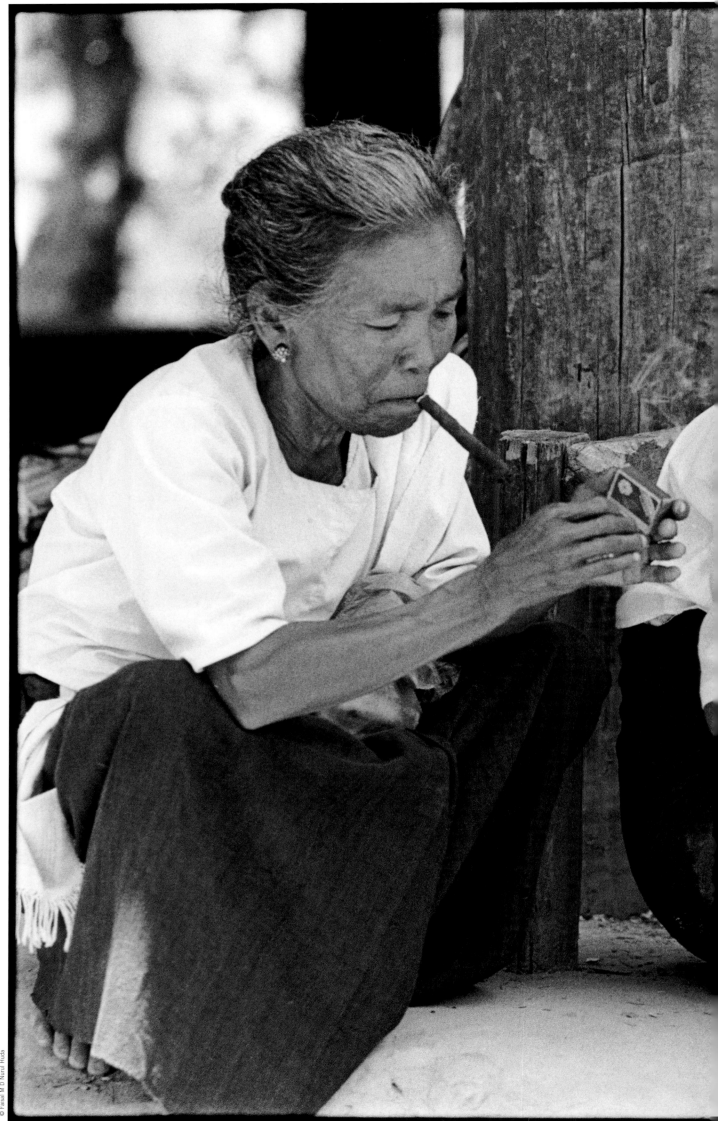

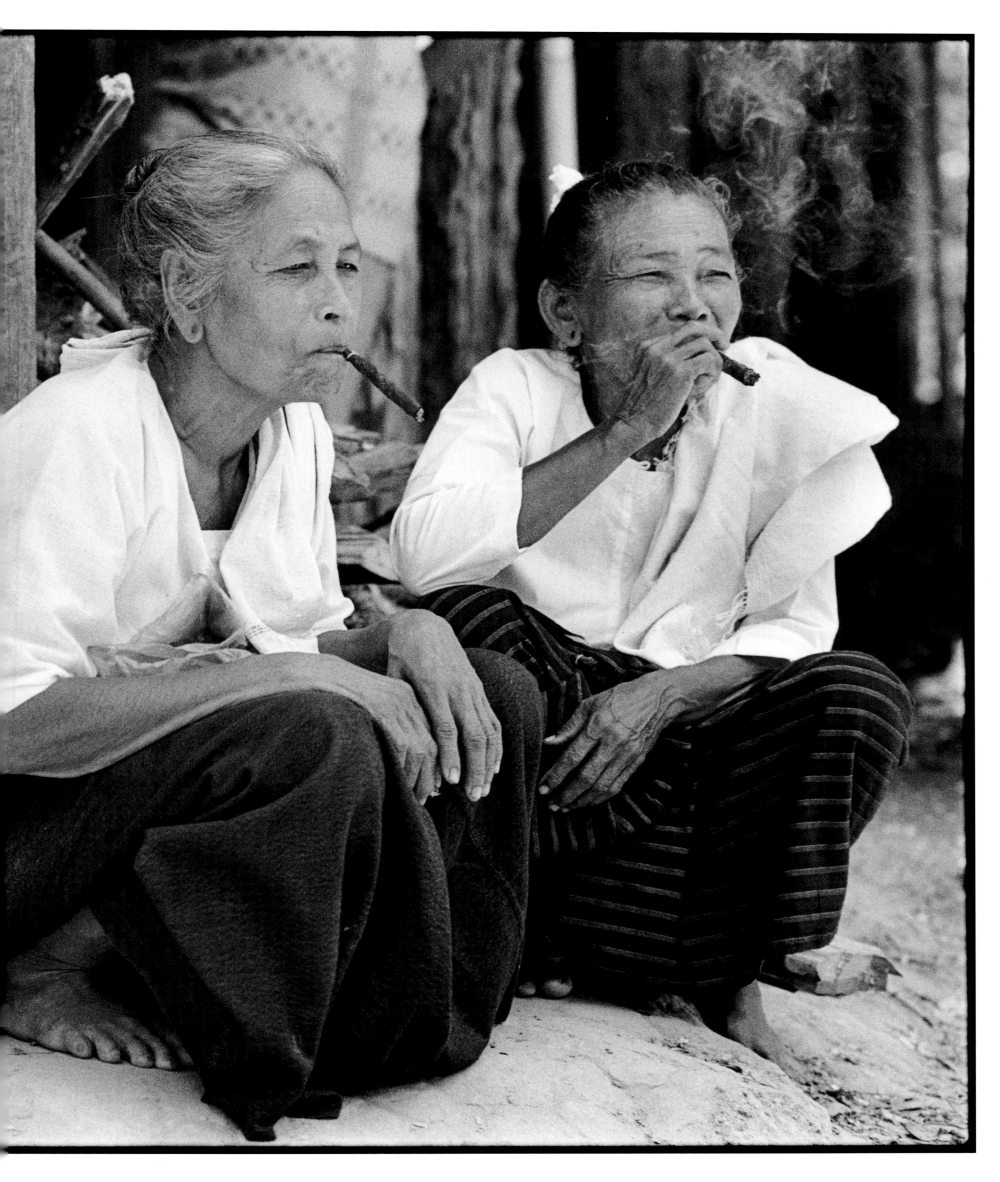

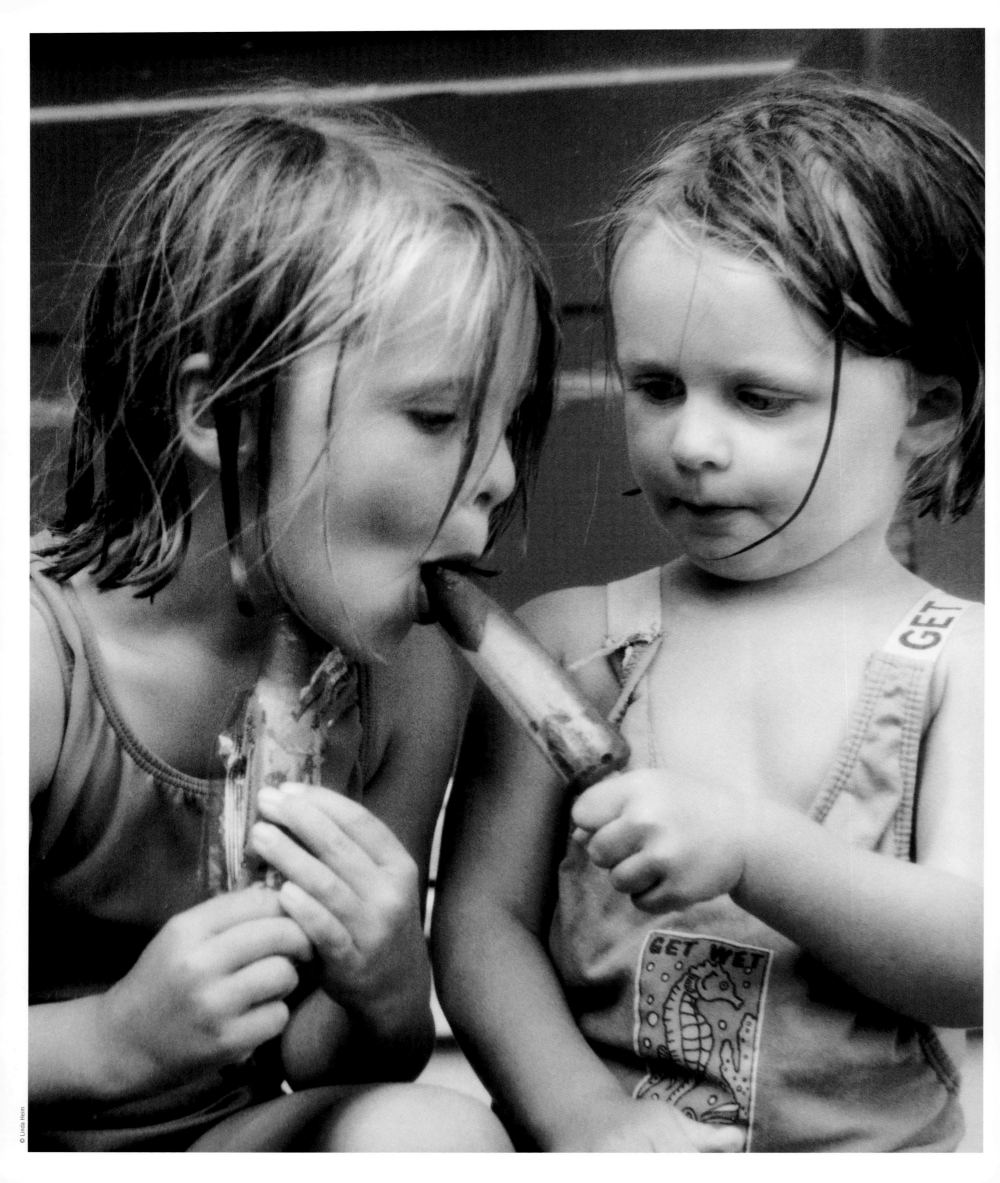

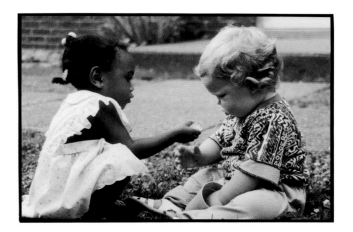

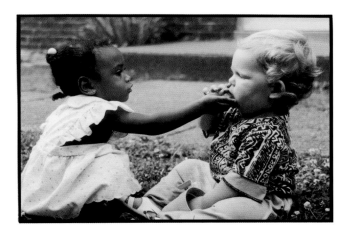

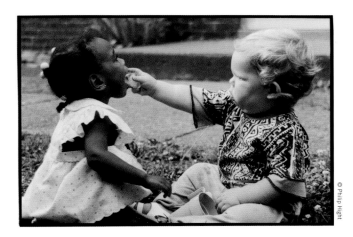

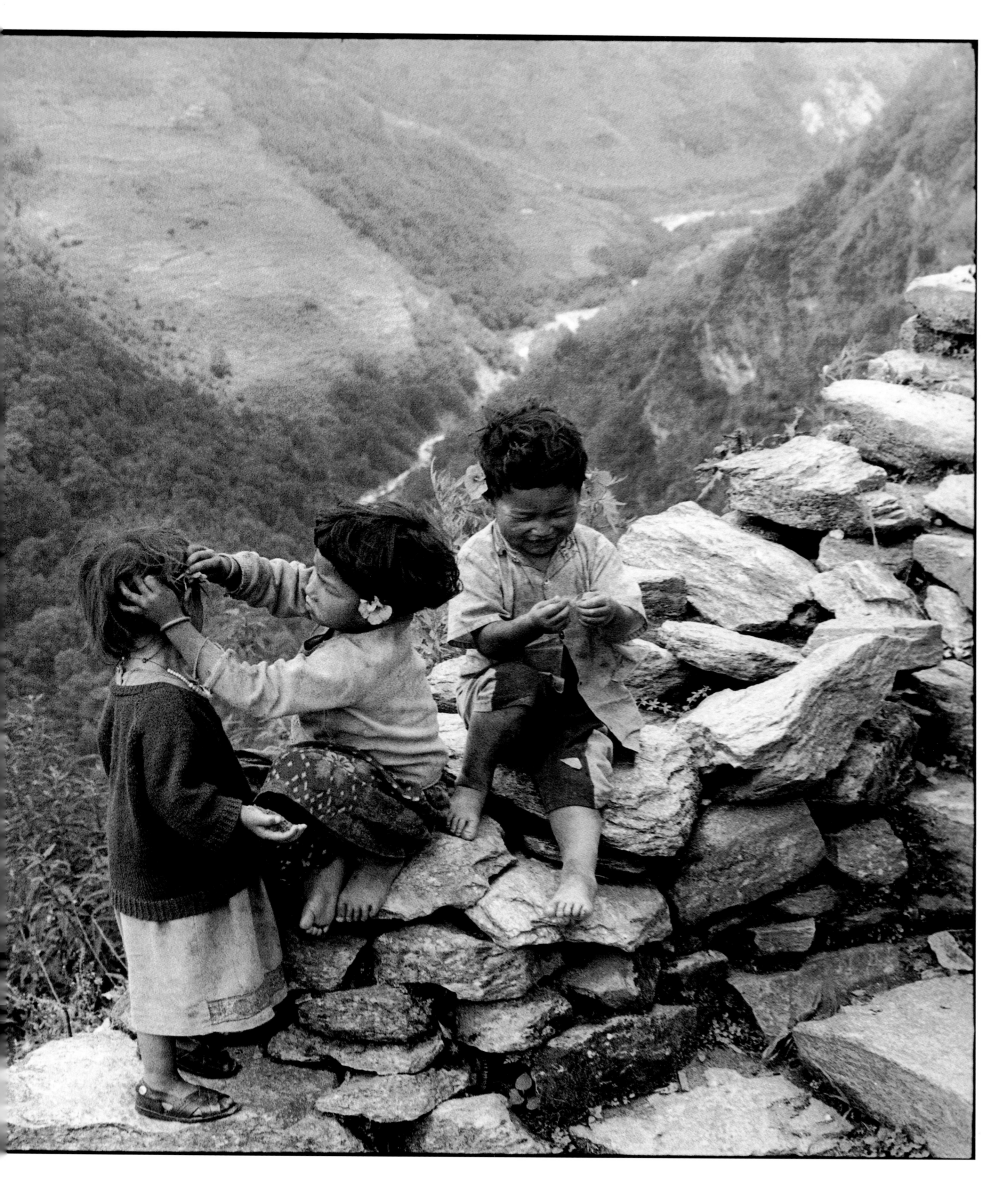

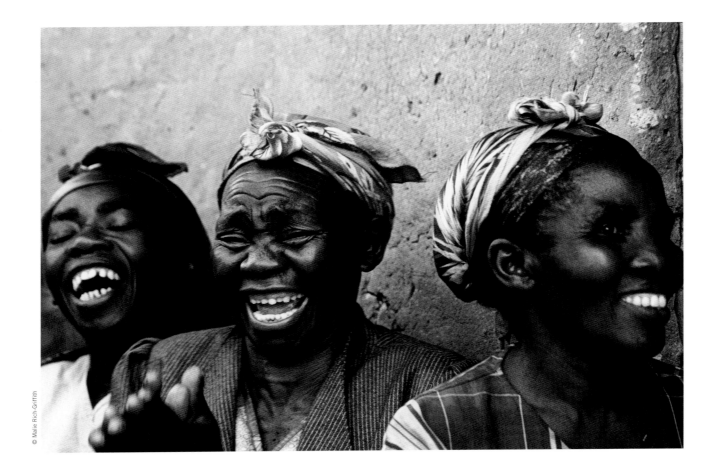

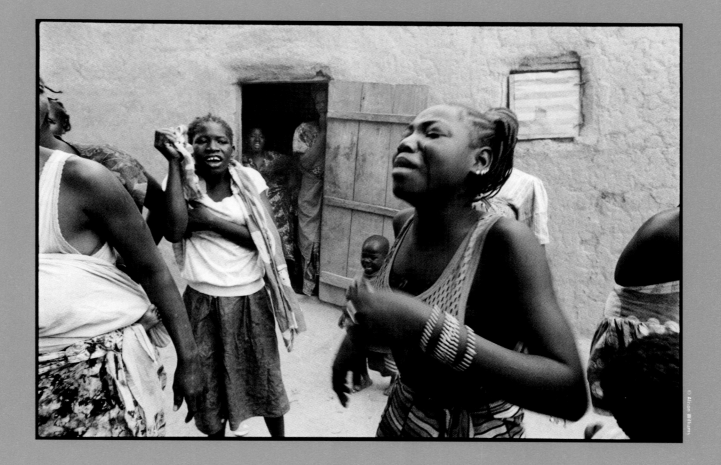

SHARED

SHARED JOY IS DOUBLE JOY. SORROW IS HALF SORROW.

[SWEDISH PROVERB]

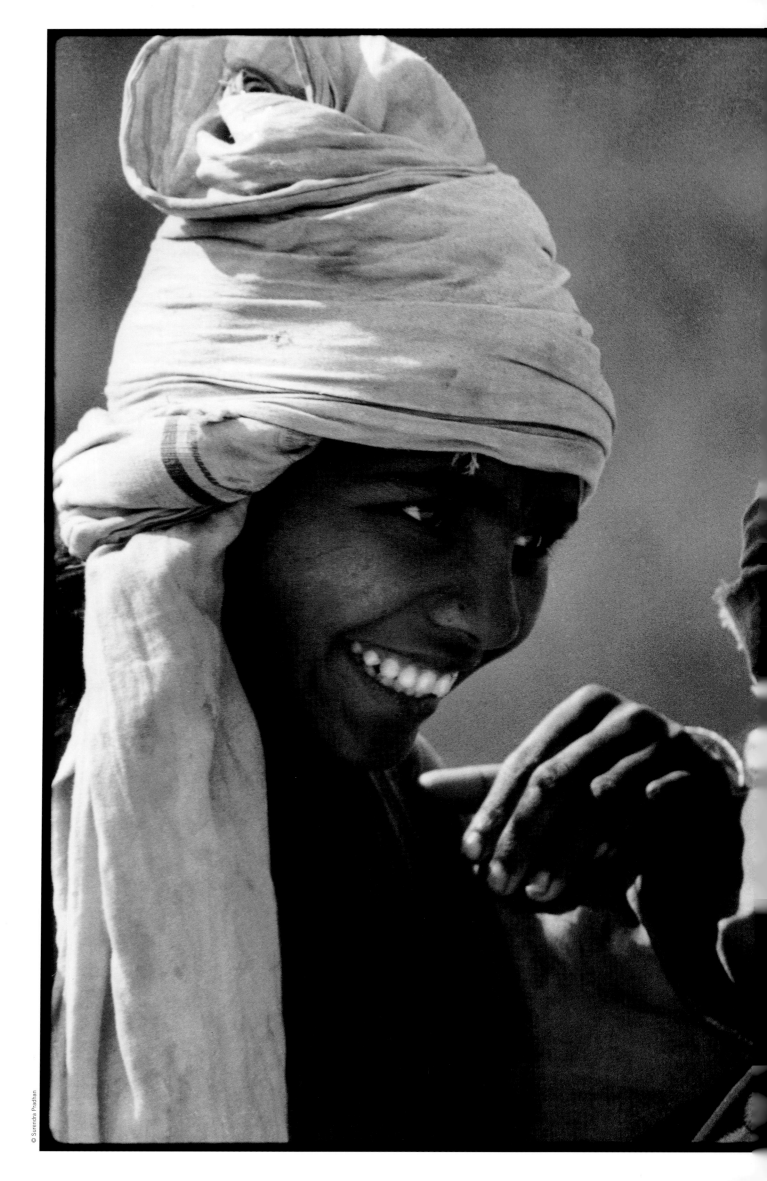

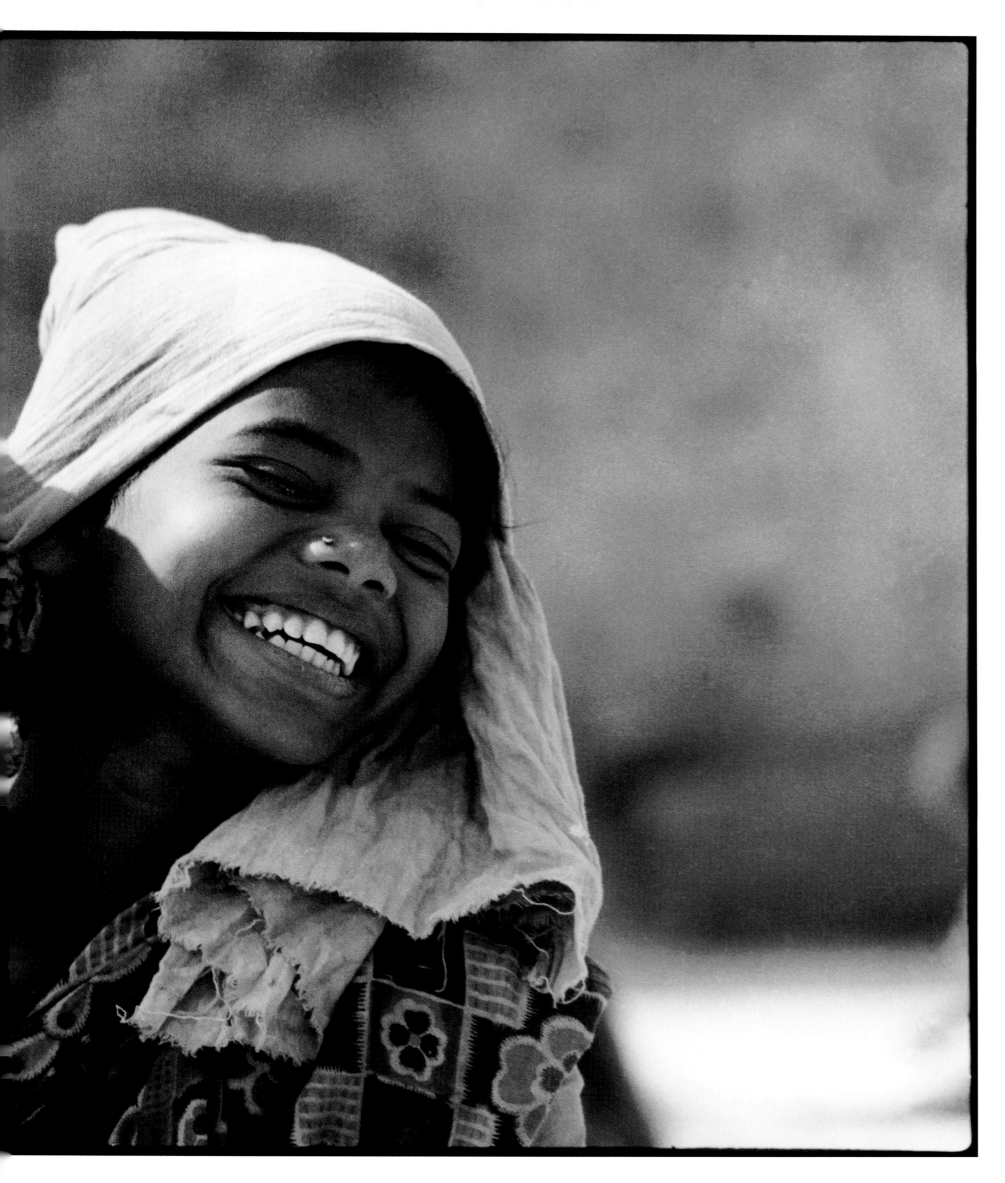

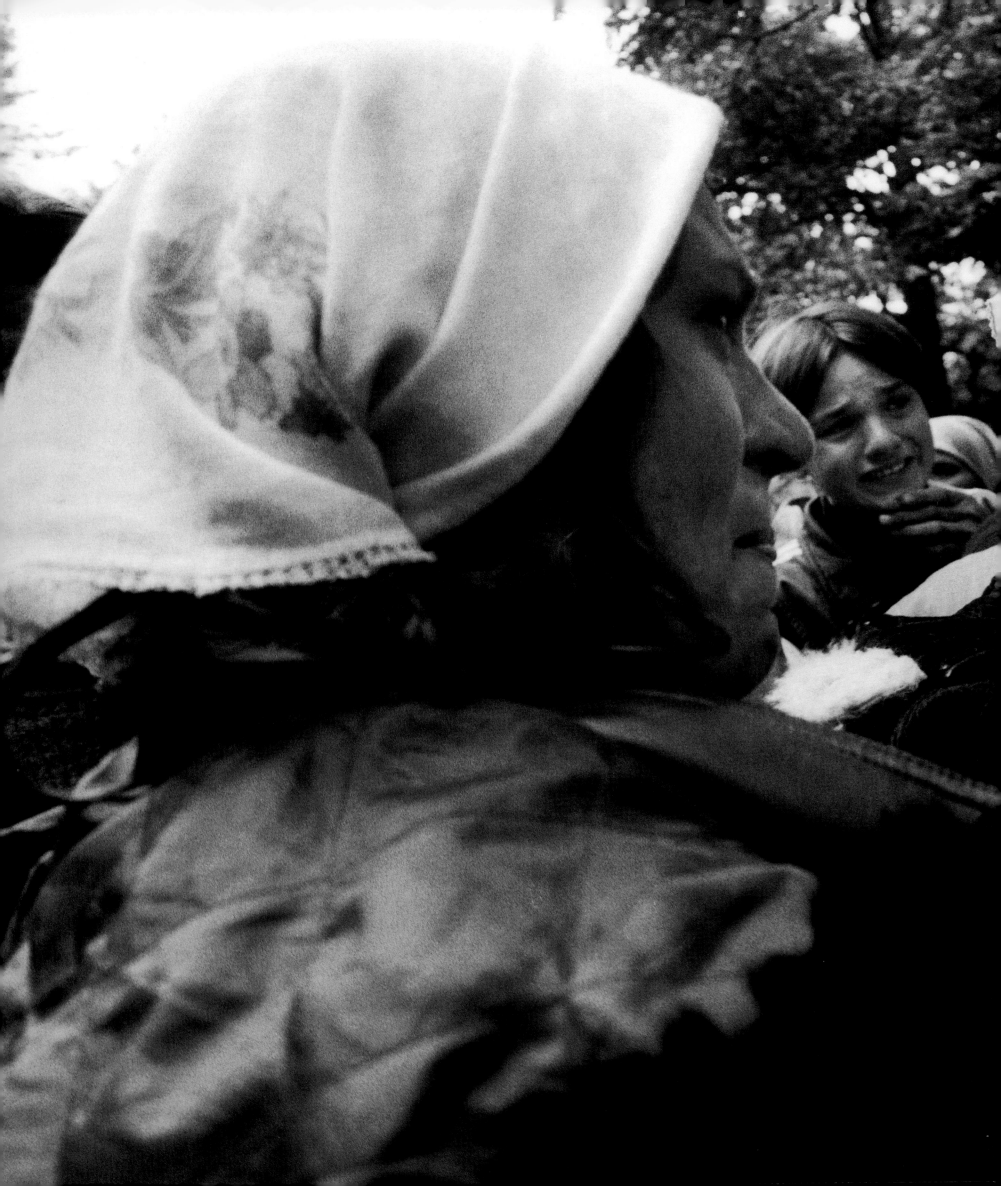

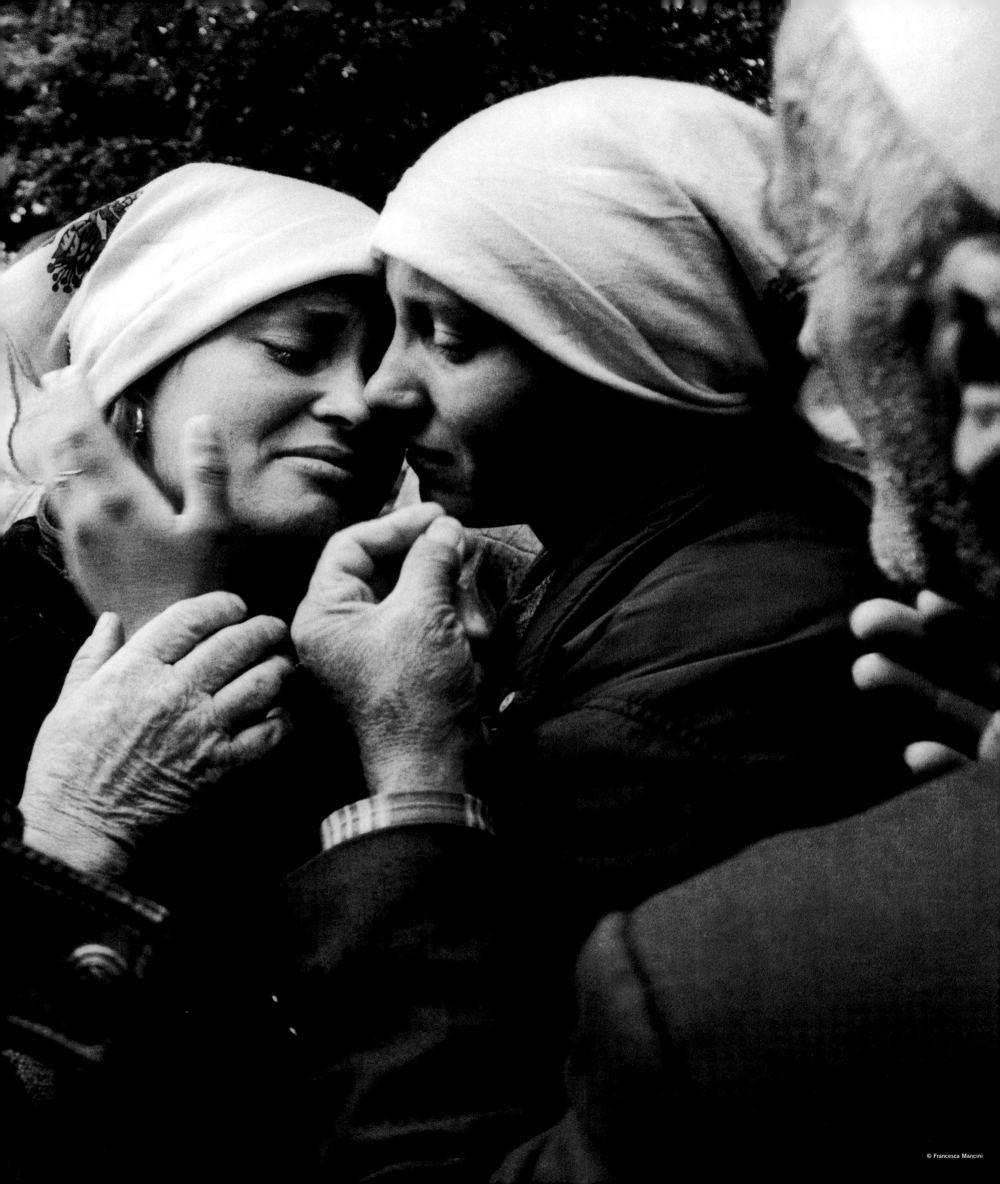

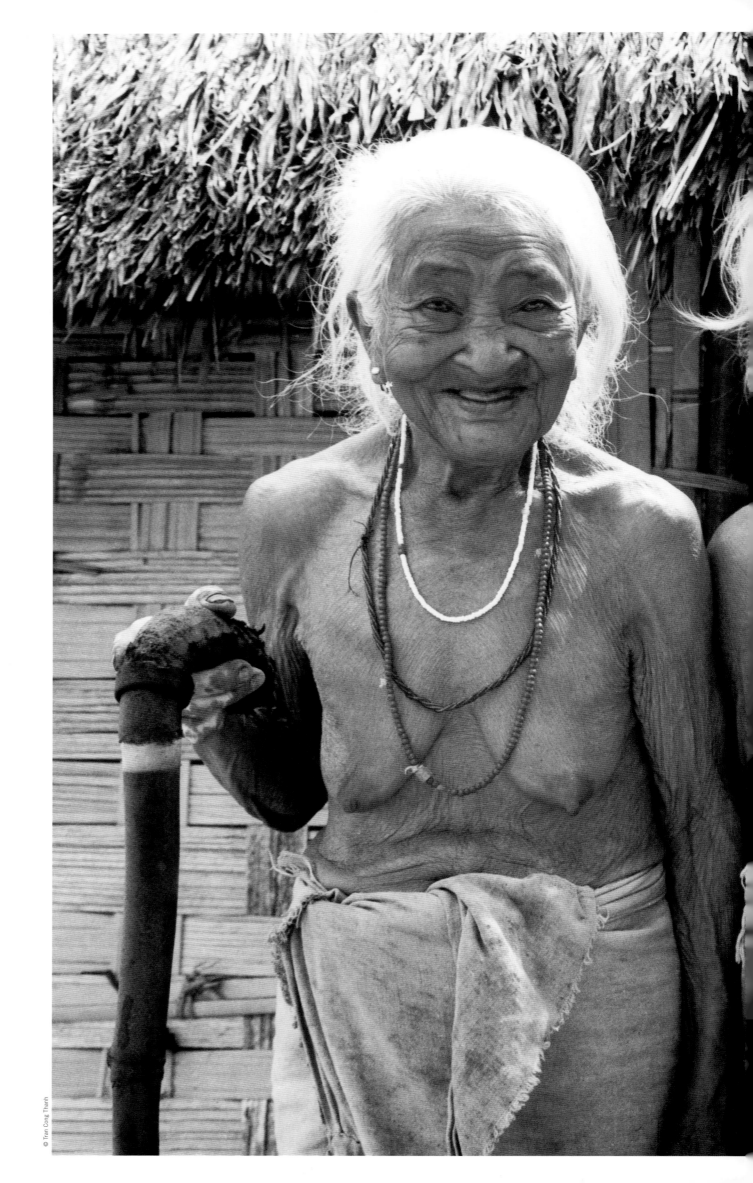

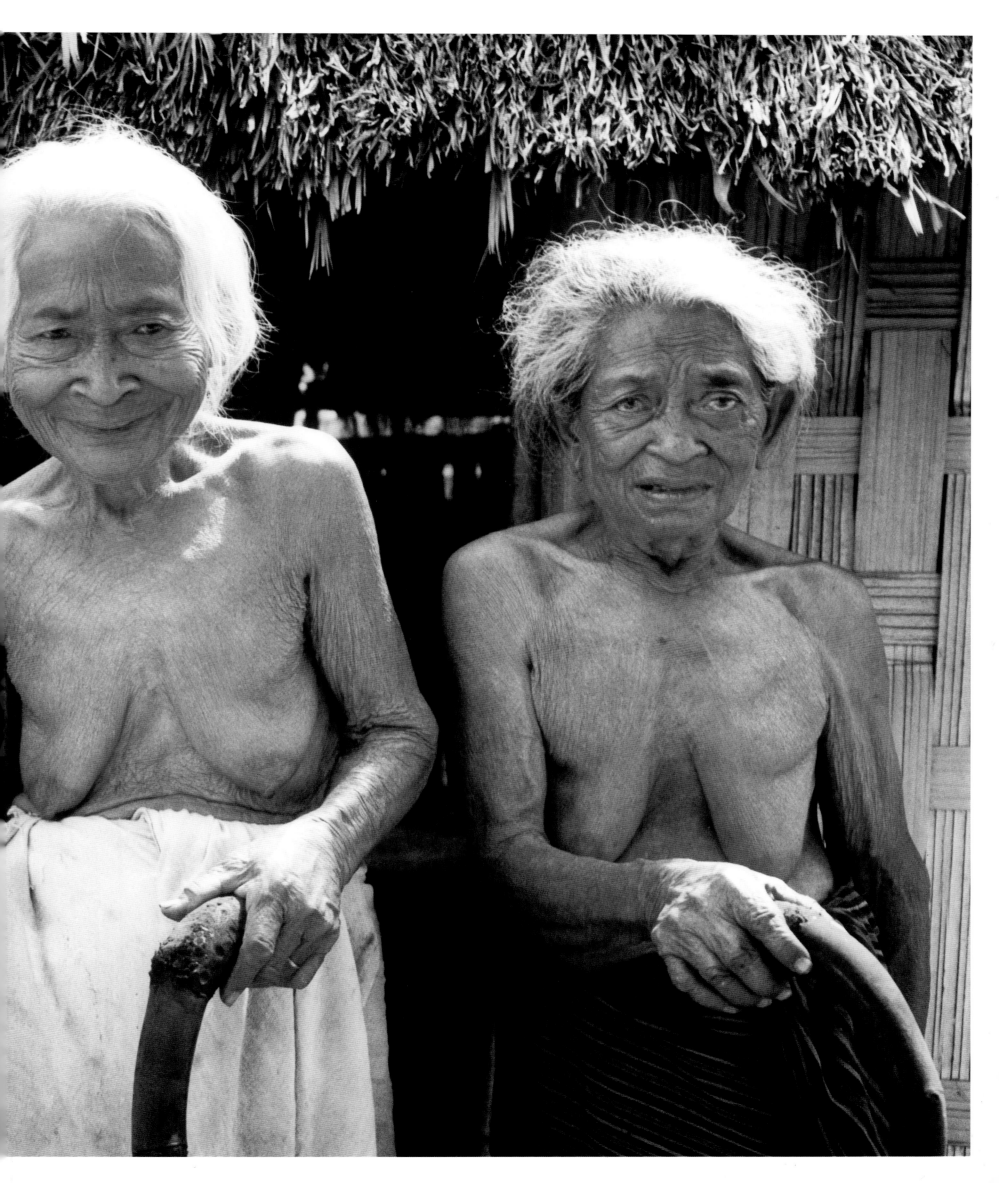

Love is but the discovery of ourselves in others, and the delight in the recognition.

[ALEXANDER SMITH]

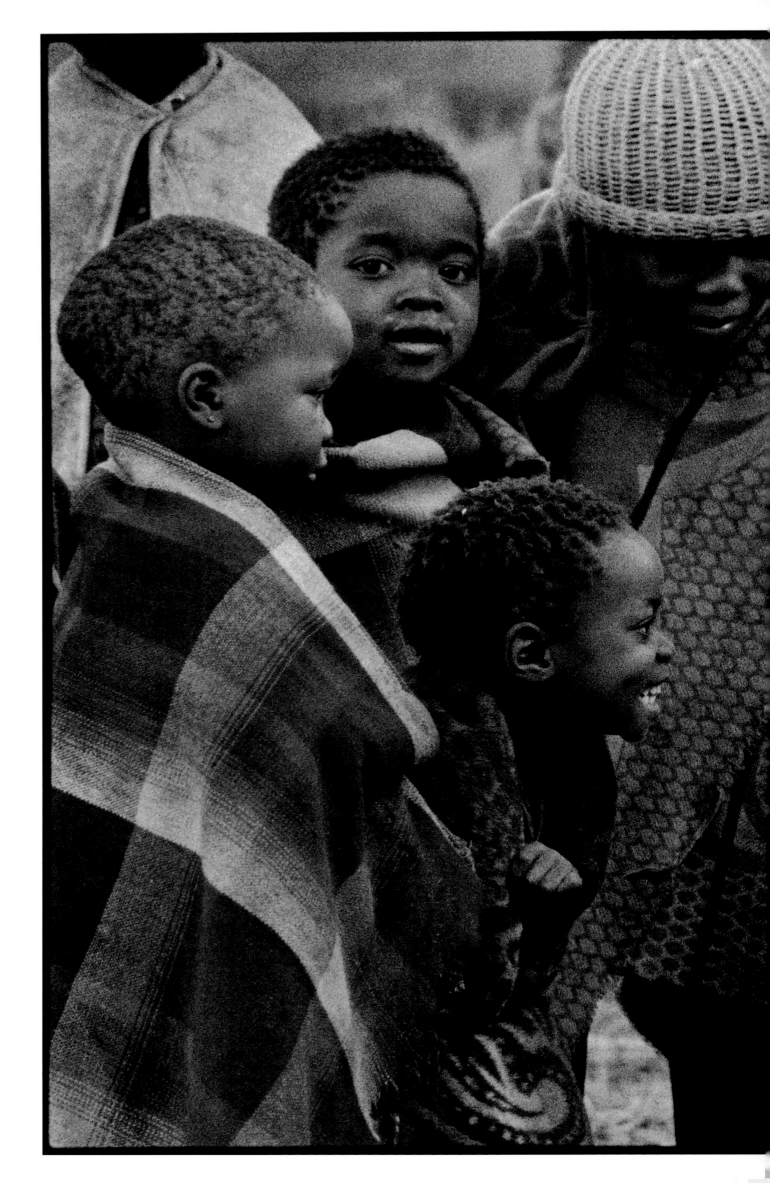

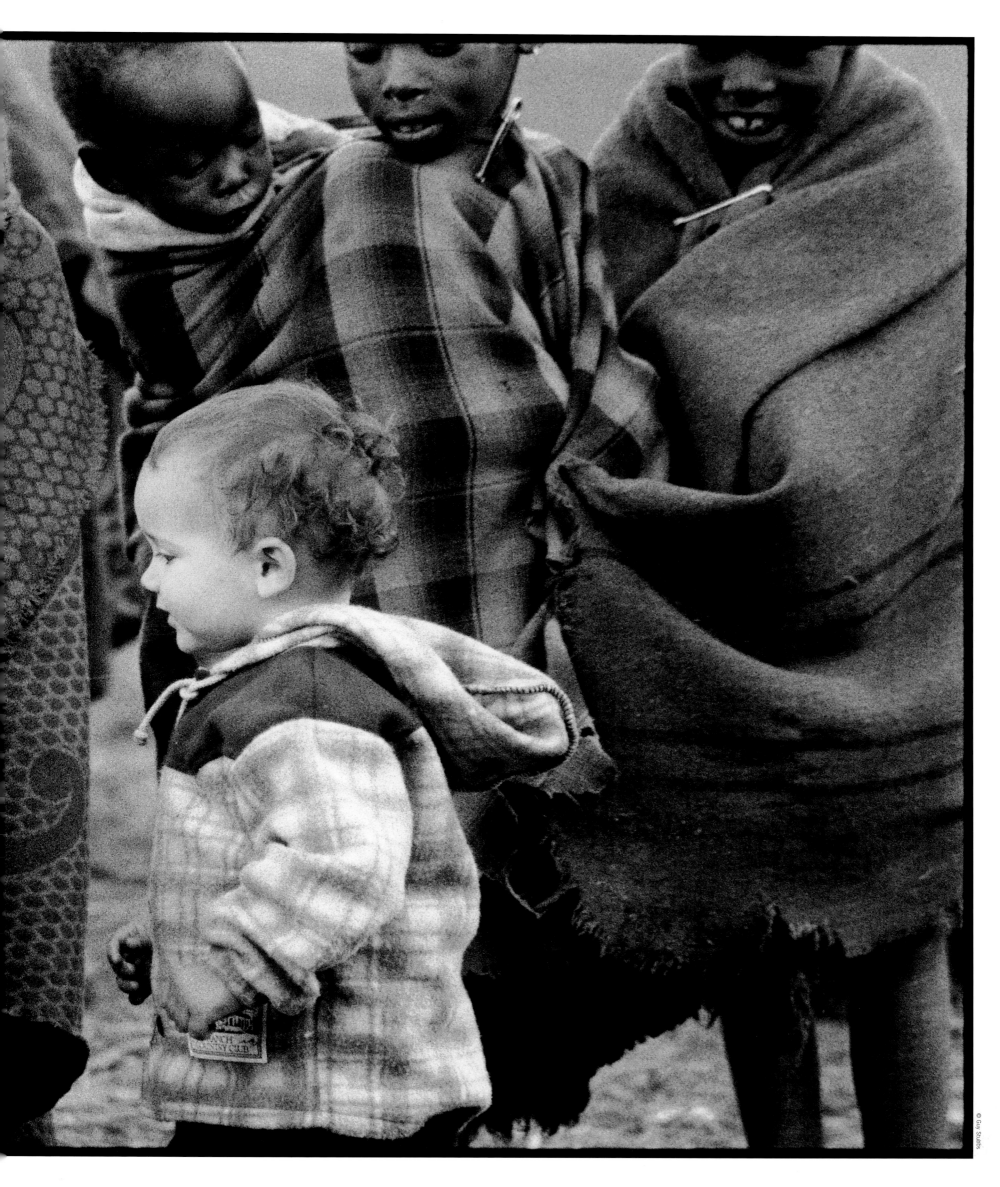

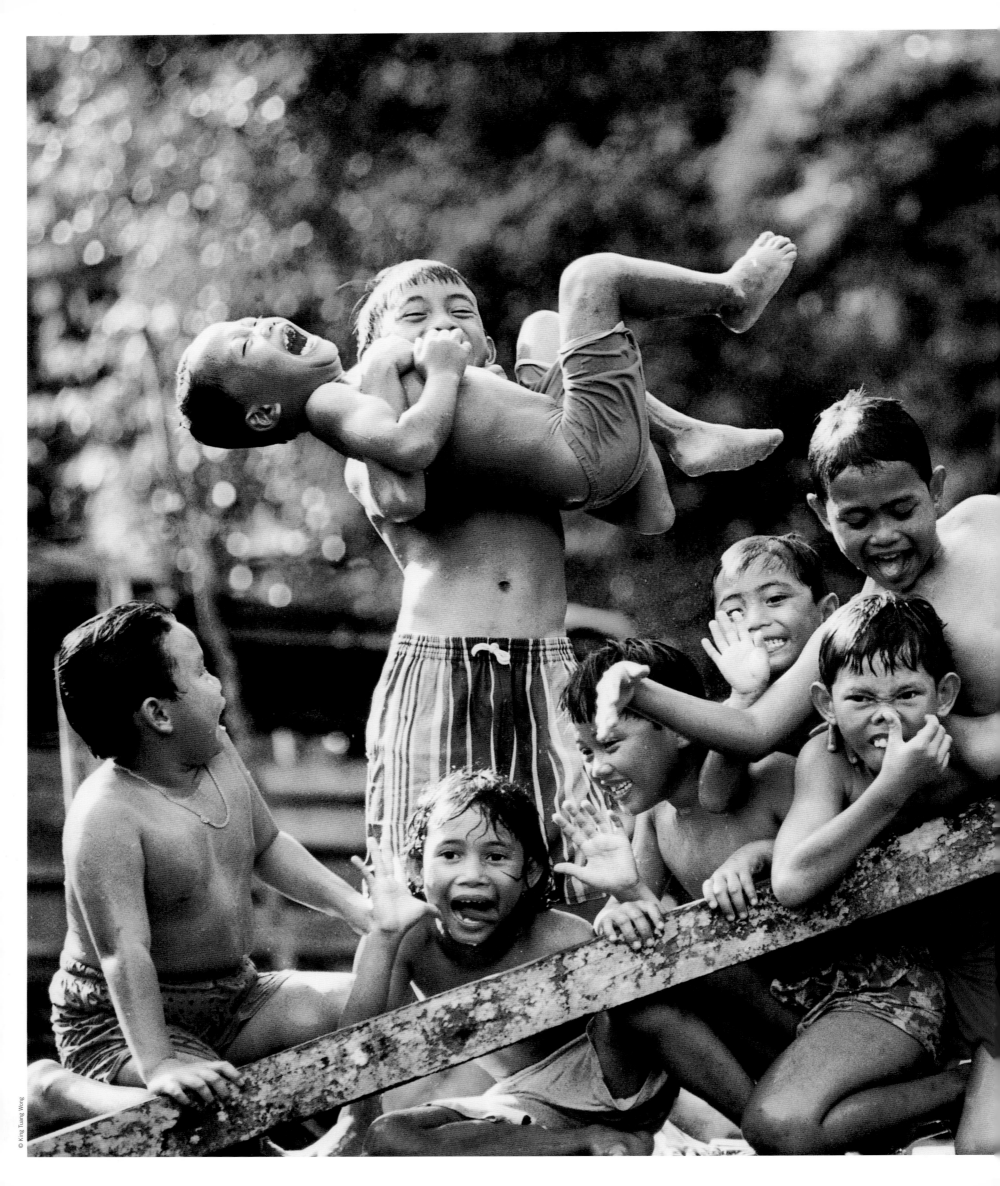

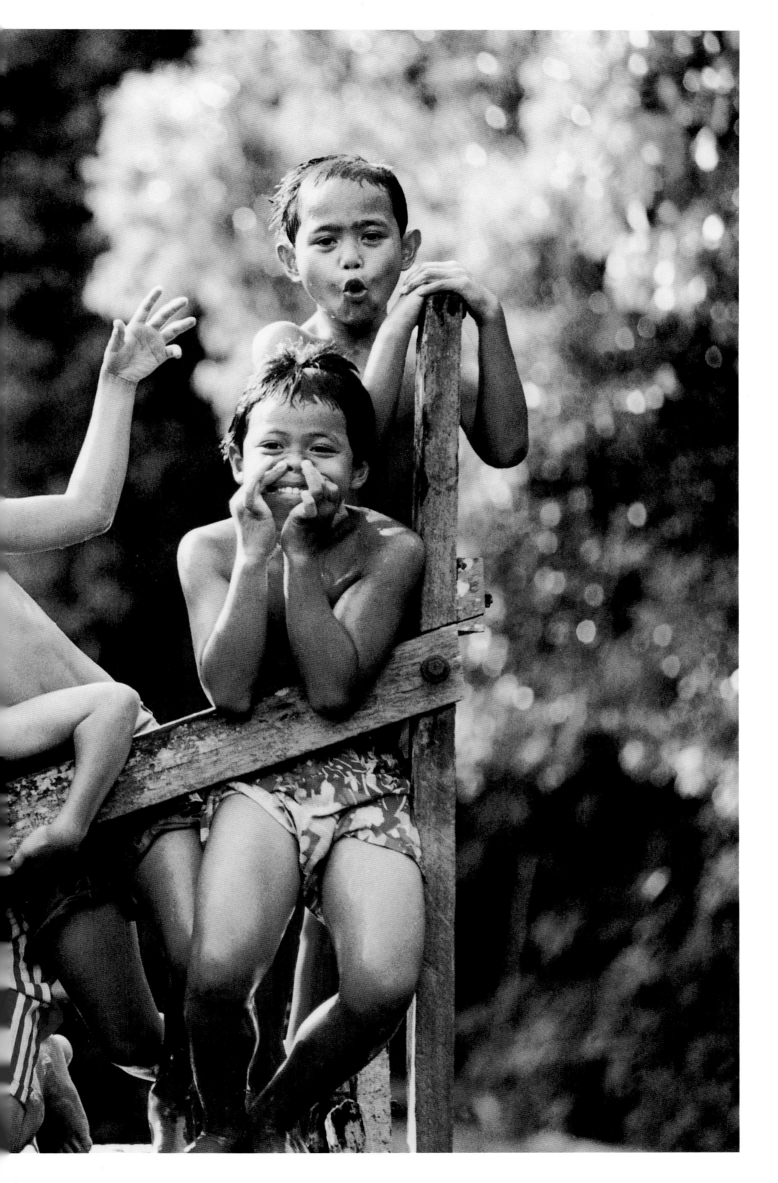

WE WOVE A WEB IN

CHILDHOOD

, A WEB OF SUNNY AIR.

[CHARLOTTE BRONTË]

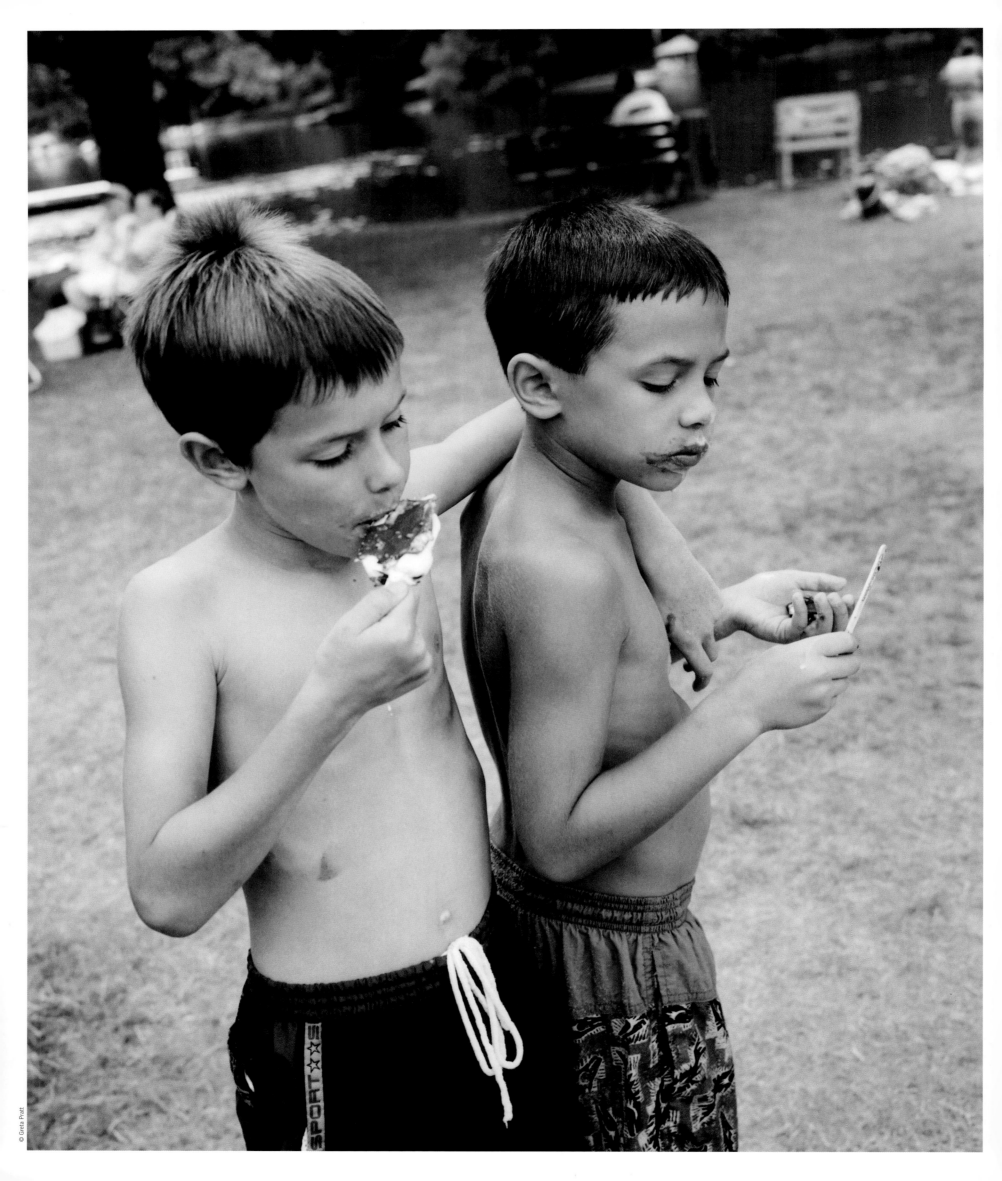

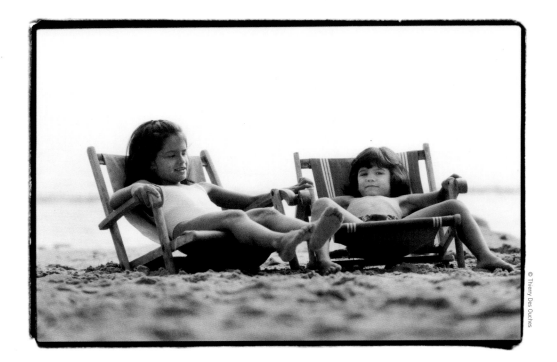

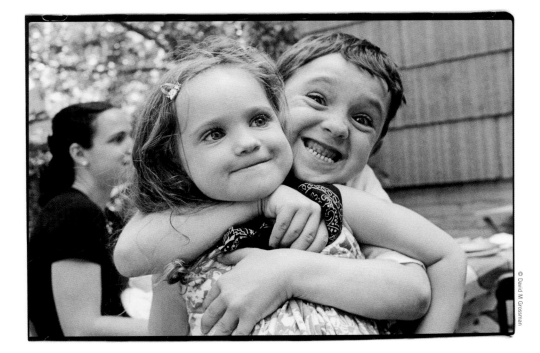

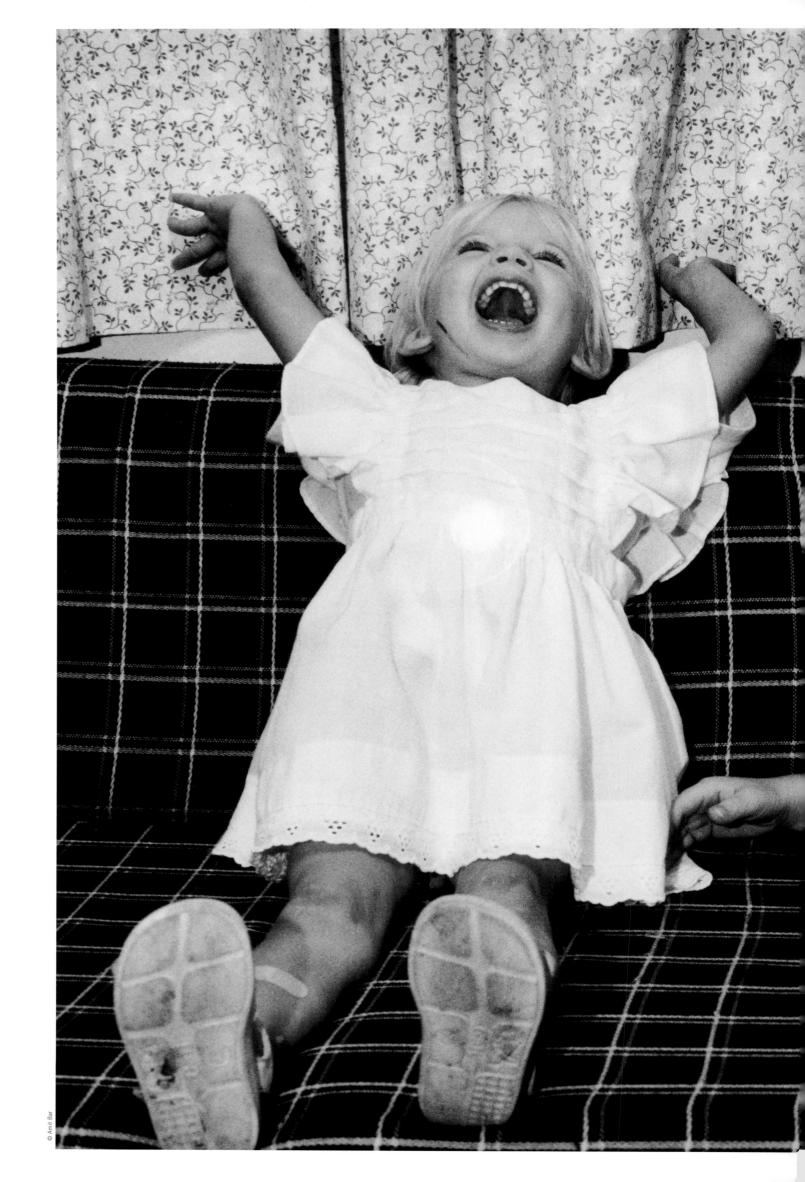

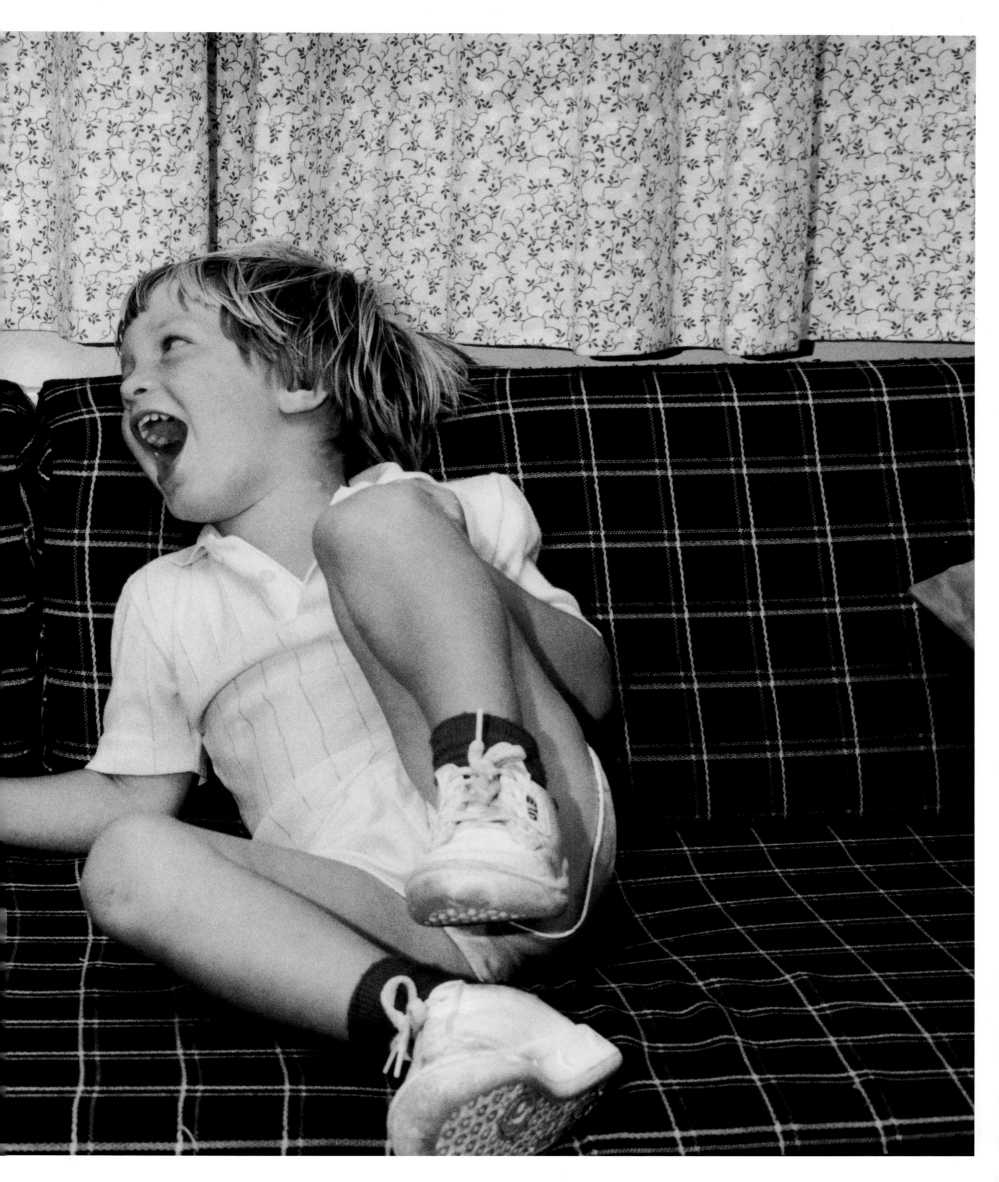

friend's house IS NEVER LONG.

THE ROAD TO A

[DANISH PROVERB]

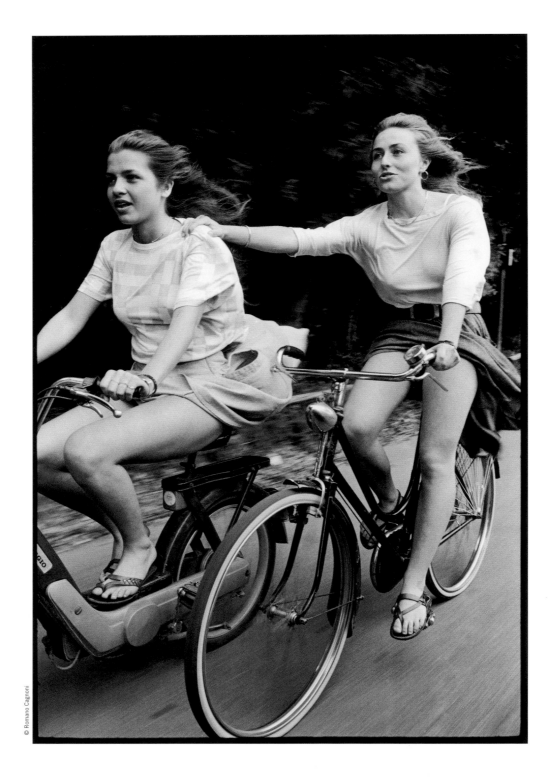

© Romano Cagnoni

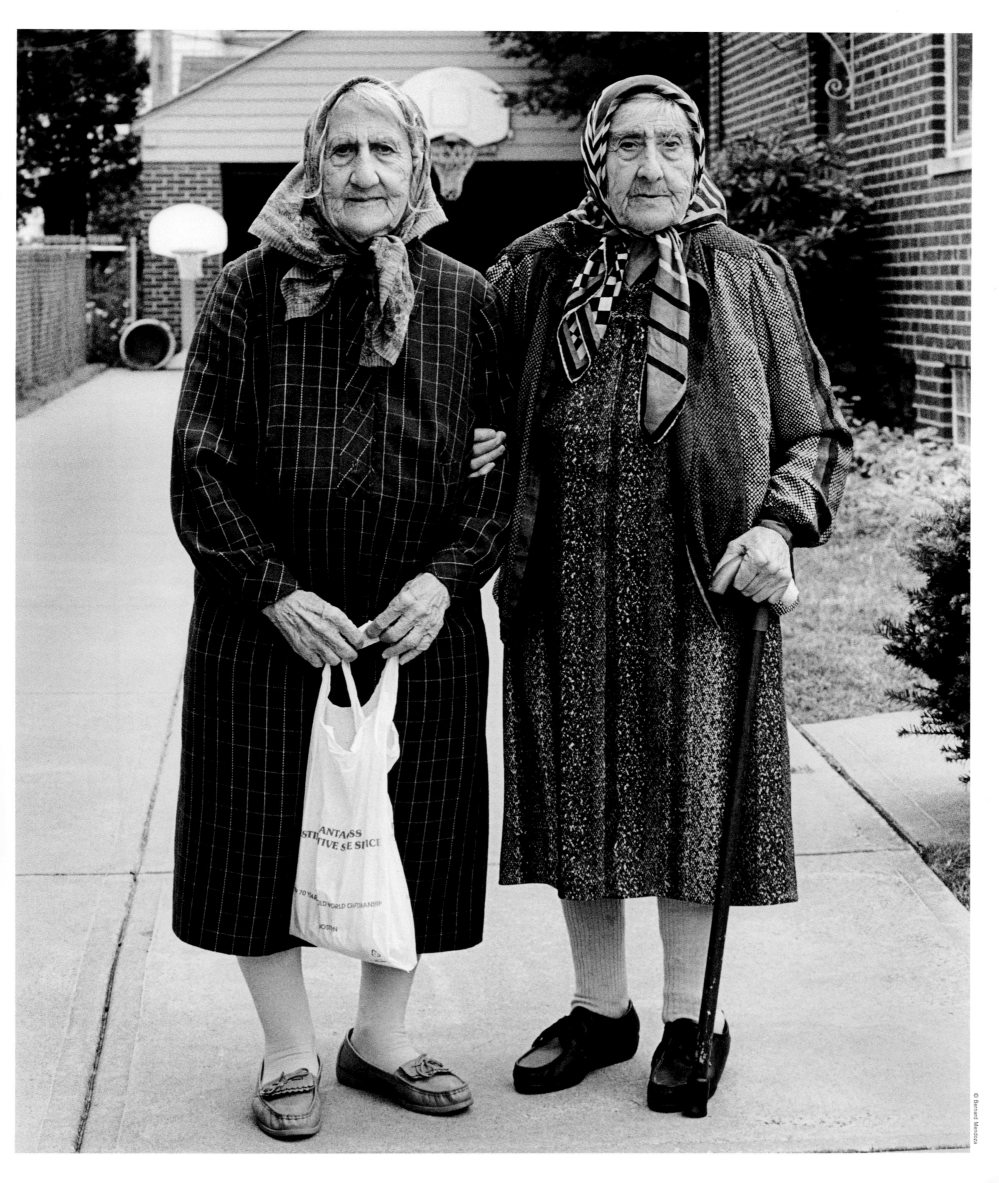

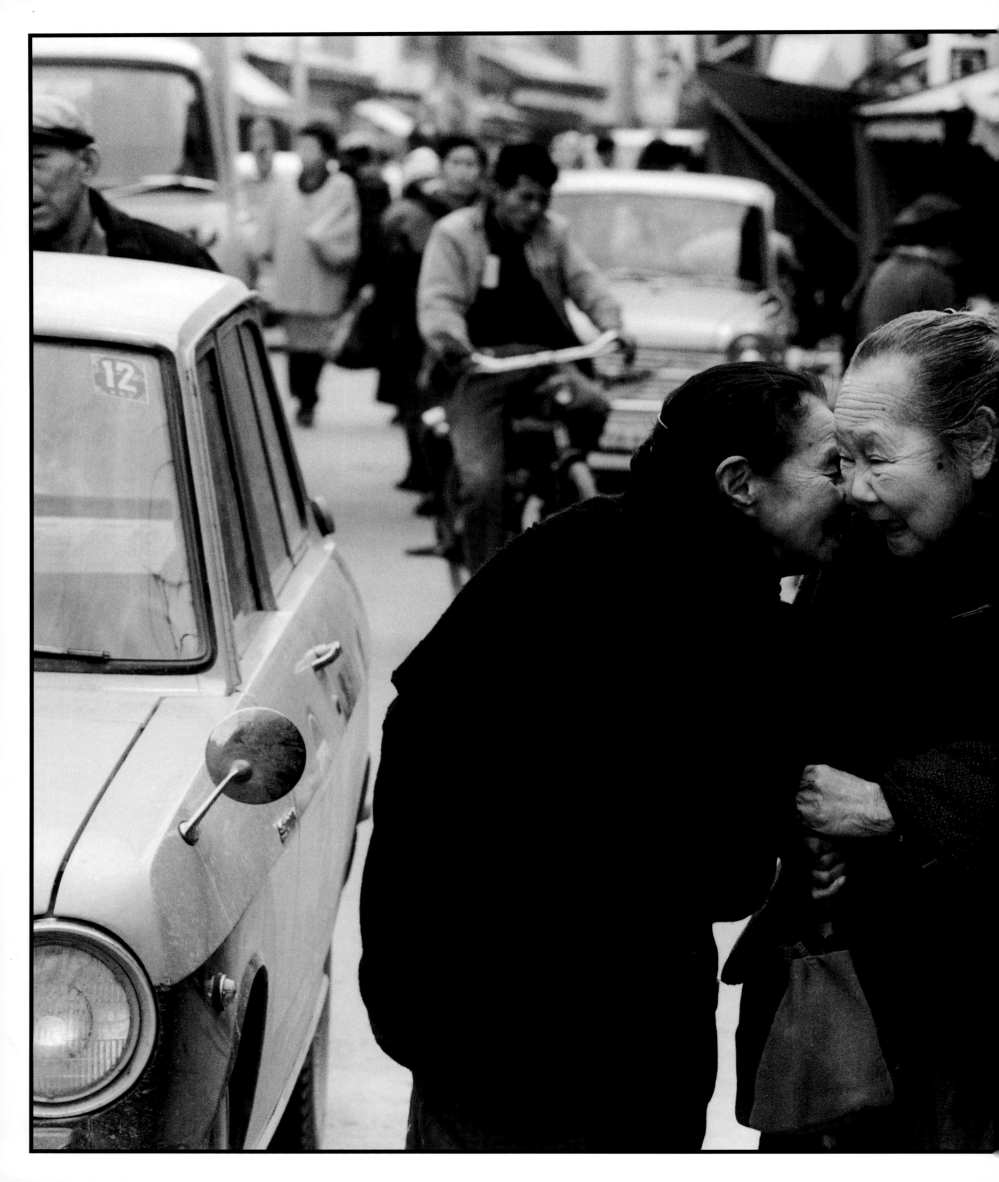

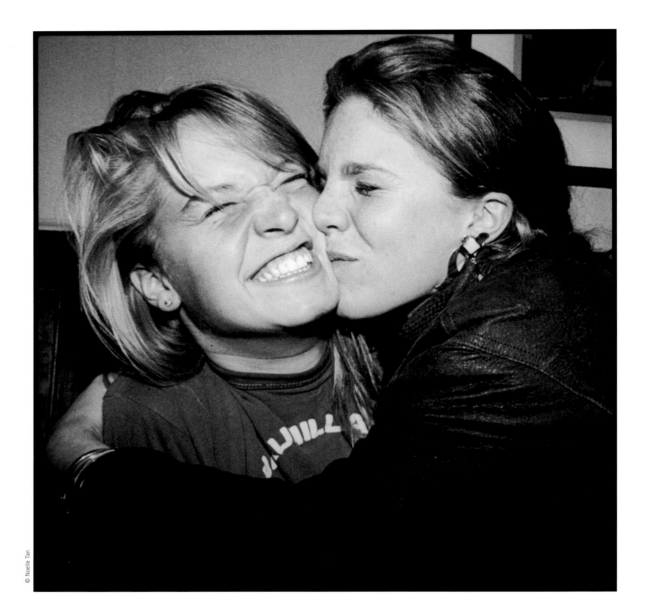

Good times made better and bad times forgotten due to the healing magic of friendship.

[MAEVE BINCHY]

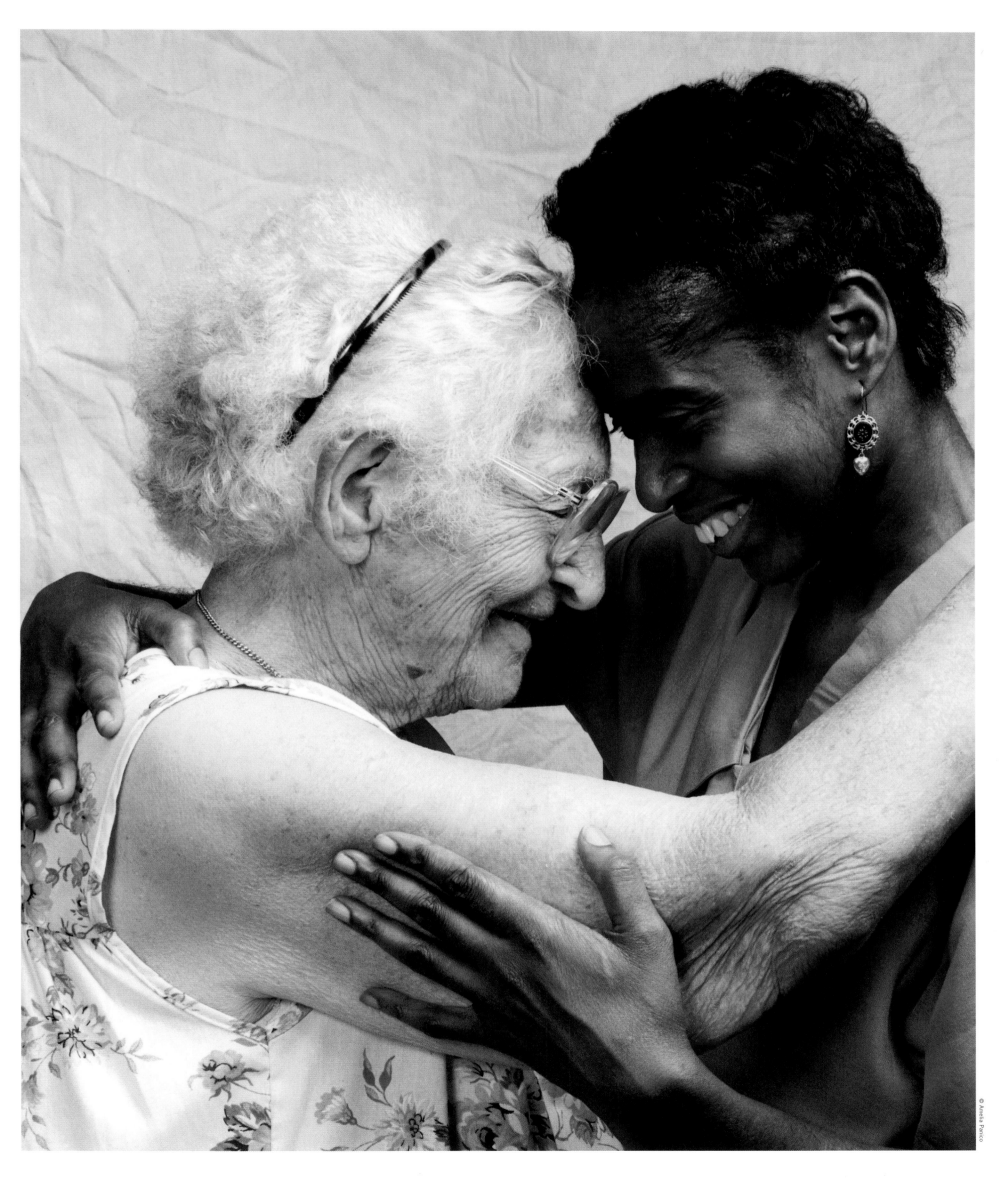

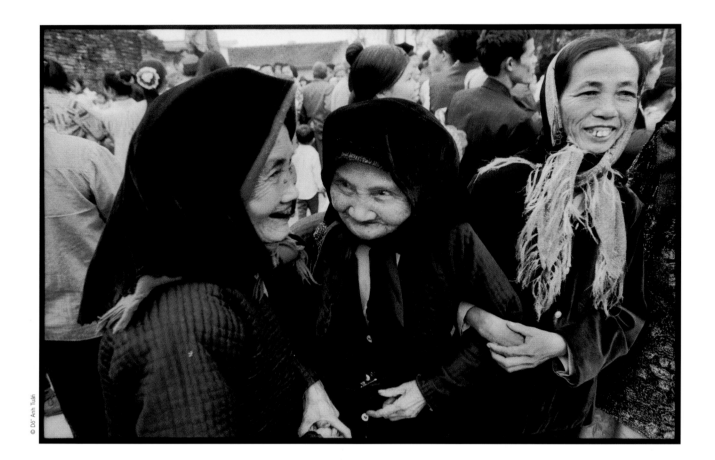

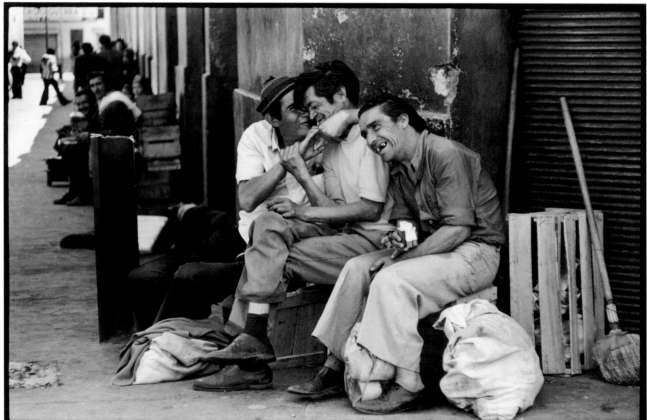

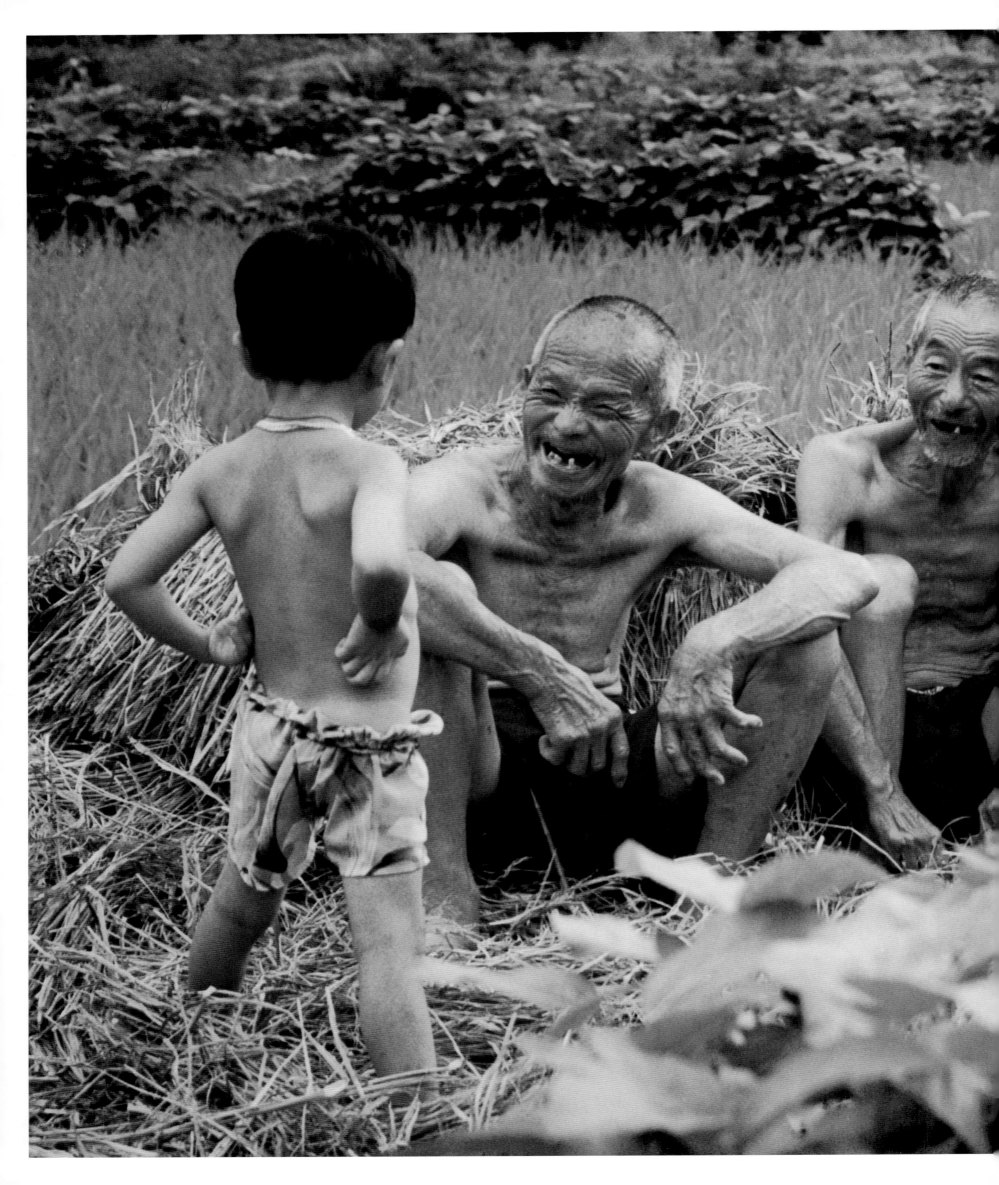

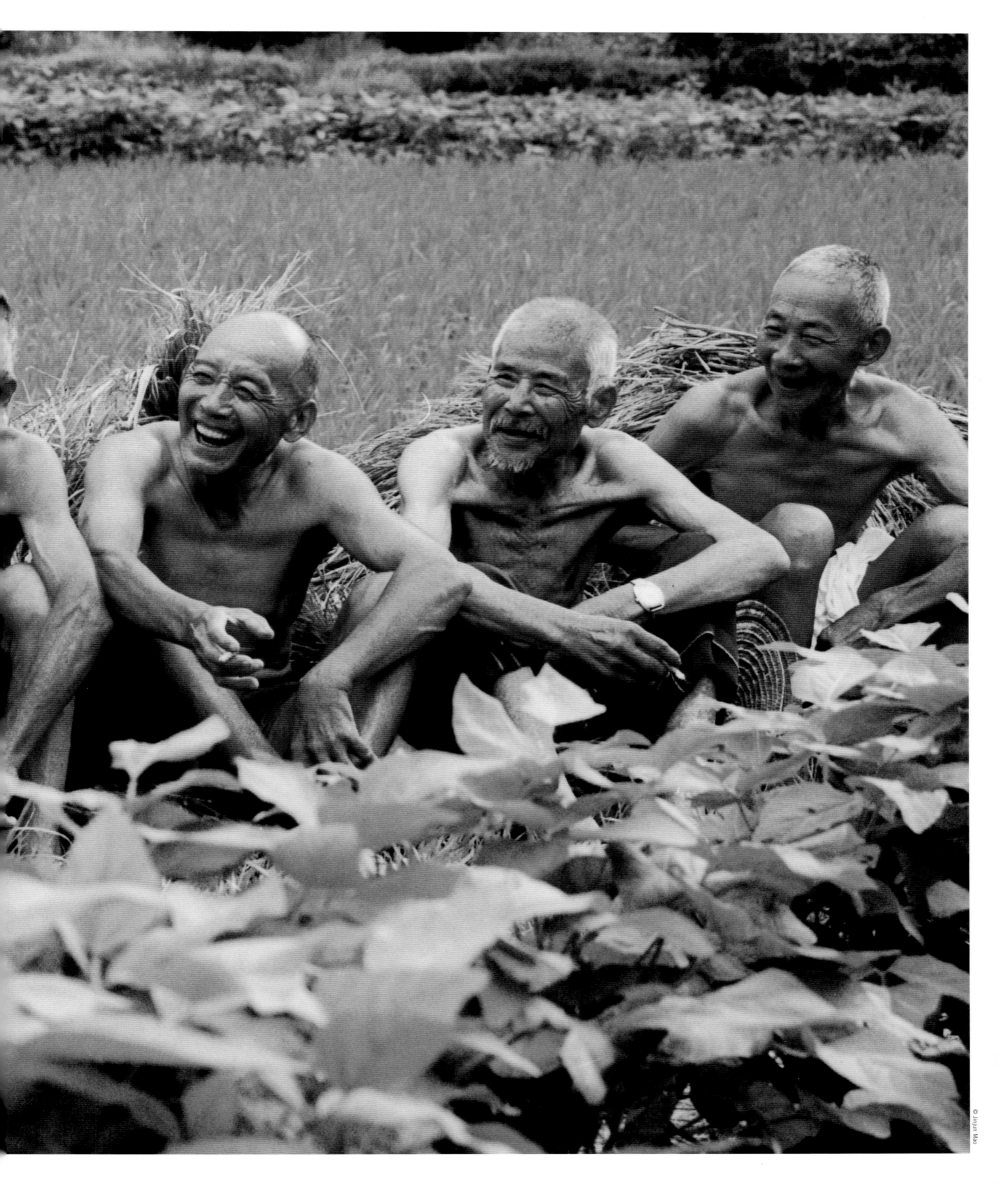

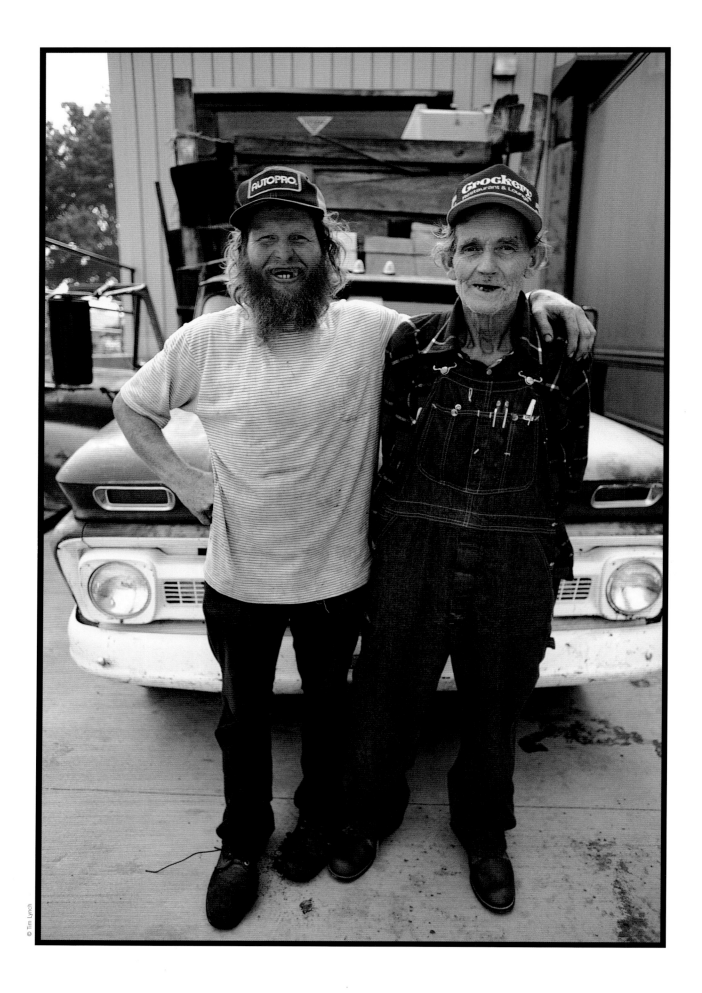

TELL ME YOUR FRIENDS, AND I'LL TELL YOU WHO YOU ARE.

[ASSYRIAN PROVERB]

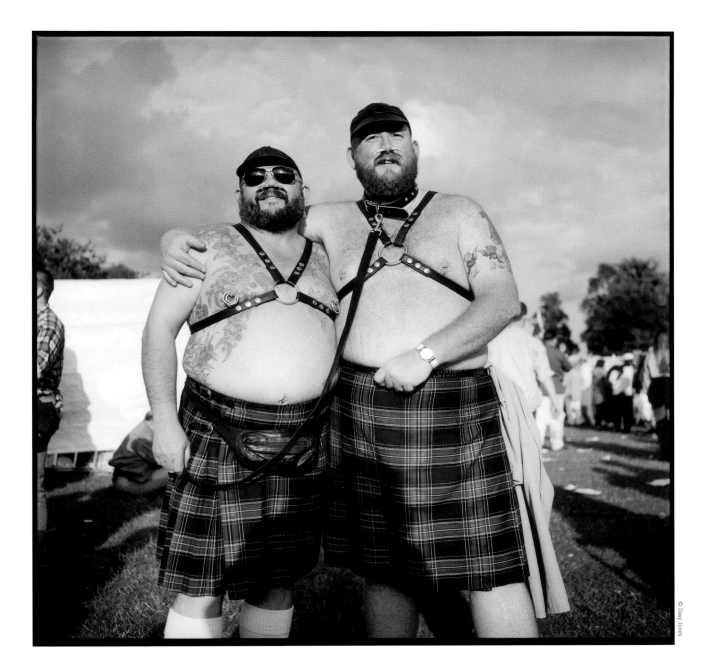

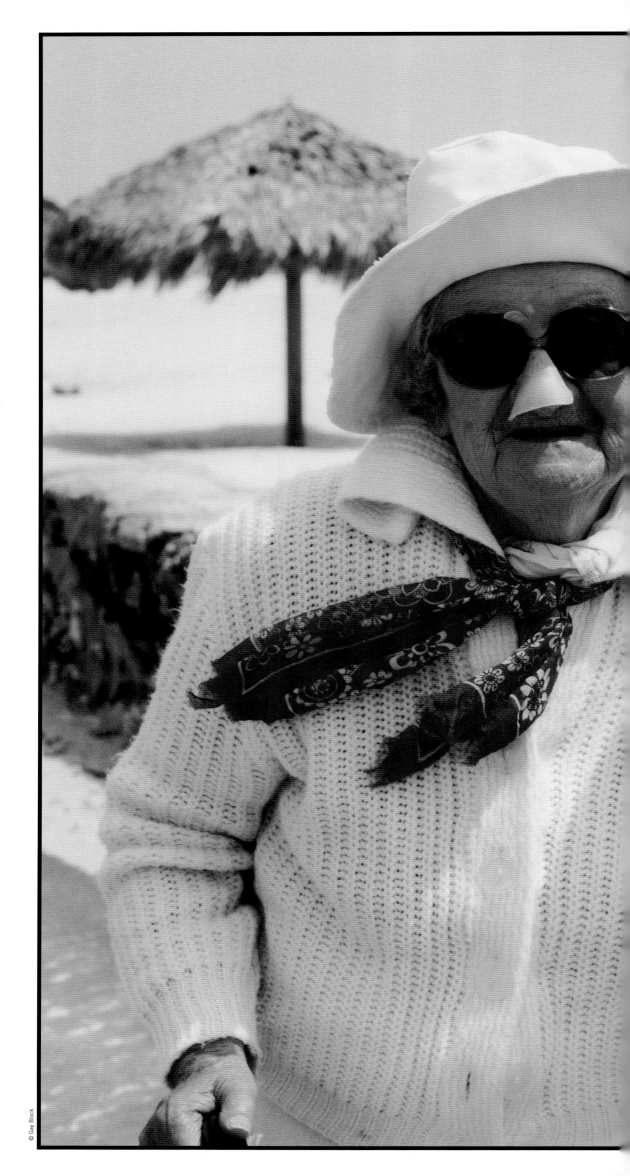

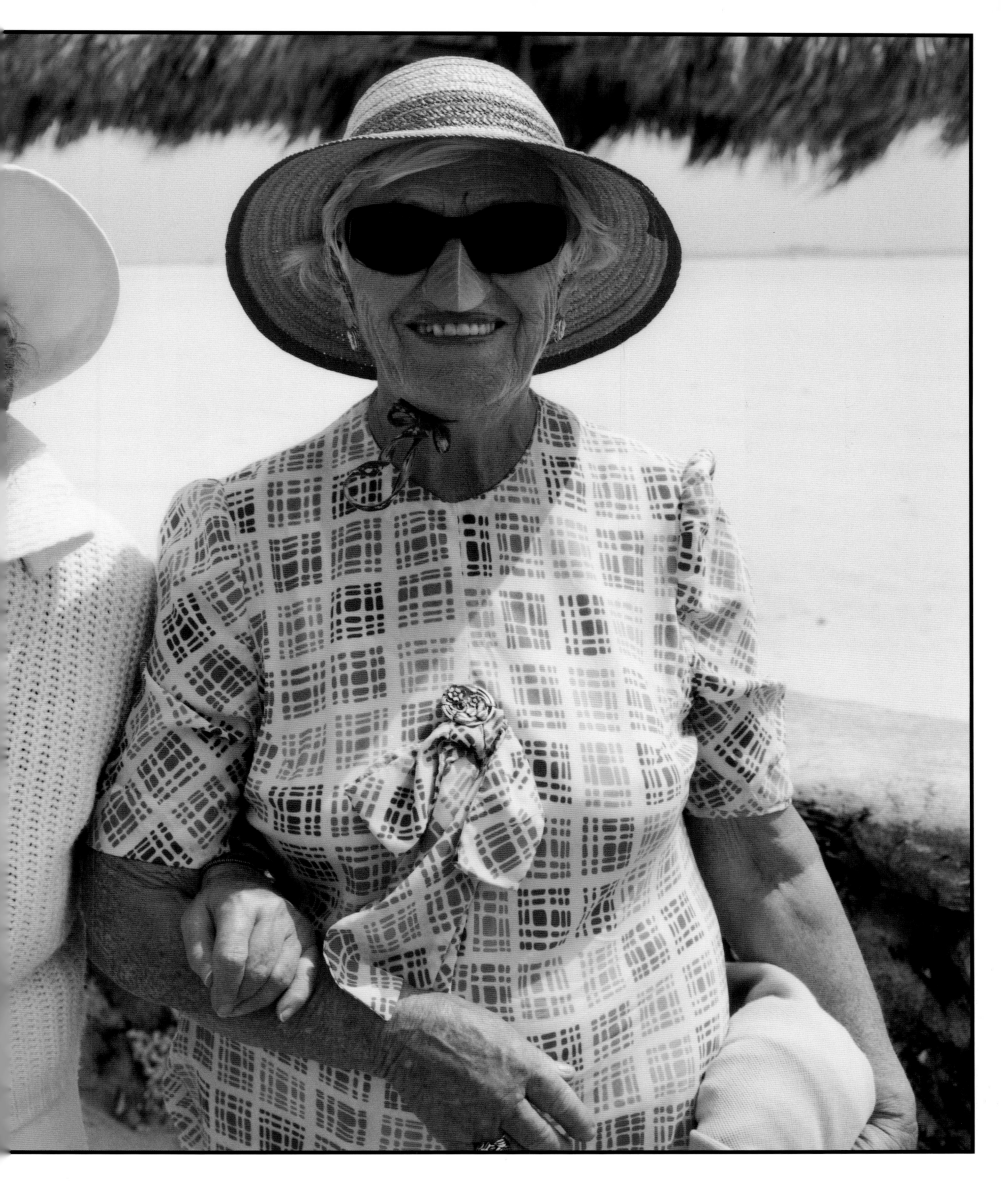

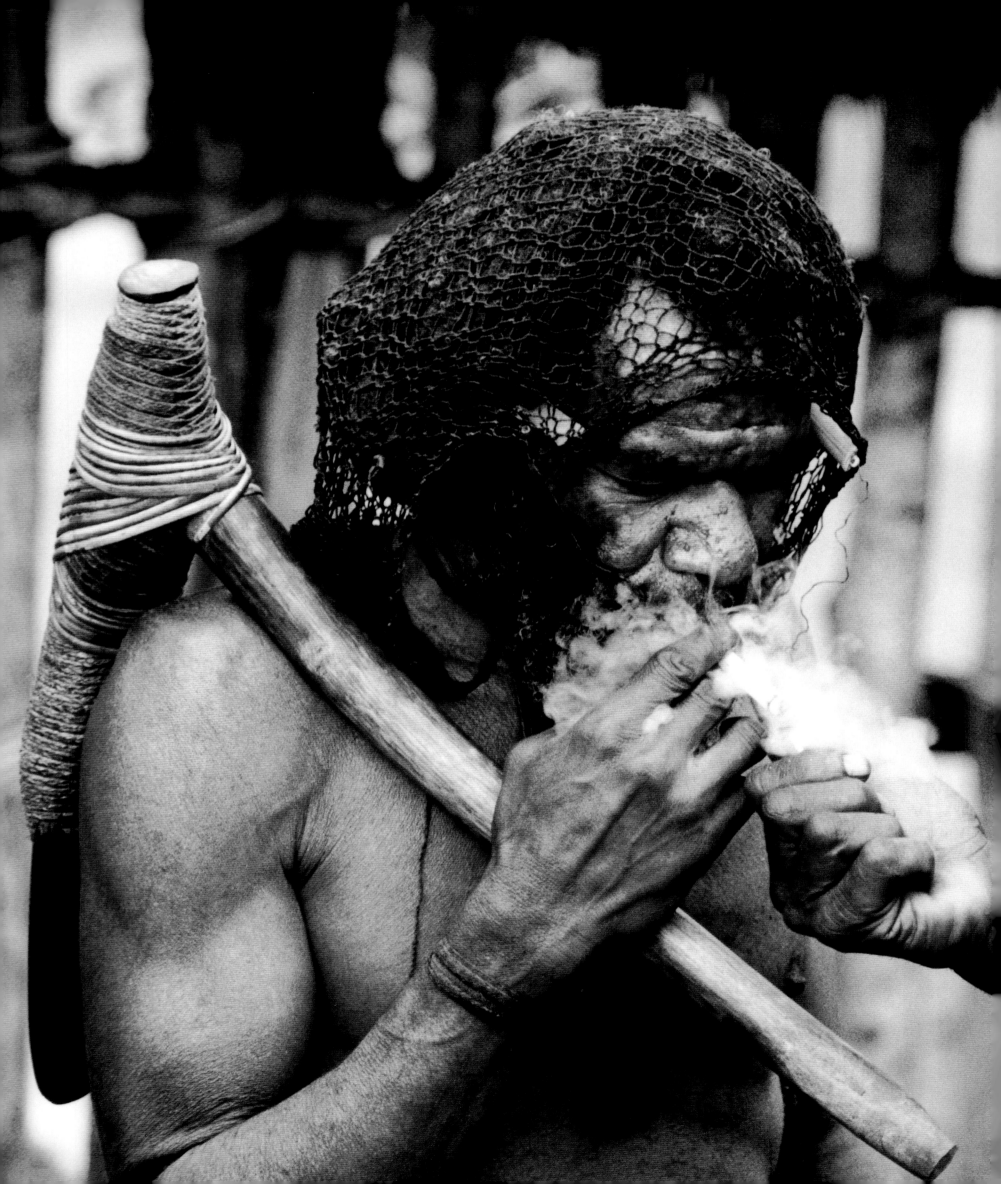

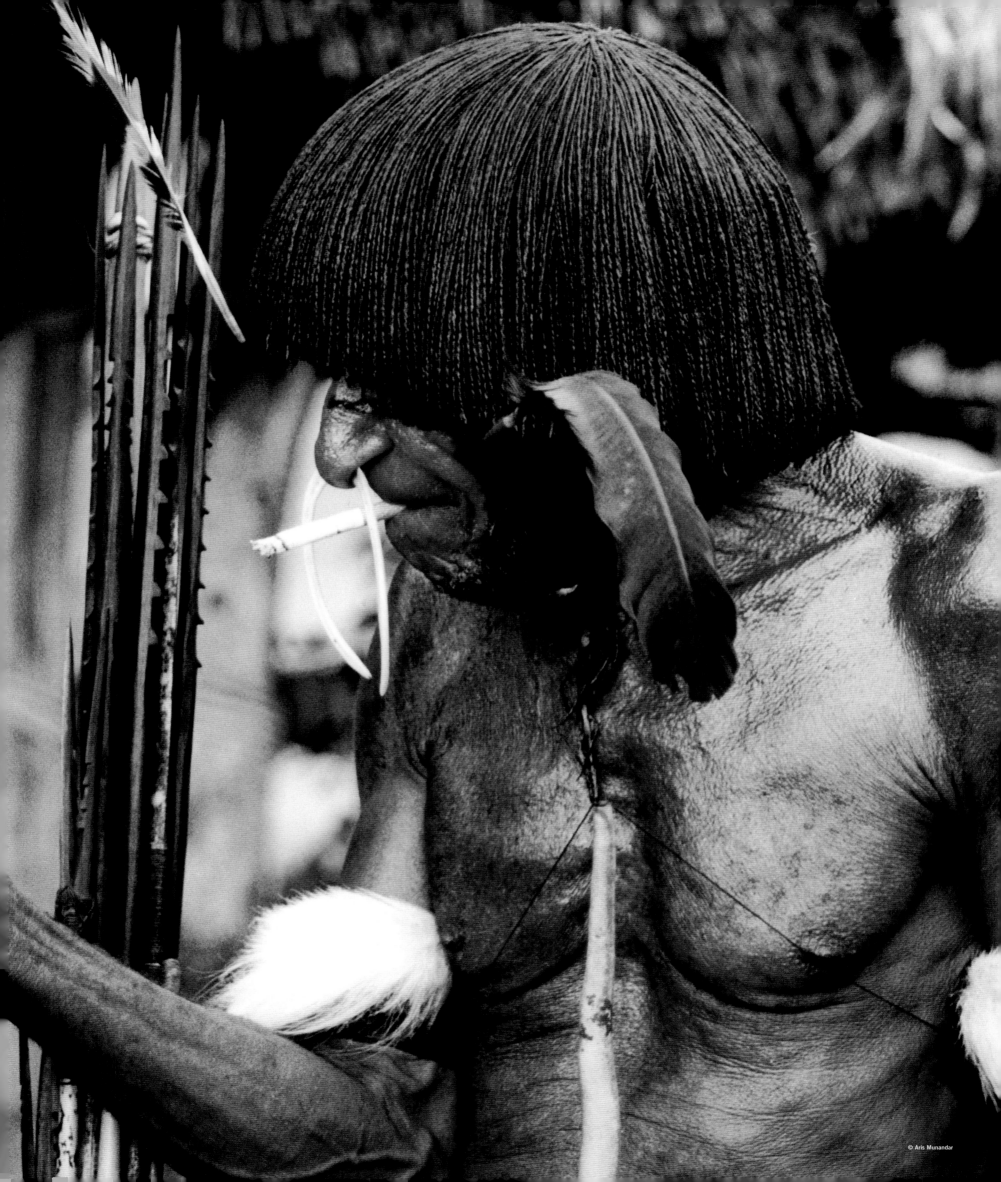

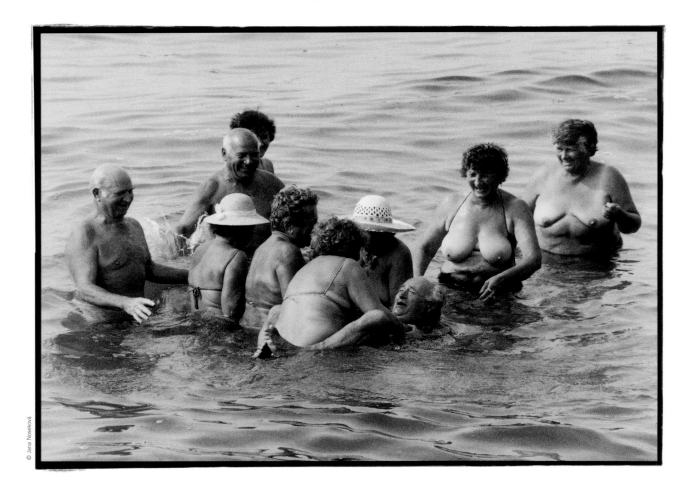

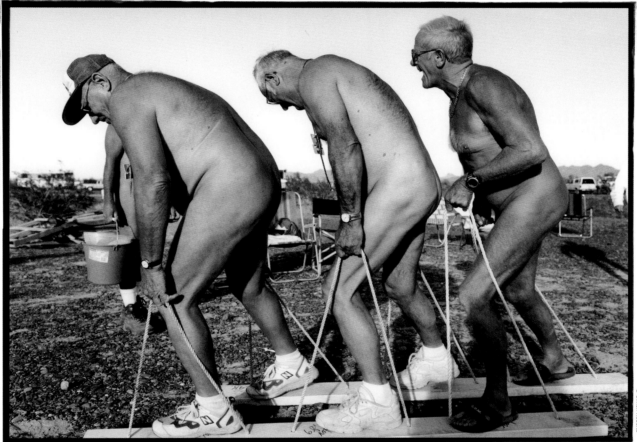

COMMUNITY . ONE SINGLE HUMAN BEING CANNOT SURVIVE.

WITHOUT THE HUMAN

[DALAI LAMA]

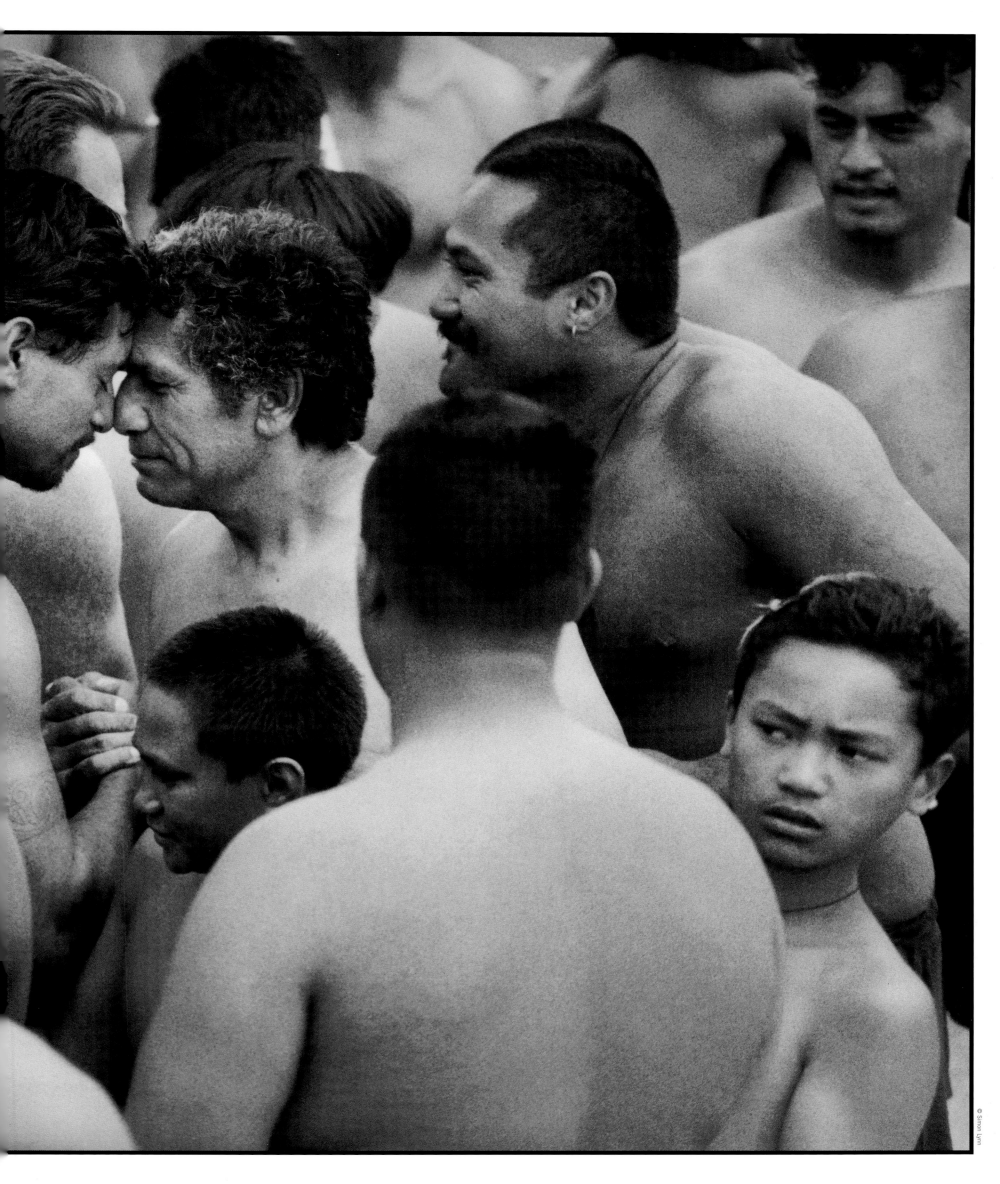

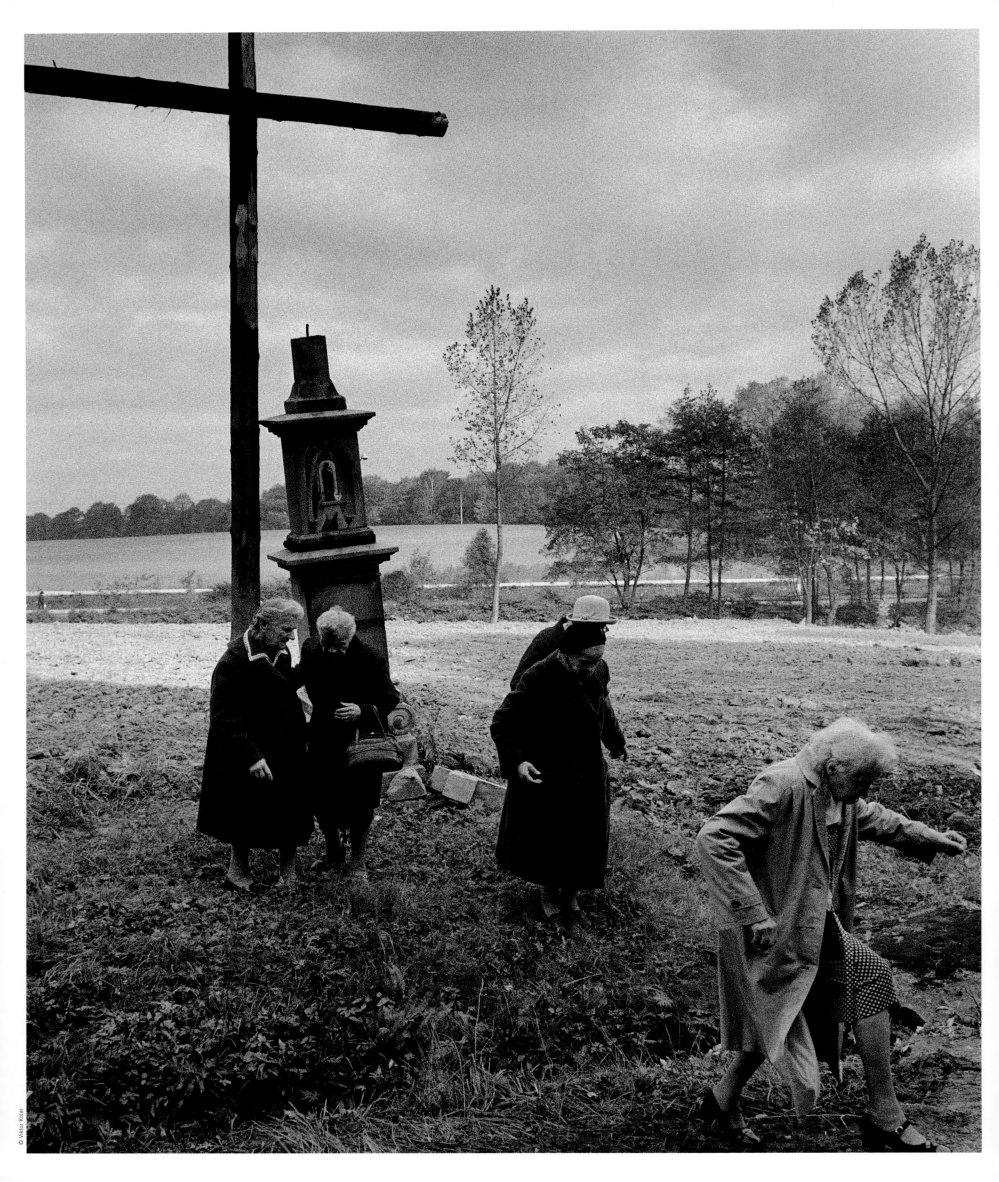

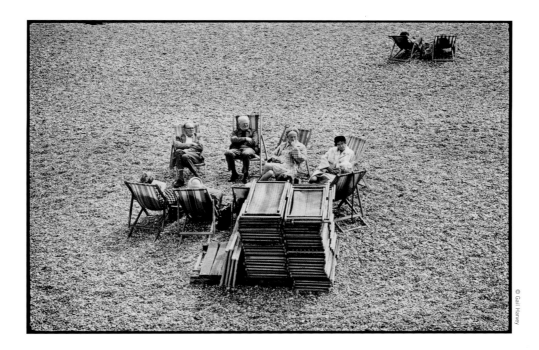

© Gail Harvey

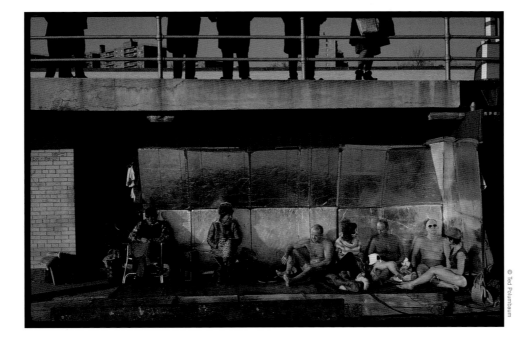

© Ted Polumbaum

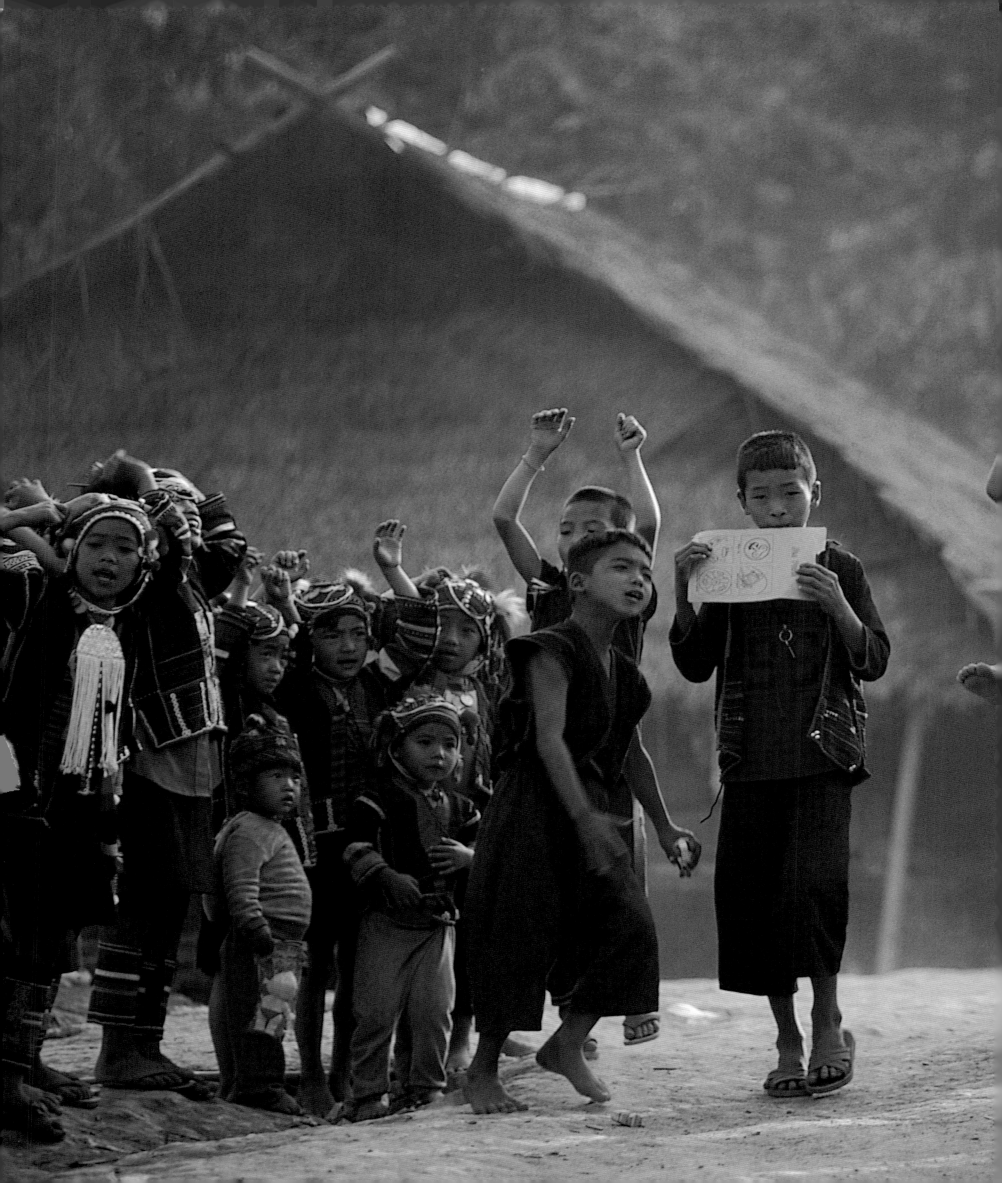

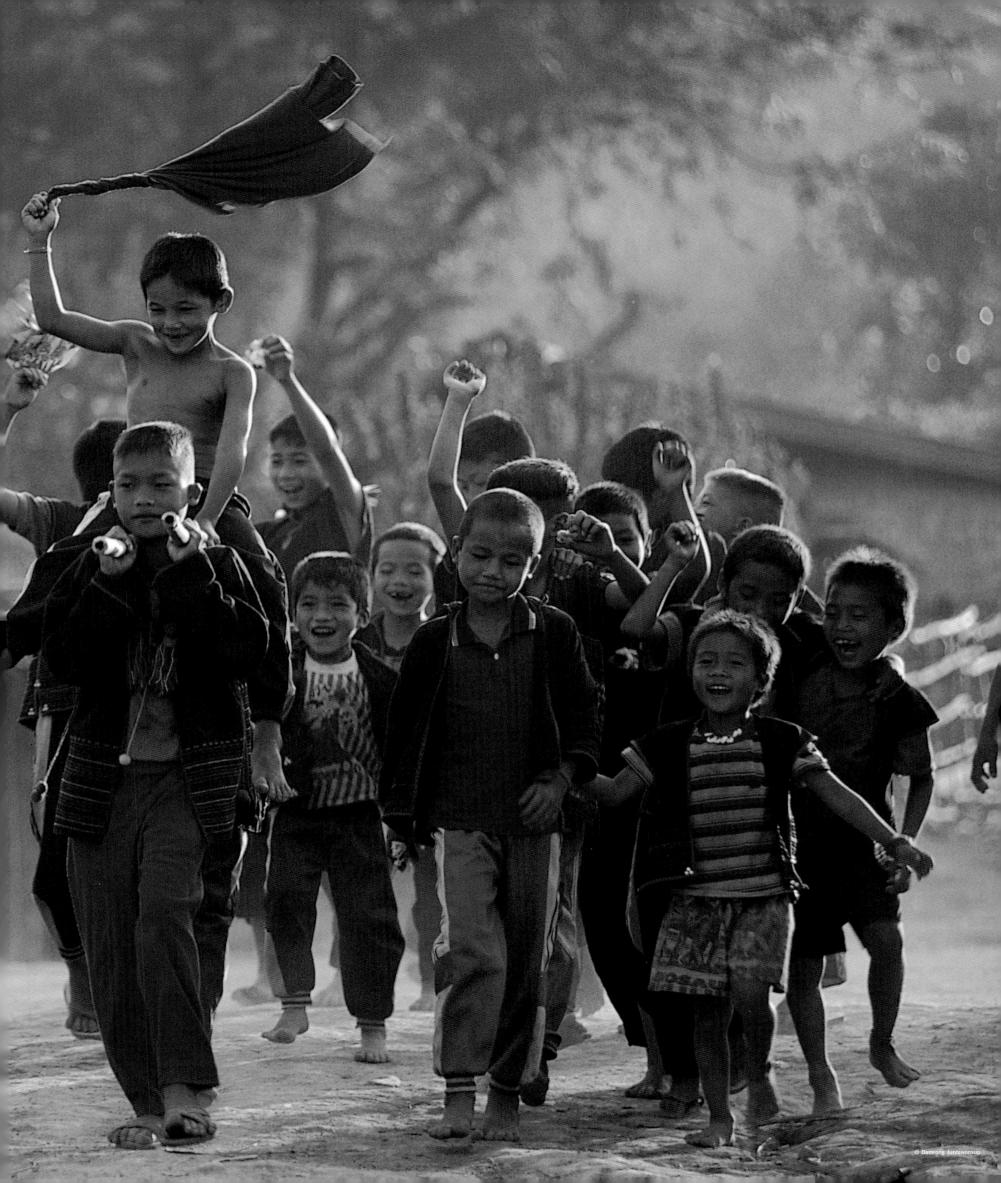

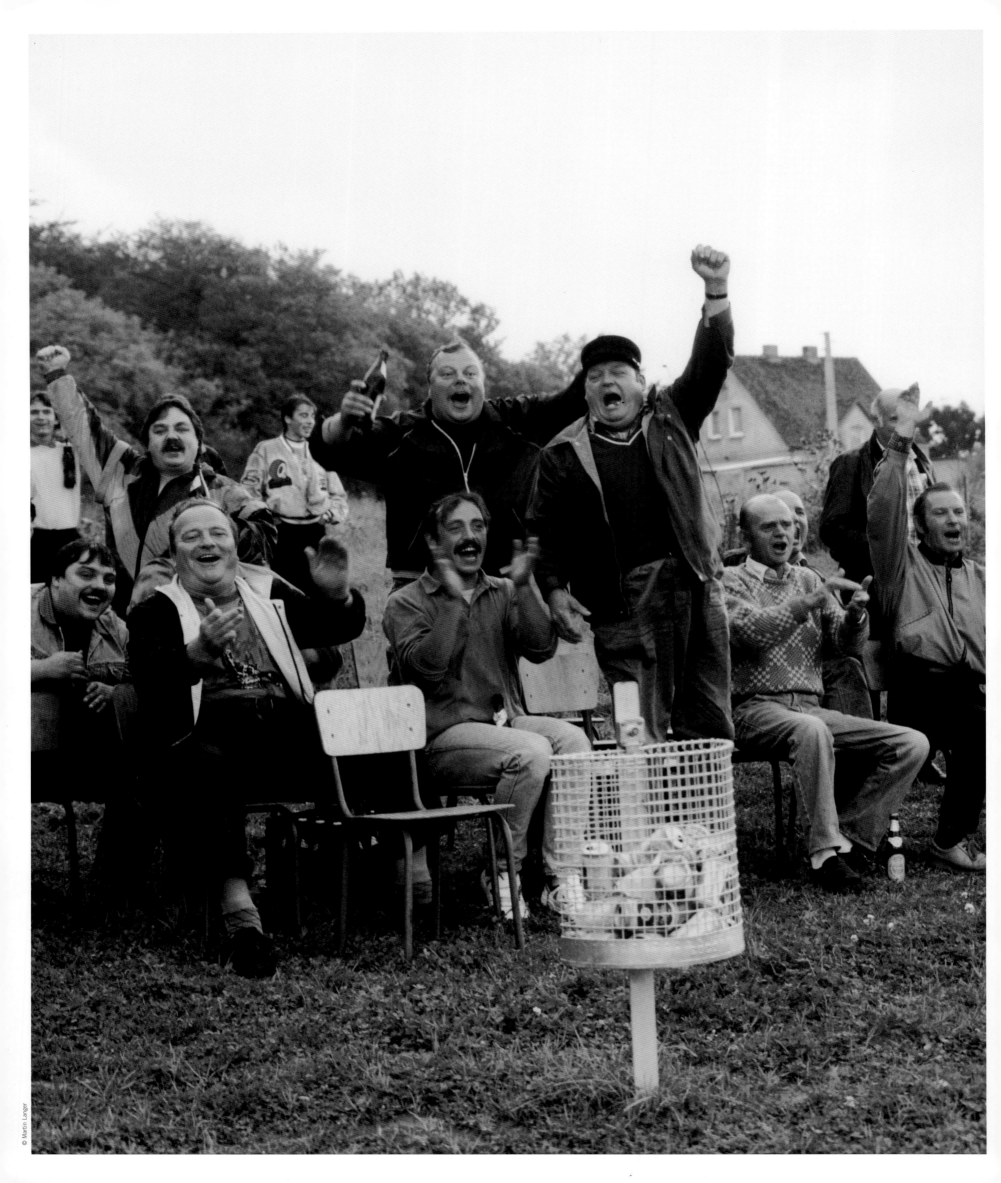

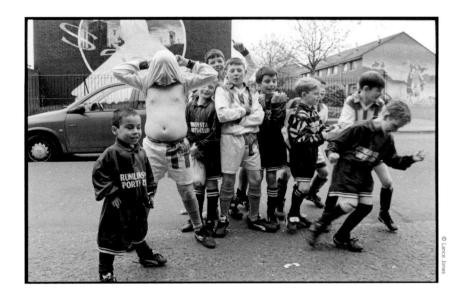

© Lance Jones

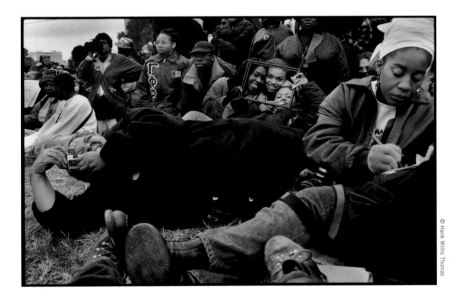

© Hank Willis Thomas

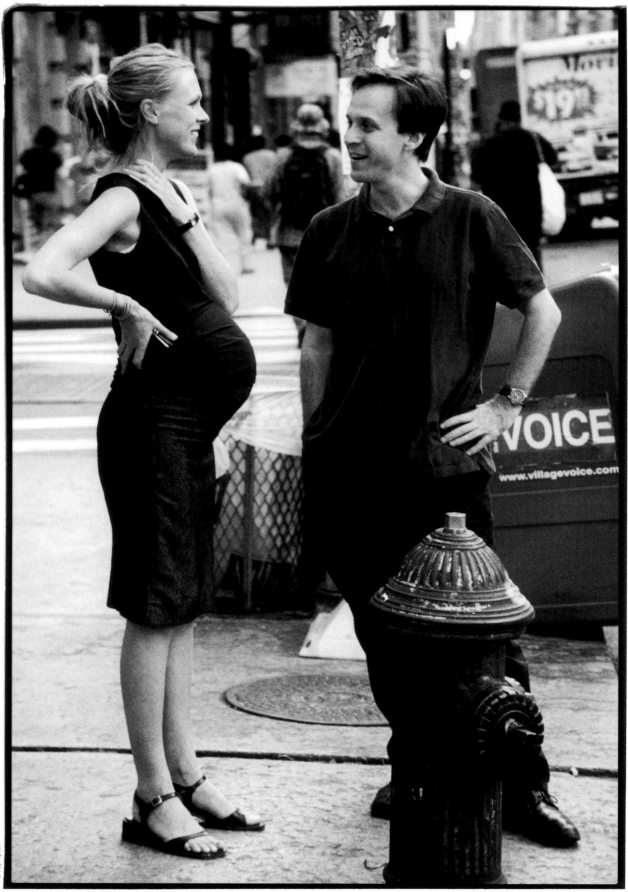

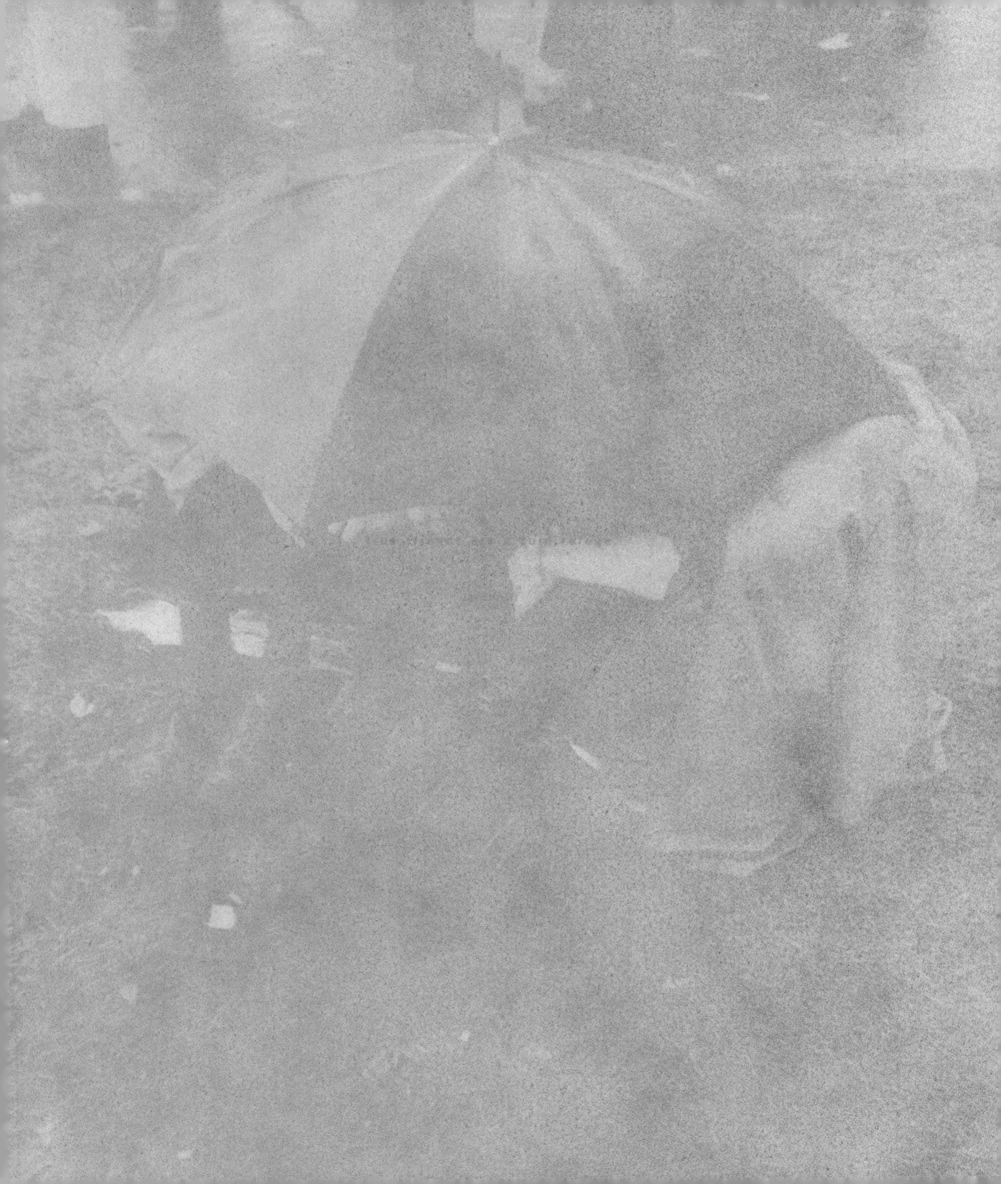

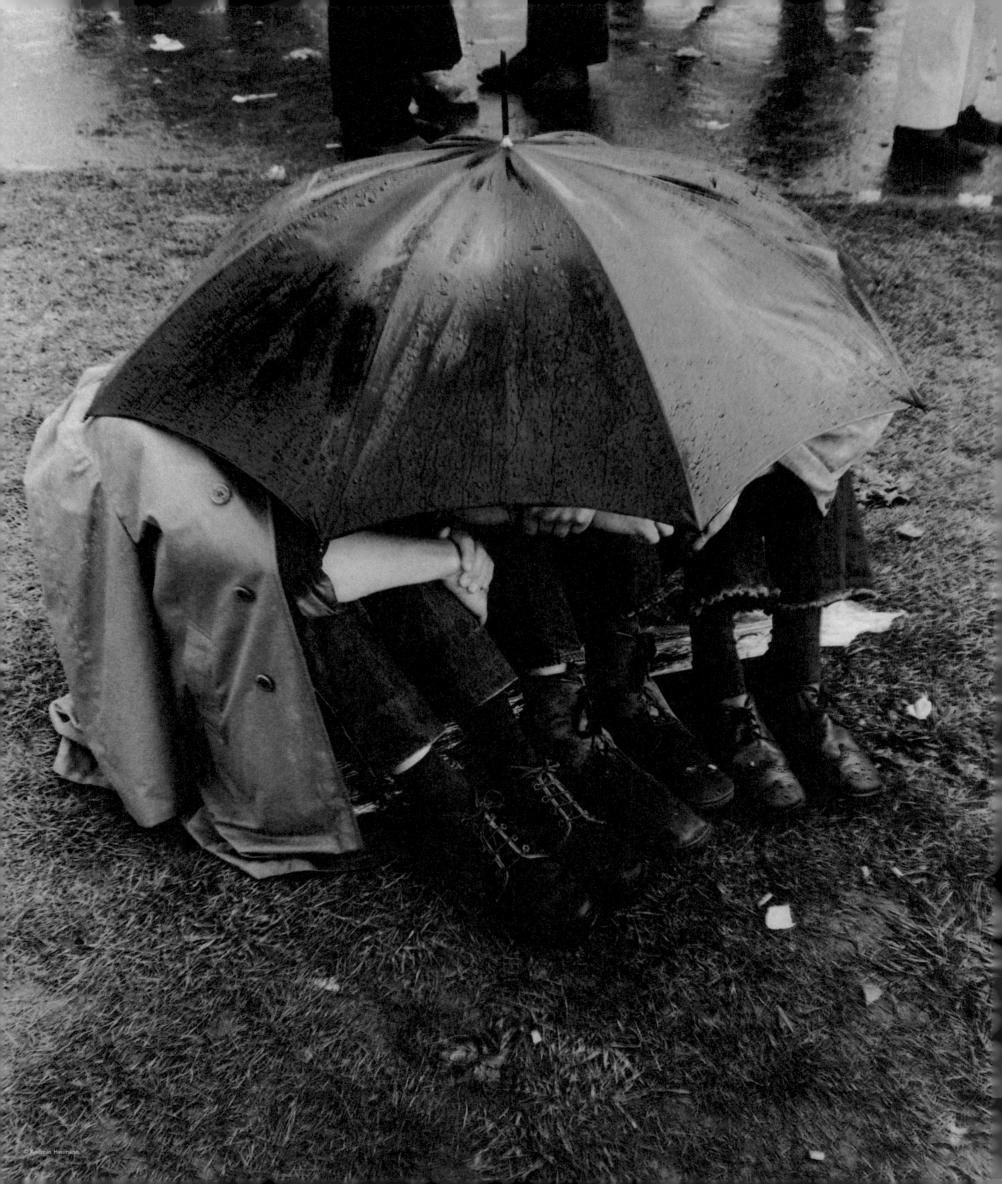

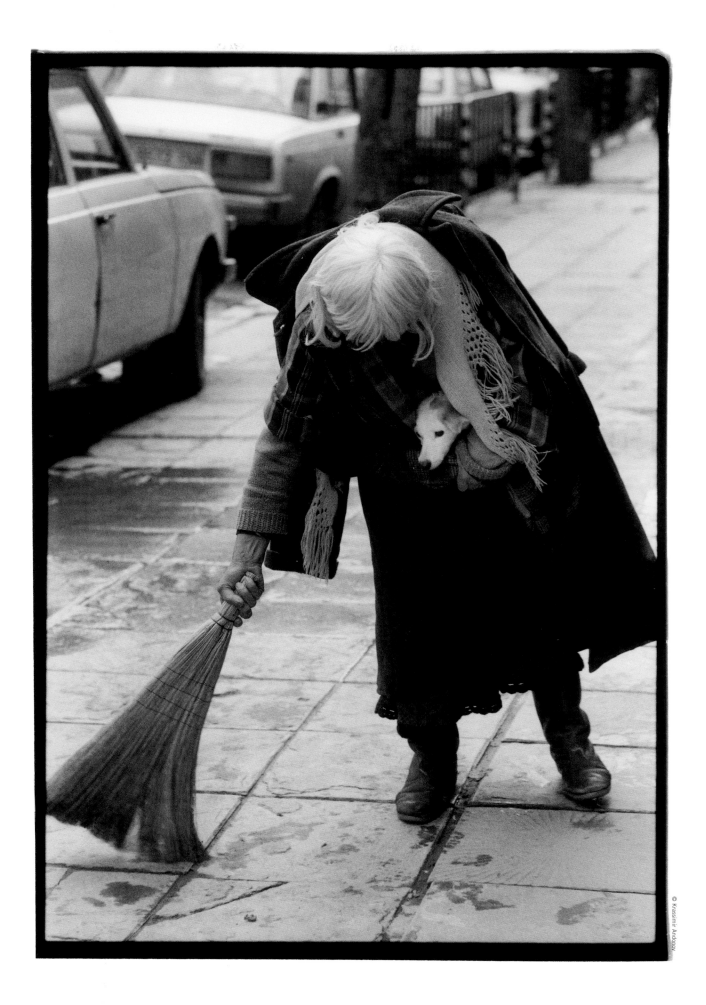

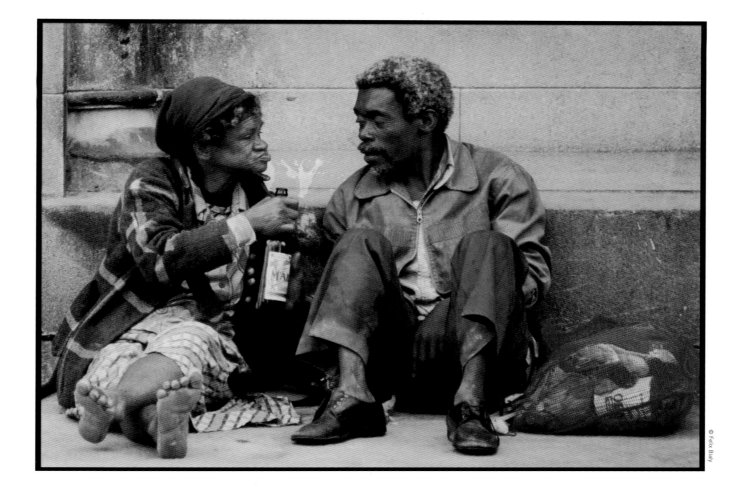

A FRIENDSHIP CAN GROW ON THE MOST UNLIKELY AND BARREN GROUND.

[MAEVE BINCHY]

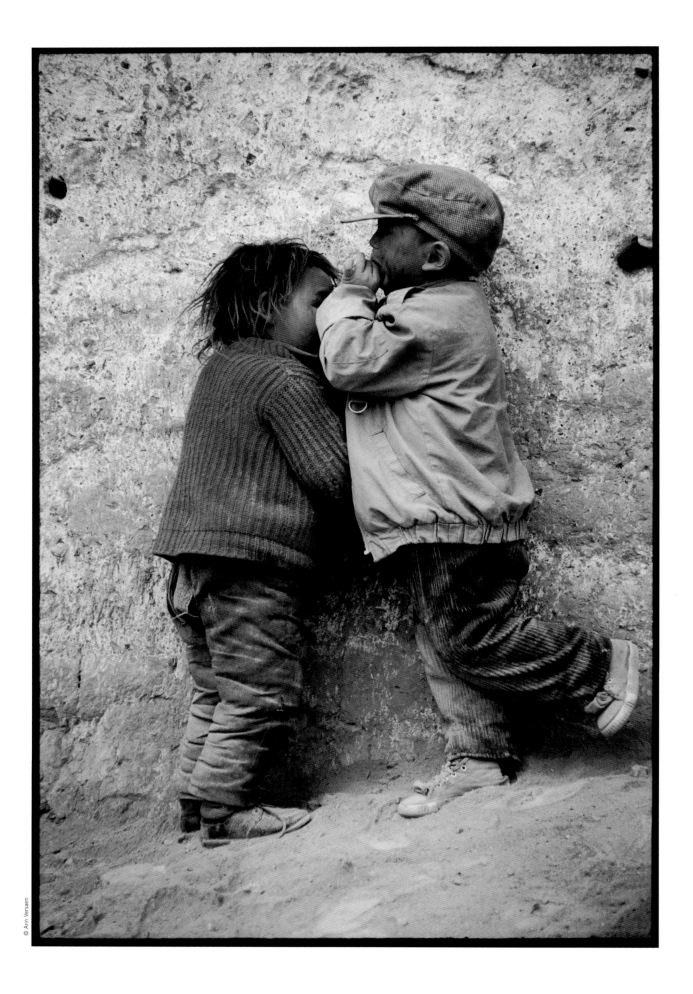

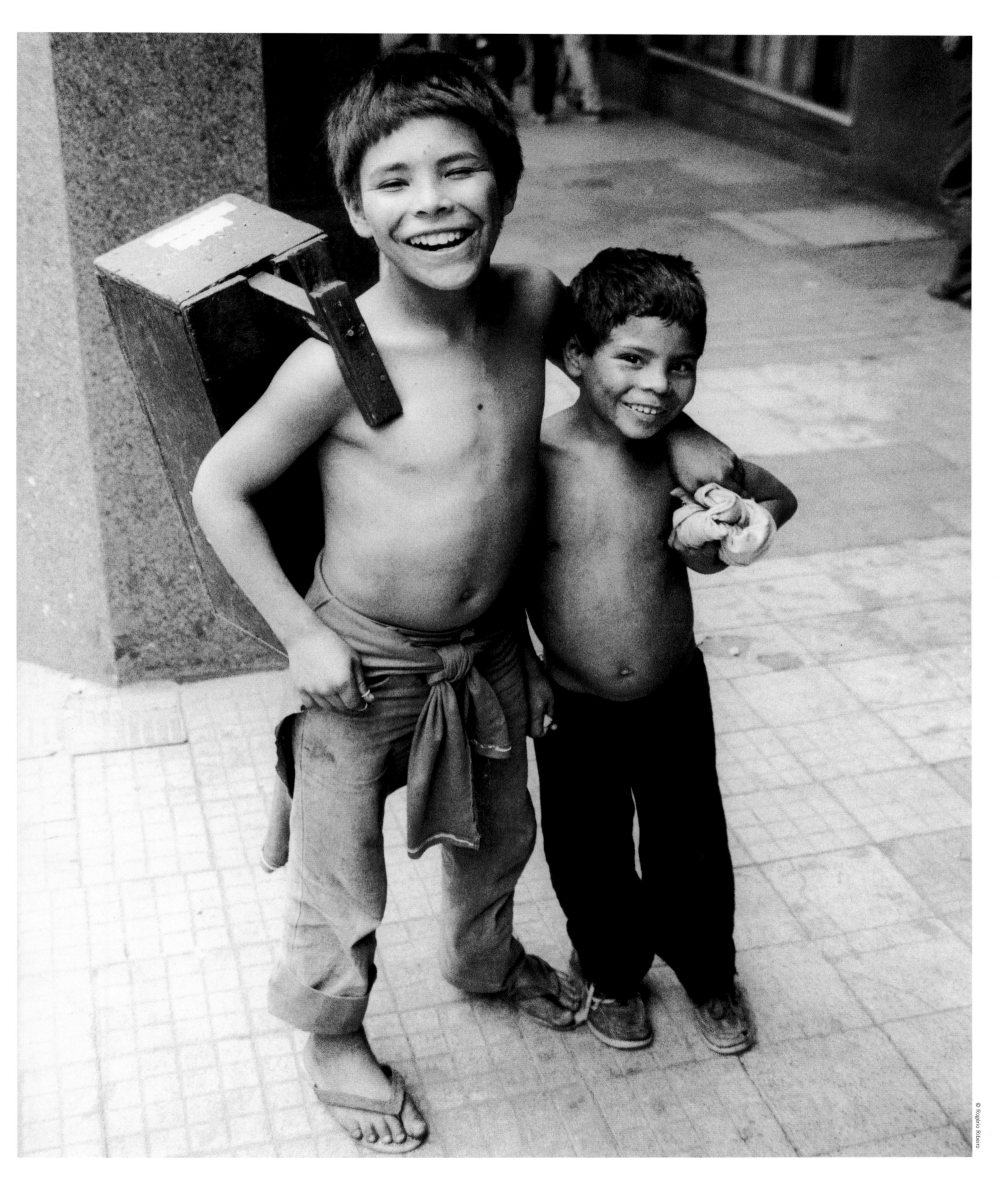

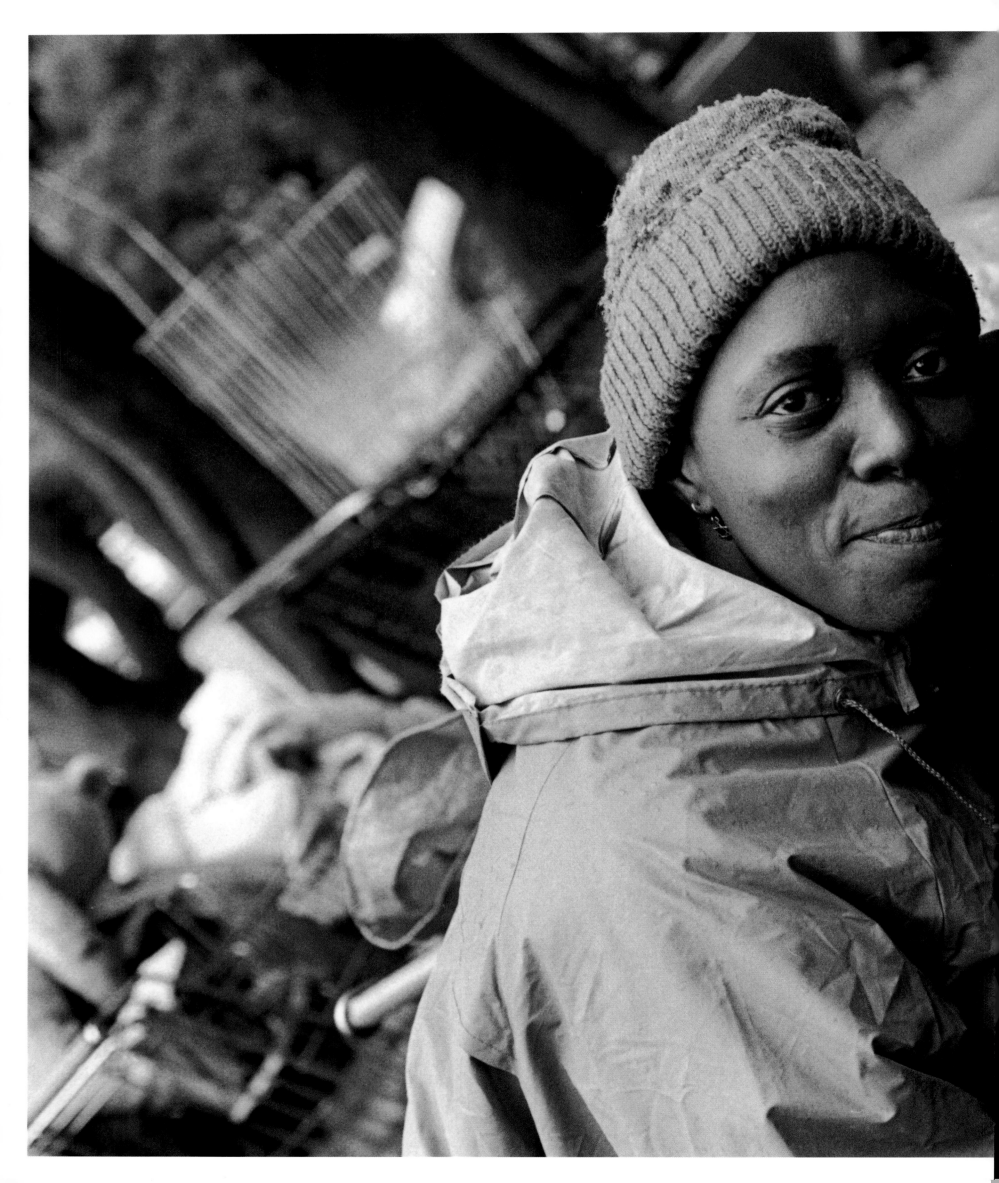

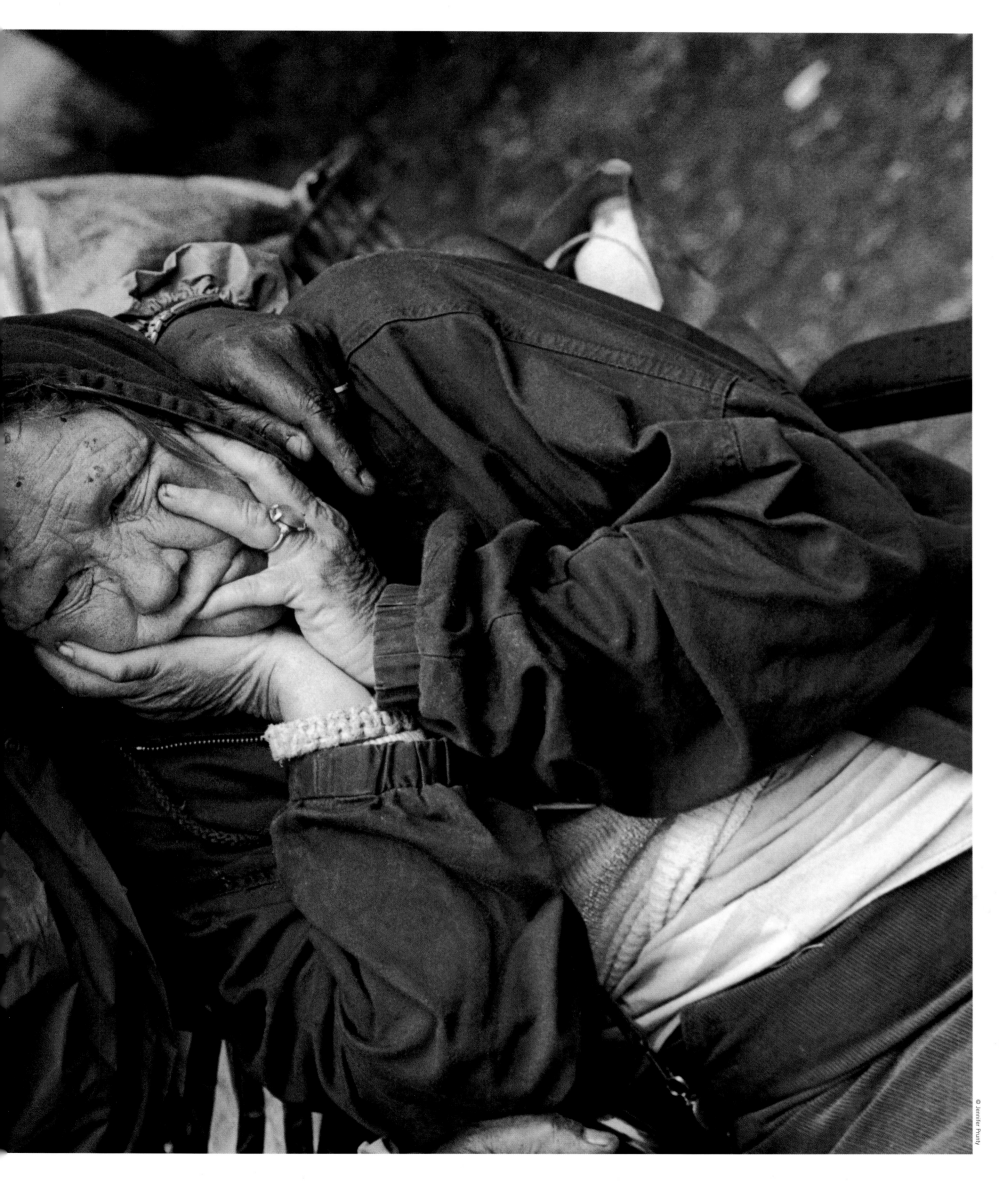

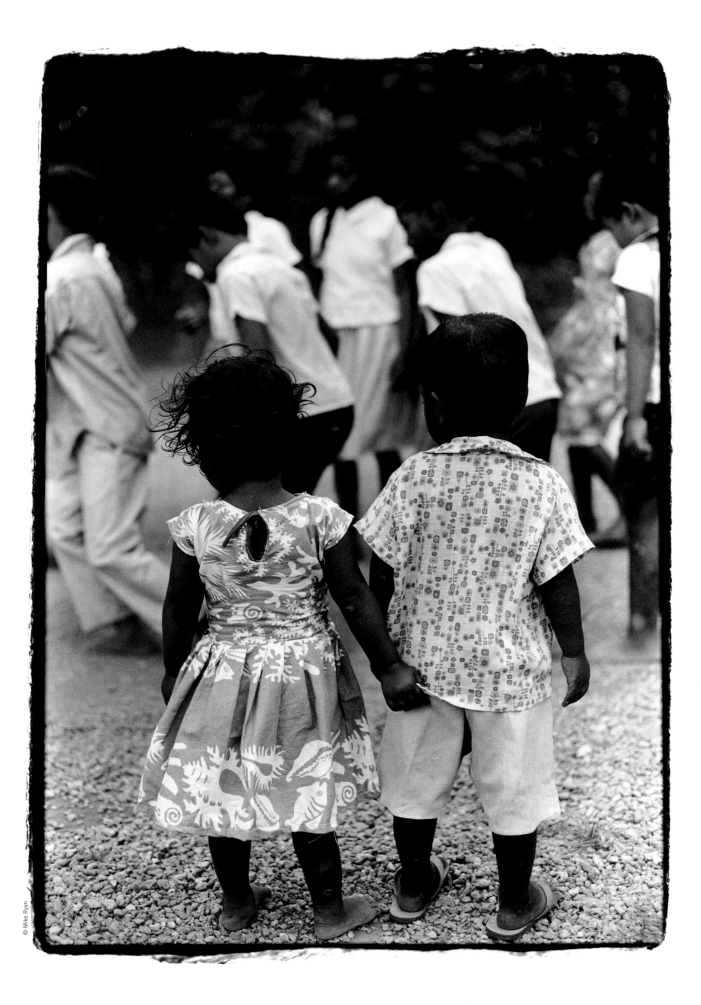

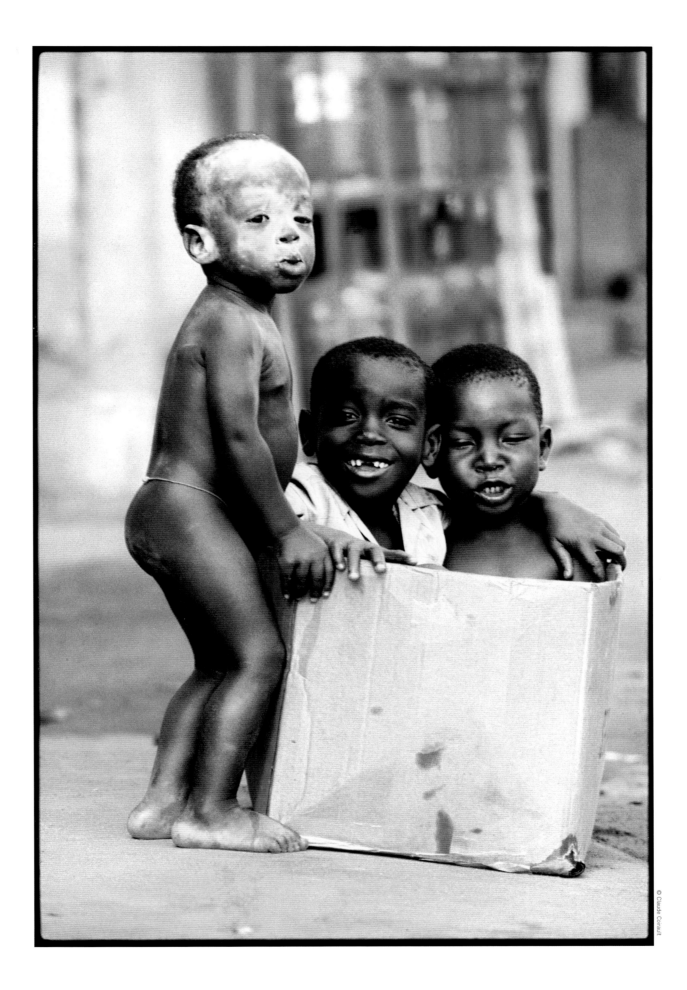

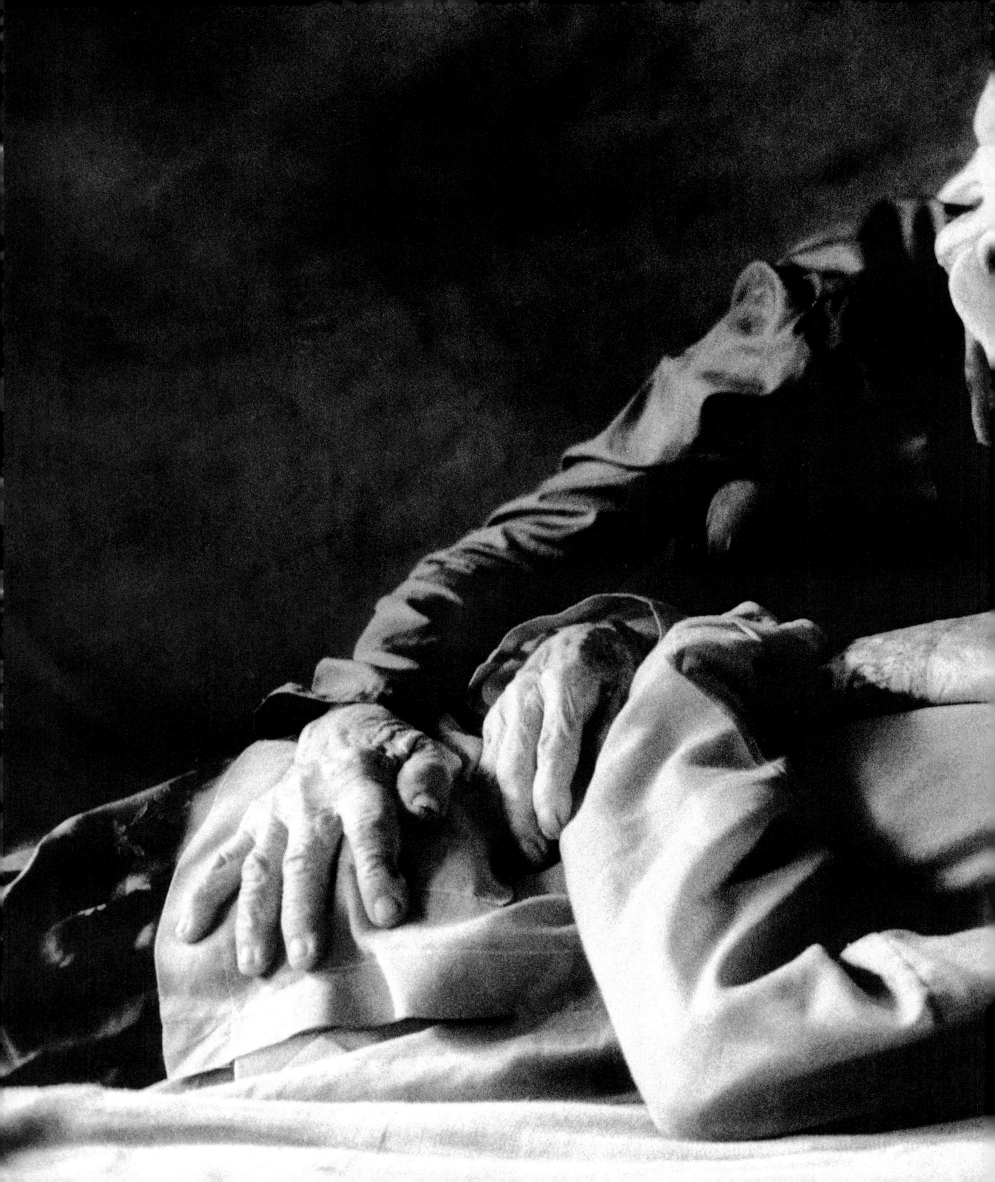

IS OFTEN A LESS DRAMATIC SPECTACLE THAN THE COURAGE OF A FINAL MOMENT;

BUT IT IS NO LESS A MAGNIFICENT MIXTURE OF TRIUMPH AND TRAGEDY.

[JOHN F KENNEDY]

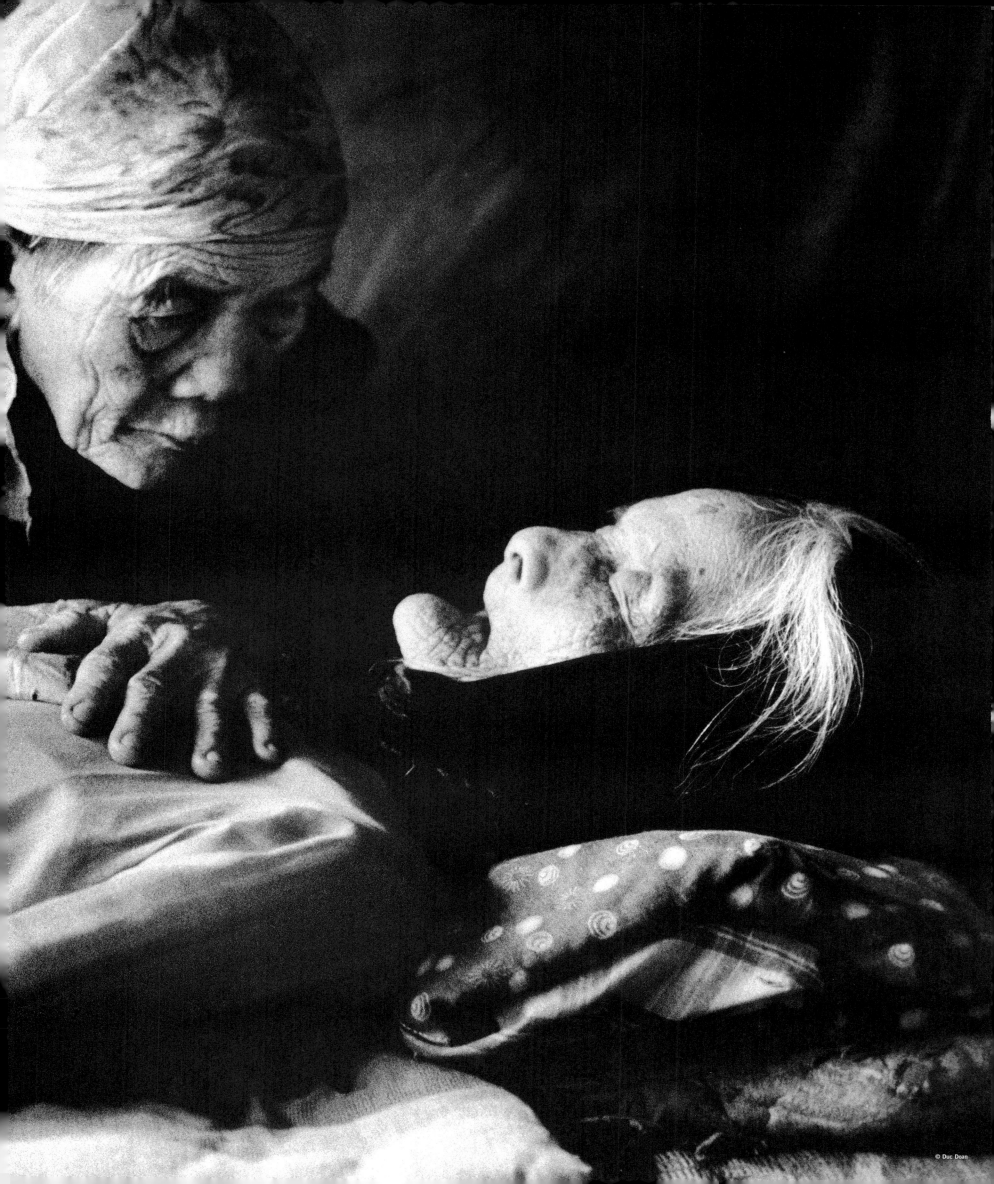

A single rose can be my garden…
A single friend,
my world.

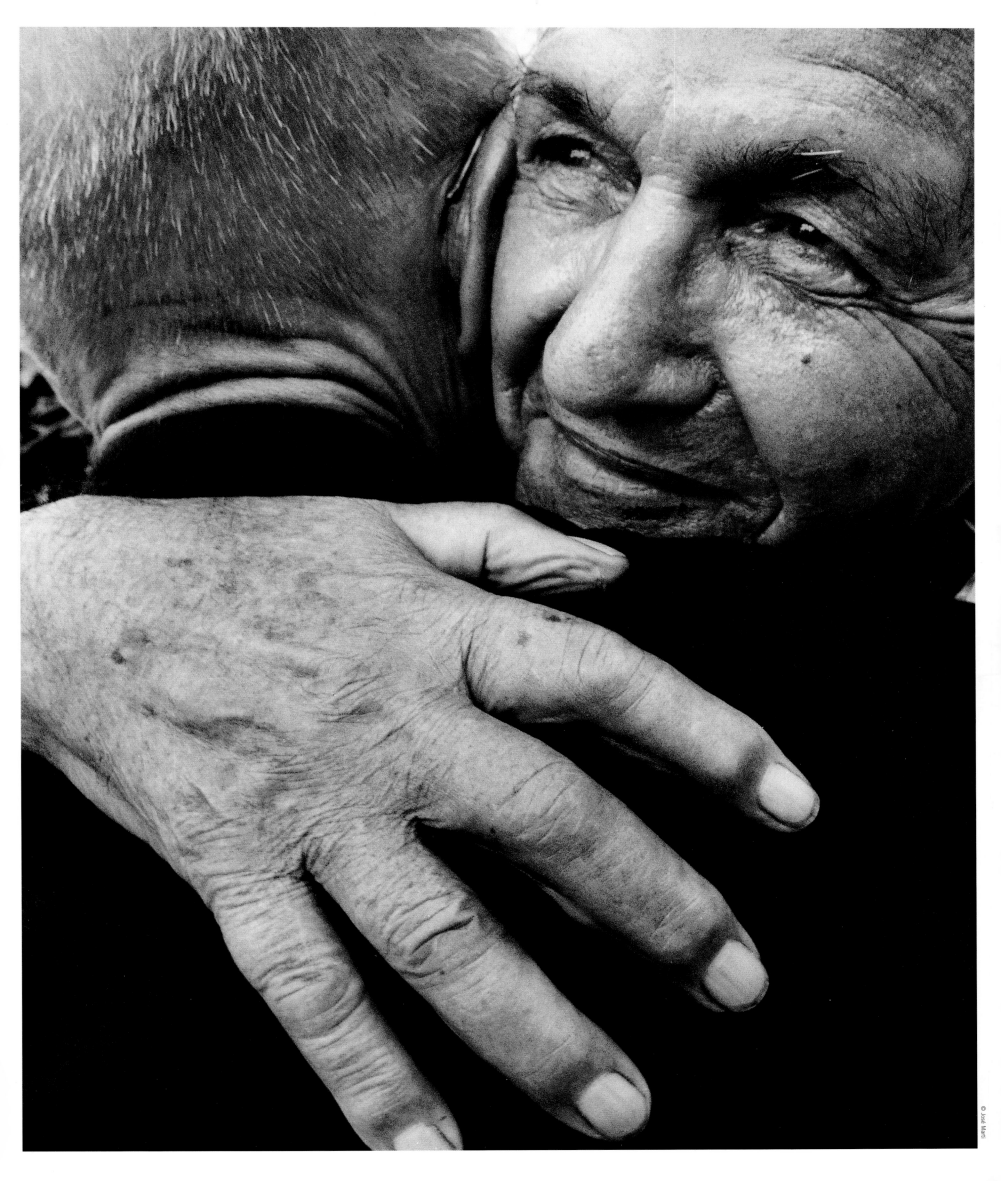

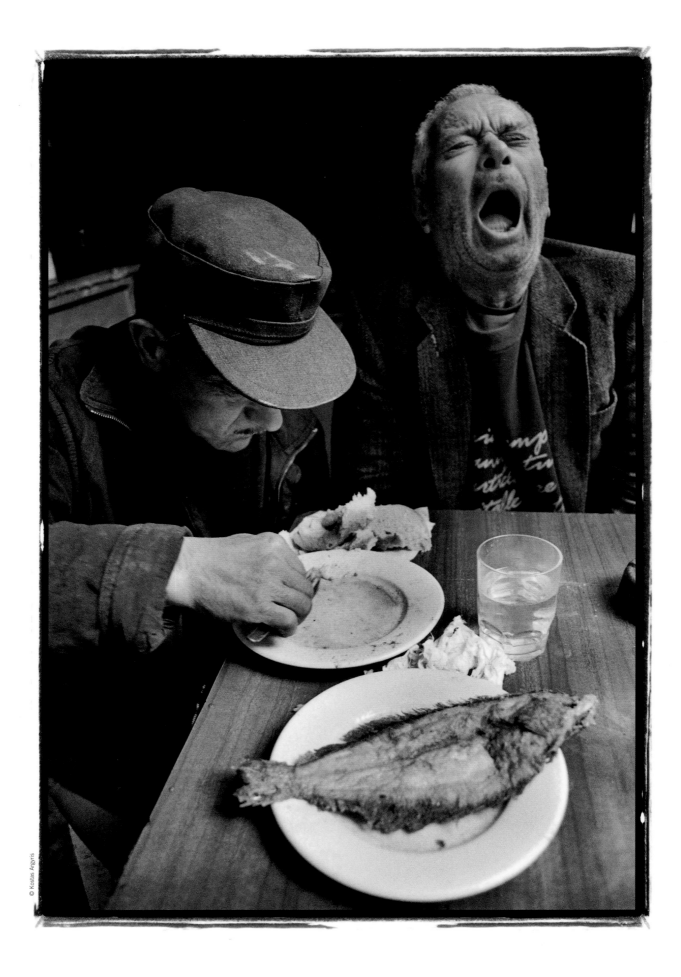

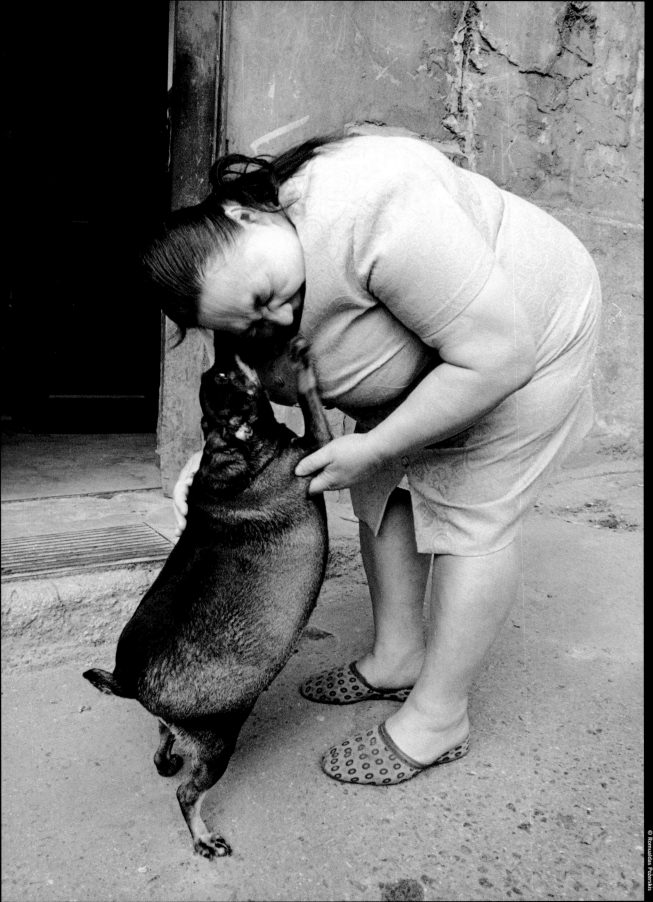

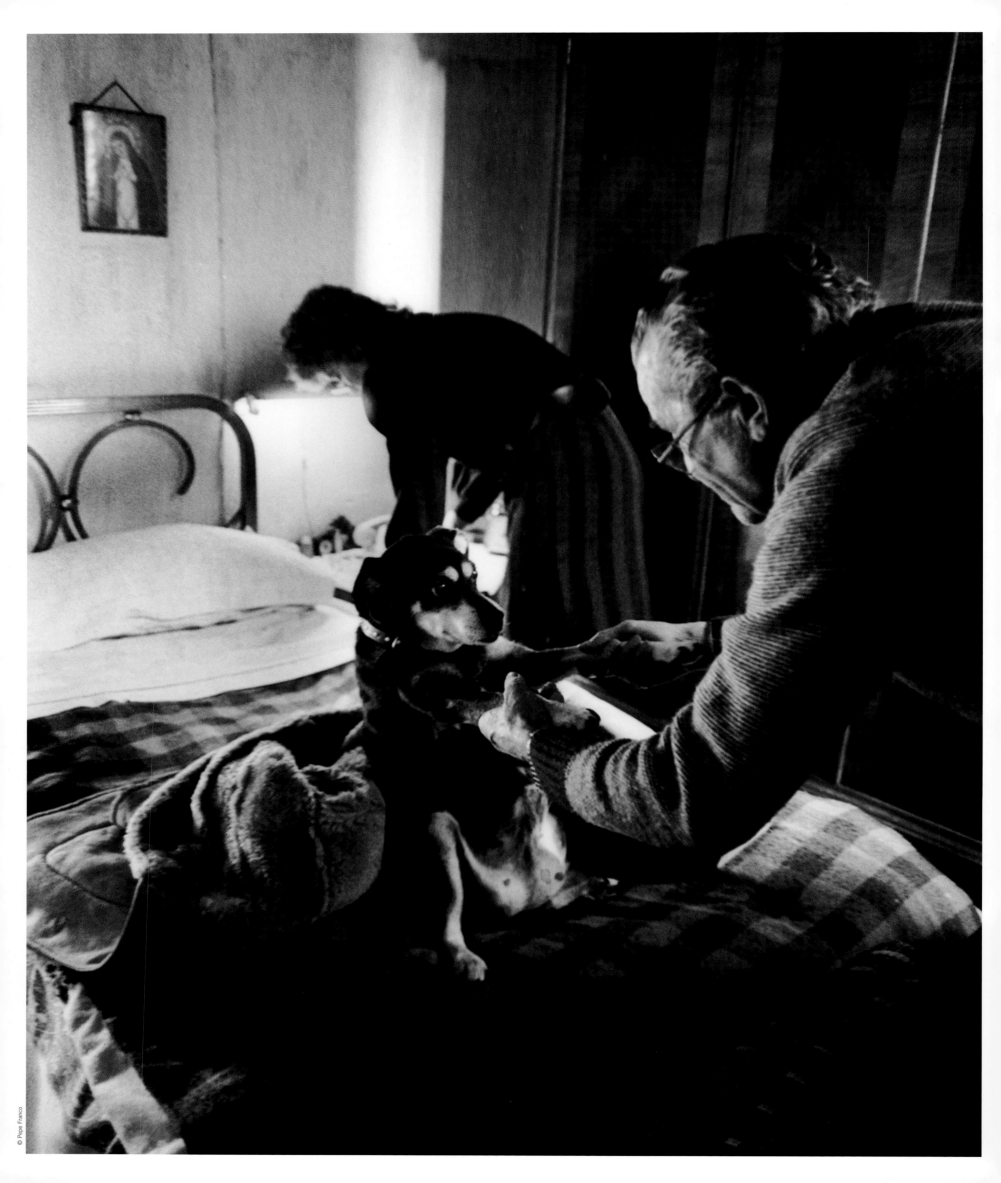

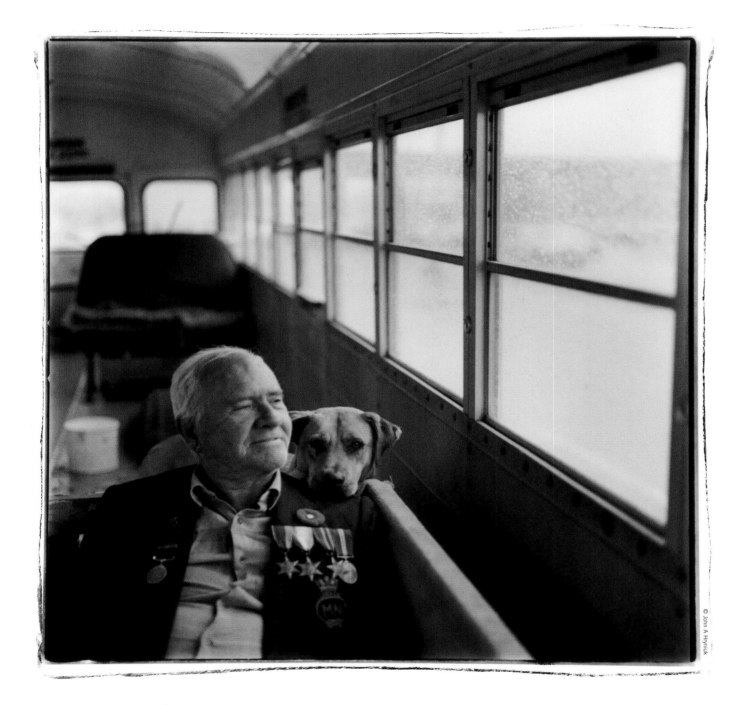

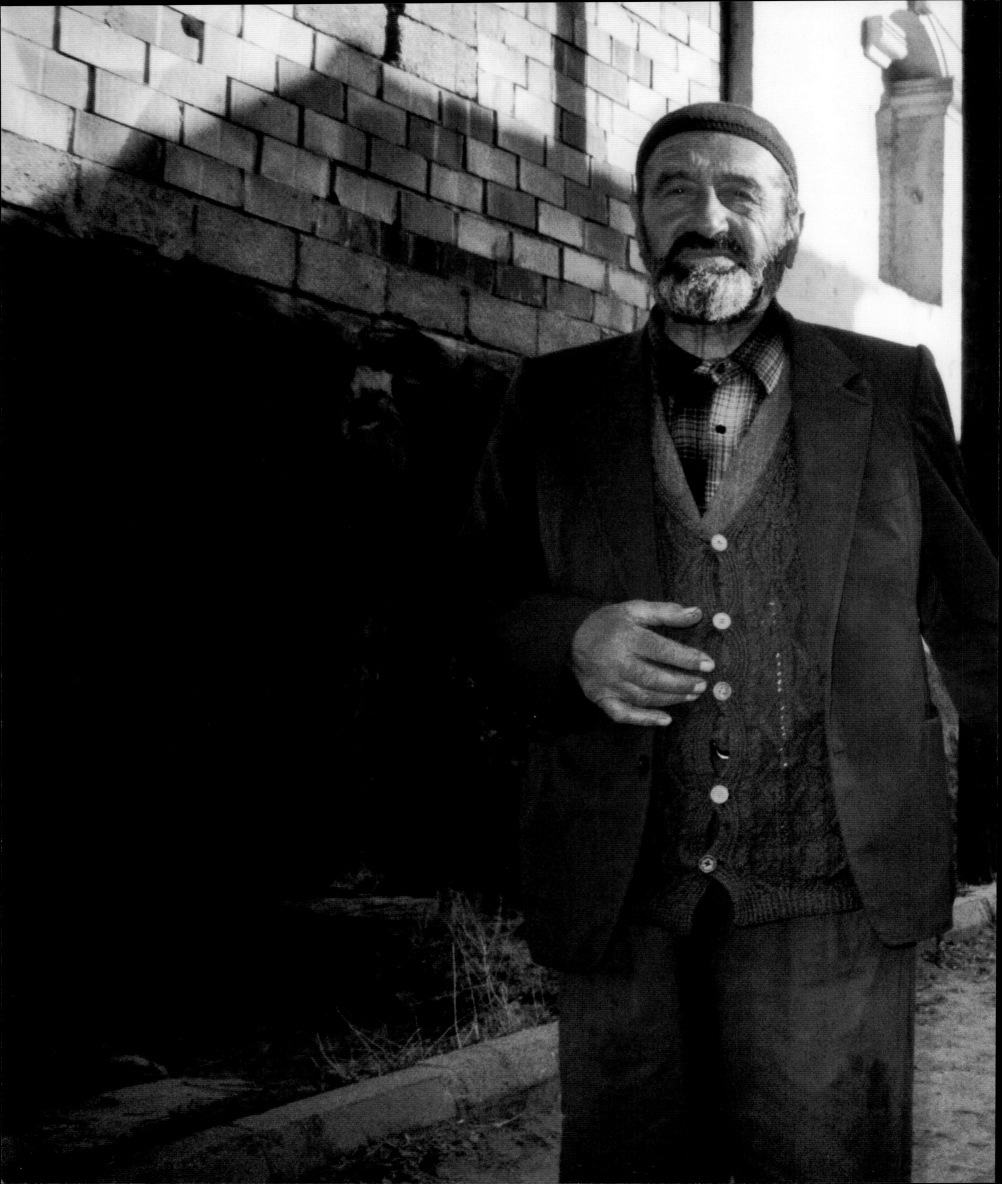

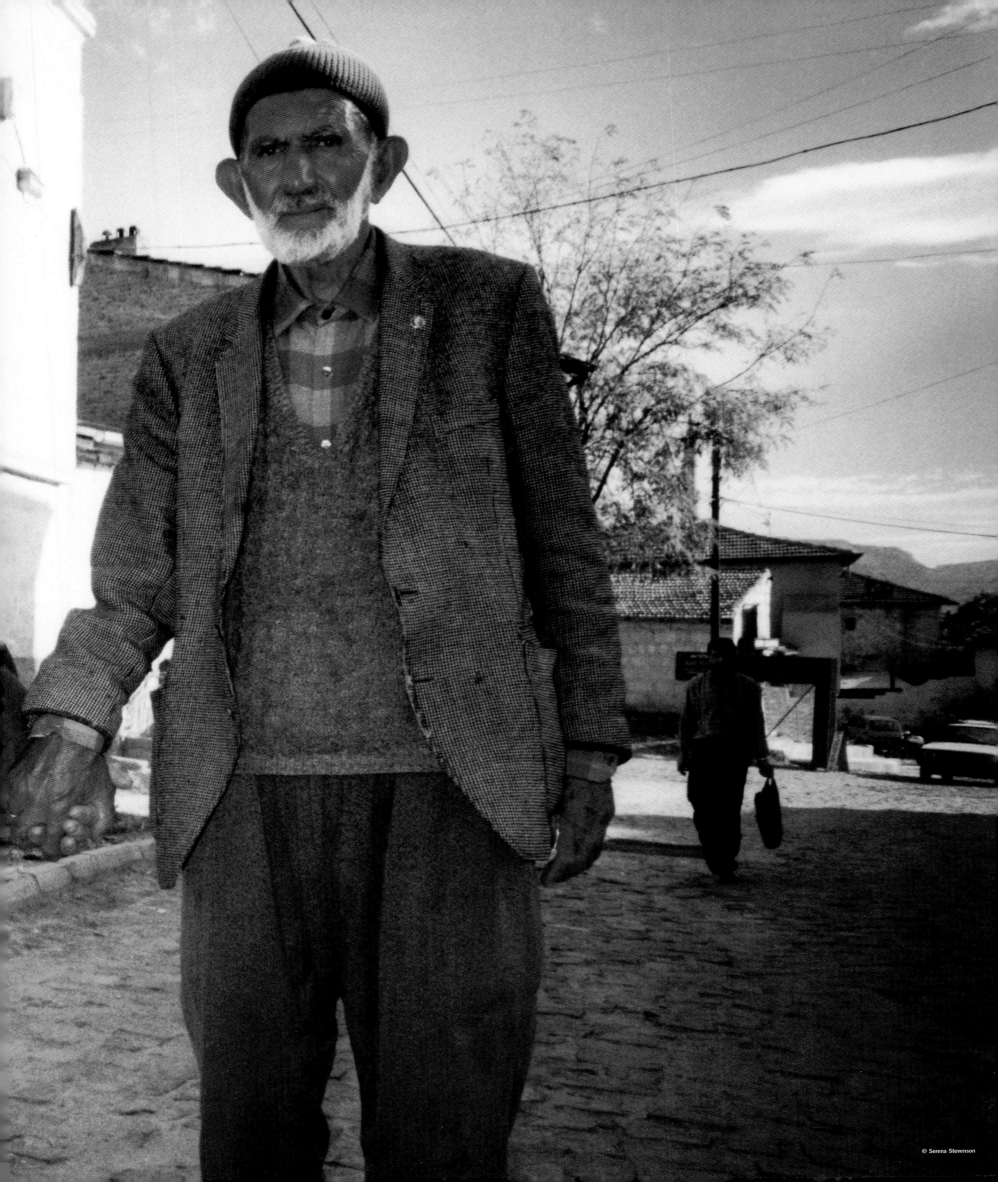

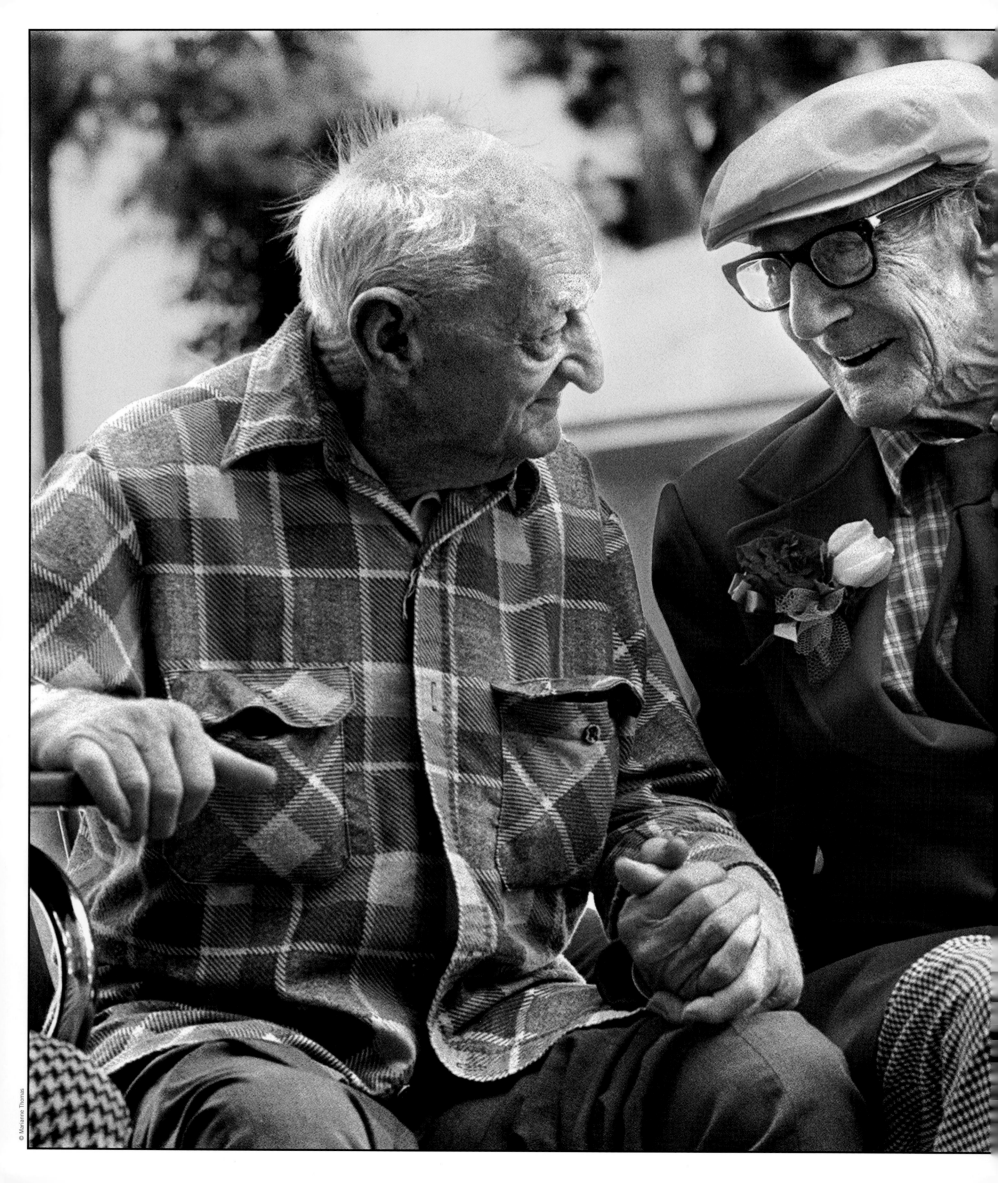

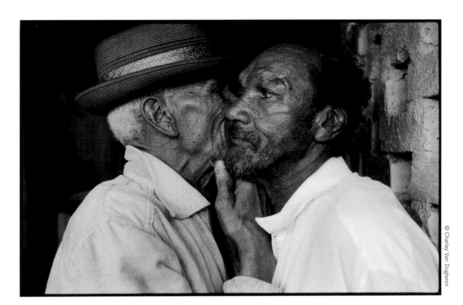

Kind words can be short
and easy to speak…
but their echoes are truly endless.

[MOTHER TERESA]

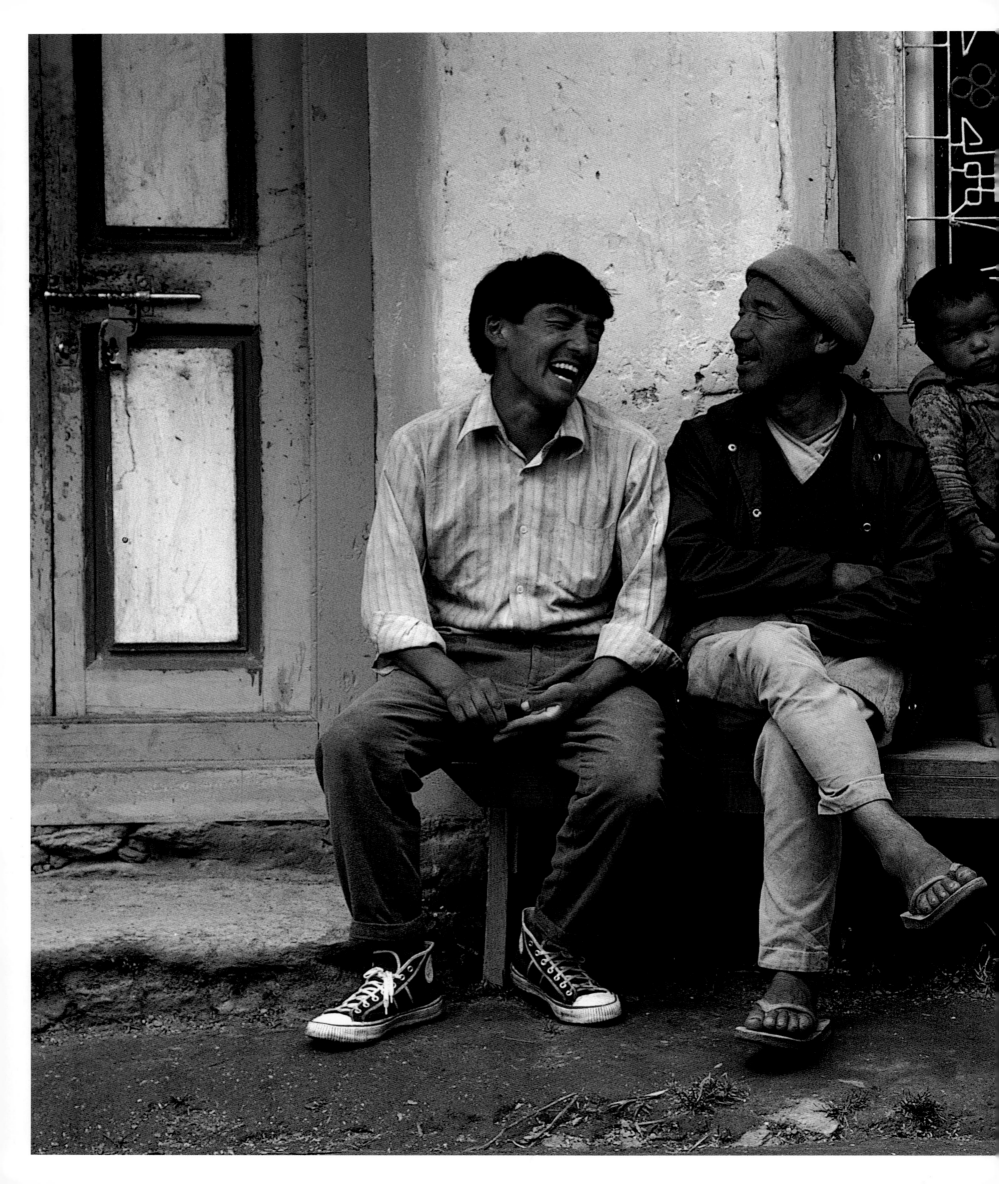

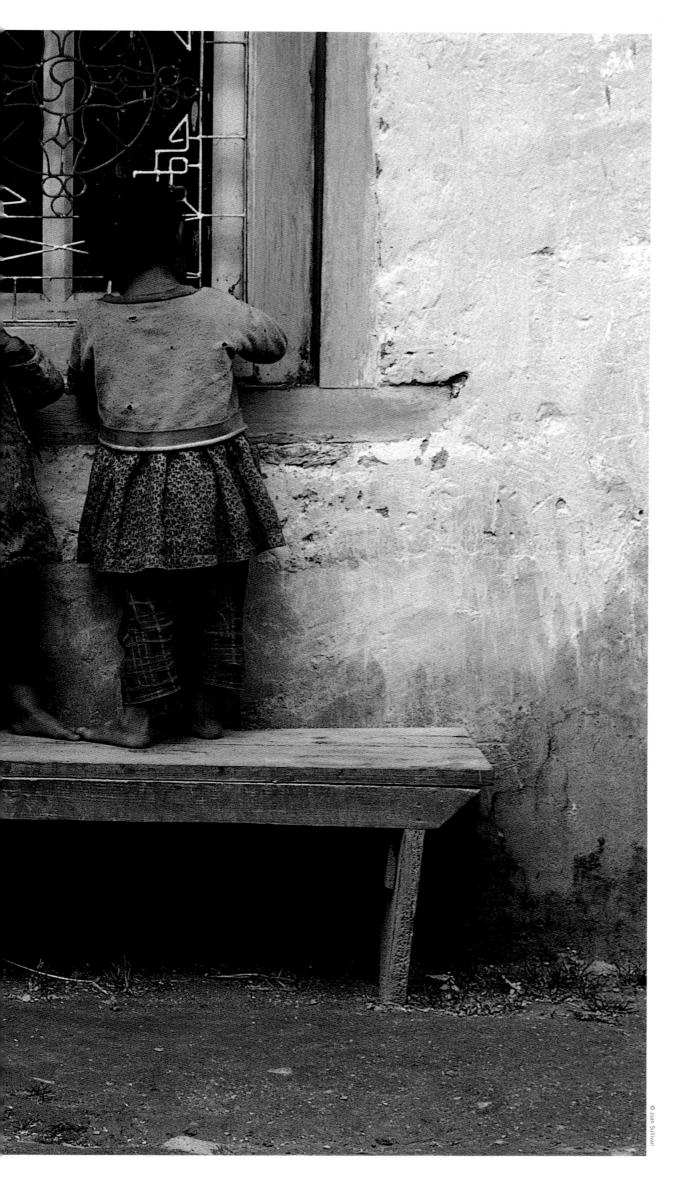

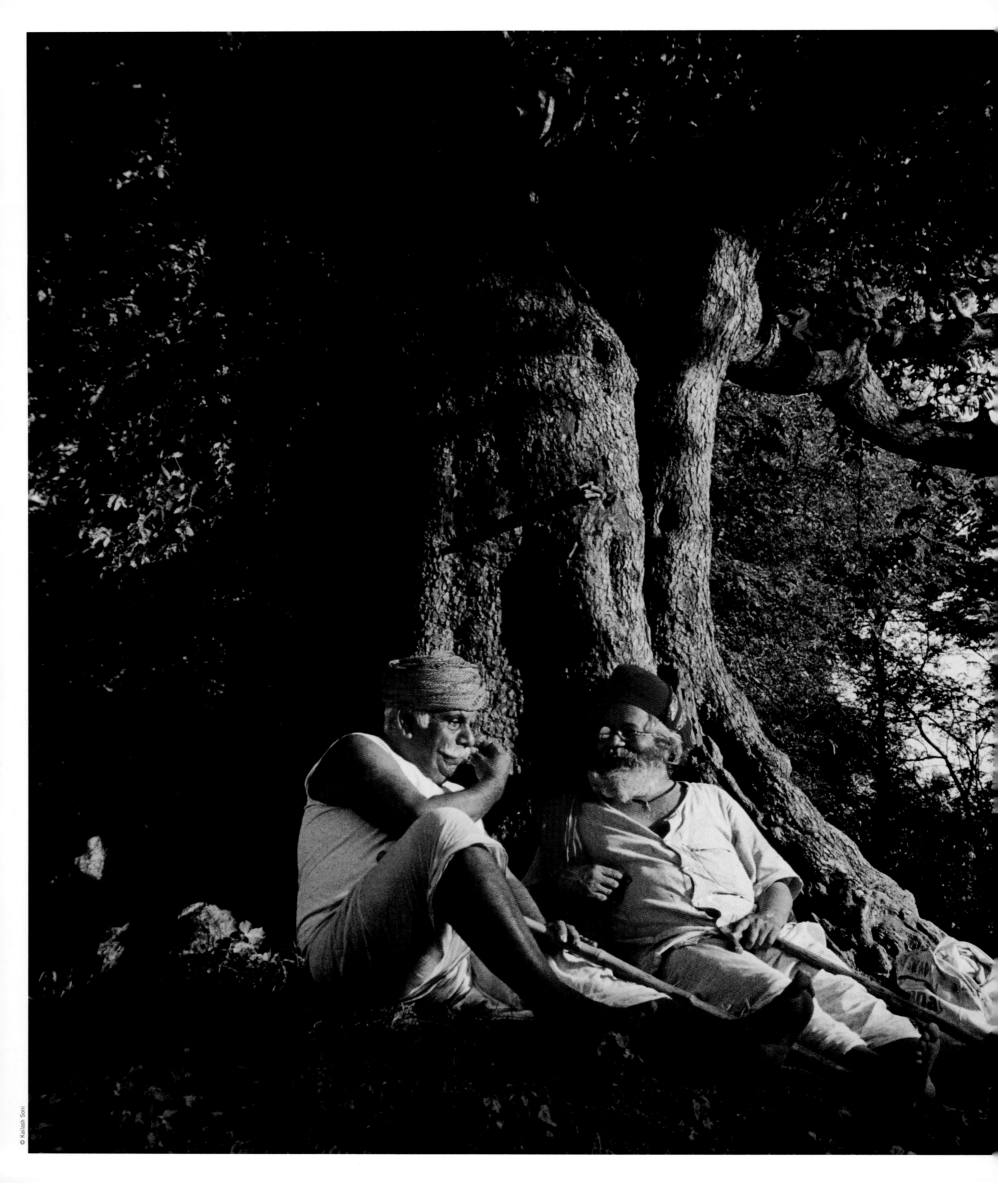

FOR MEMORY HAS PAINTED THIS PERFECT DAY, WITH

COLORS

THAT NEVER FADE.

[CARRIE JACOBS BOND]

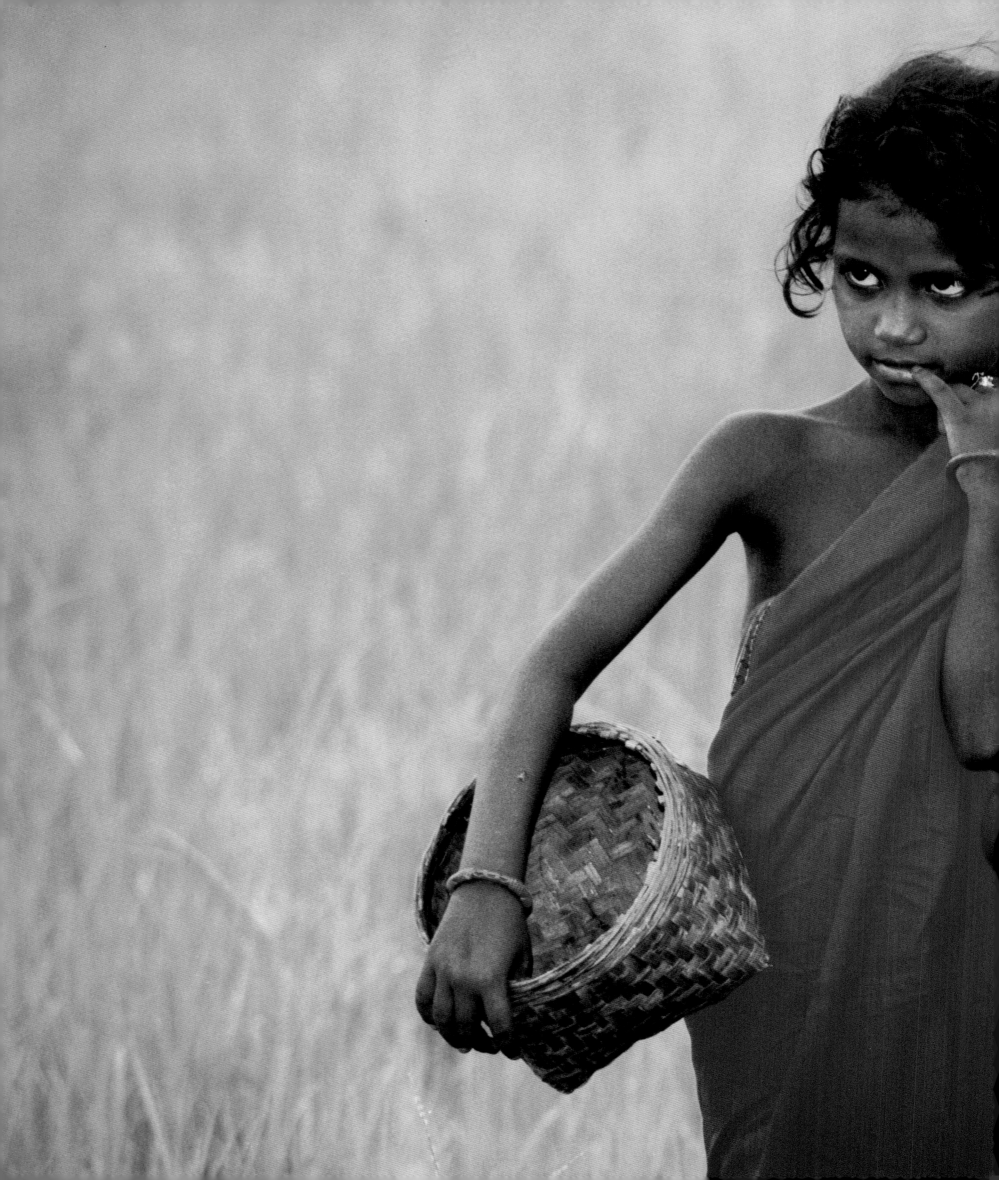

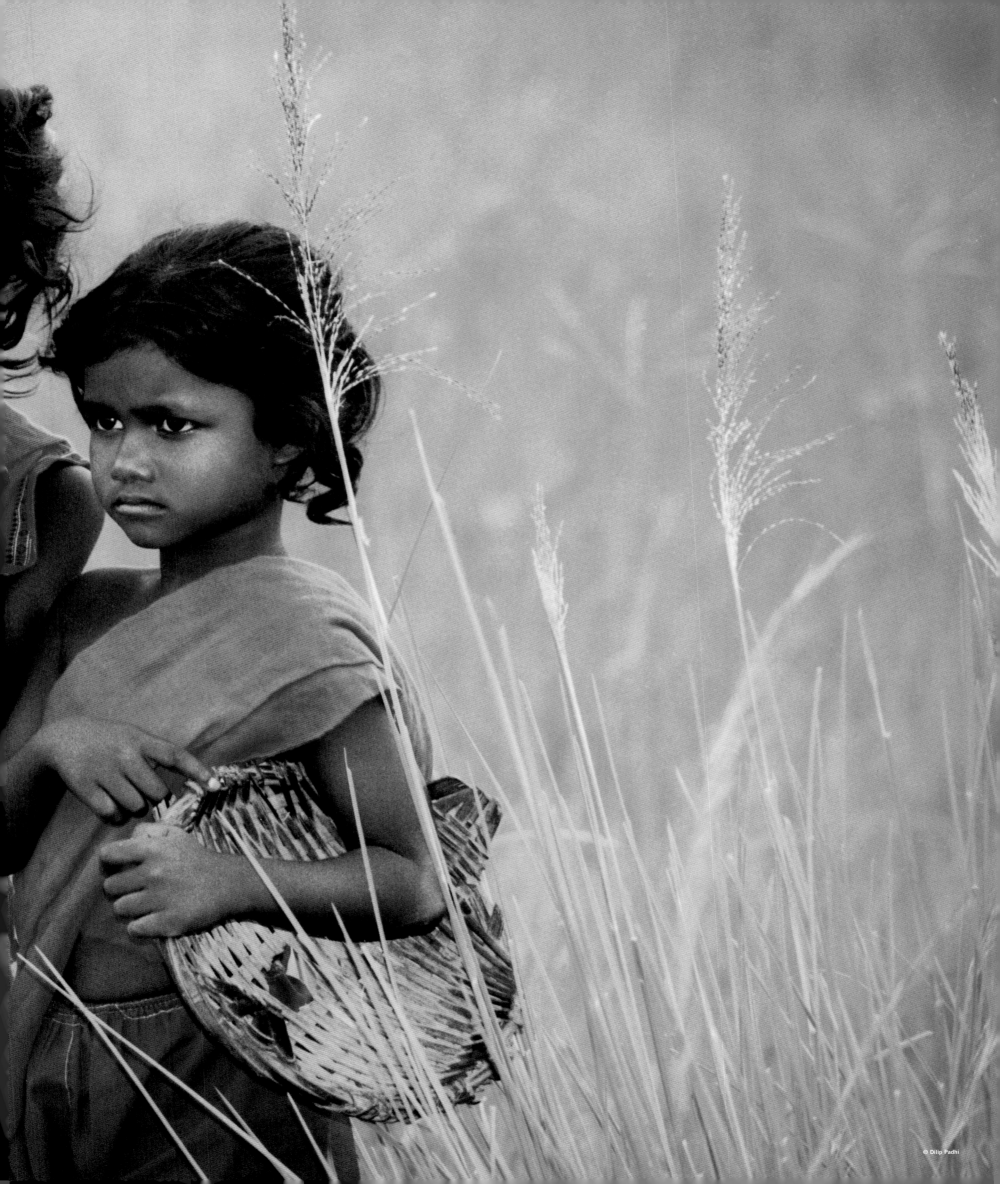

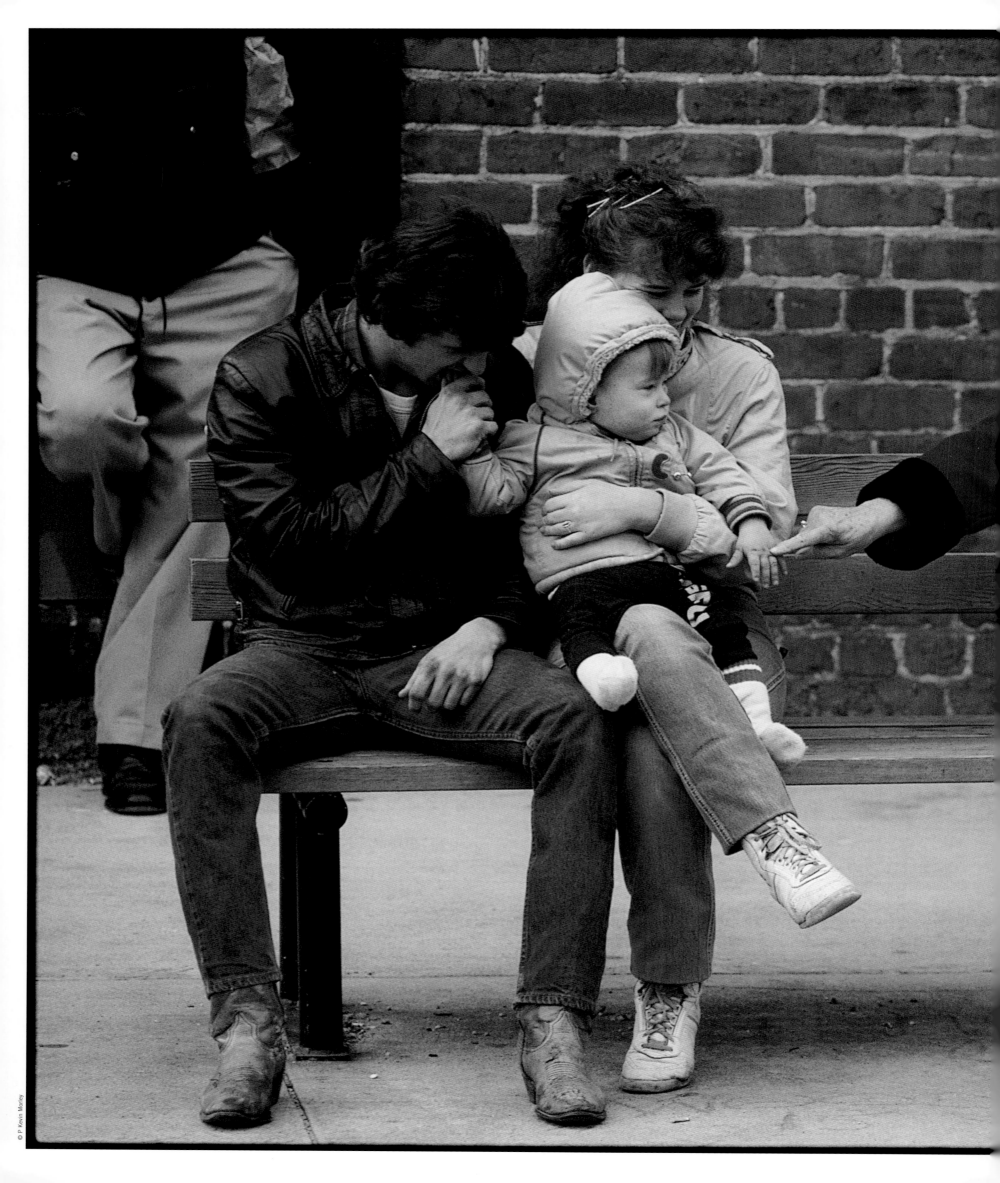

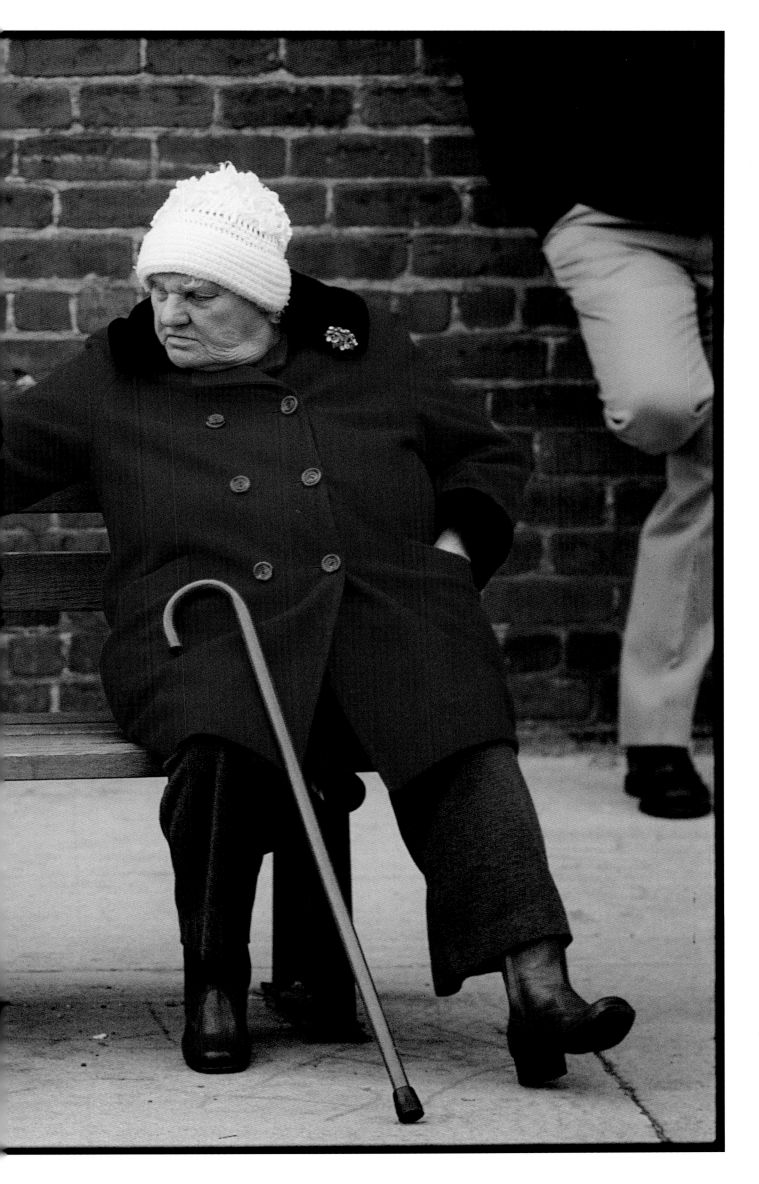

SOME PEOPLE MOVE OUR SOULS

[UNKNOWN]

TO DANCE.

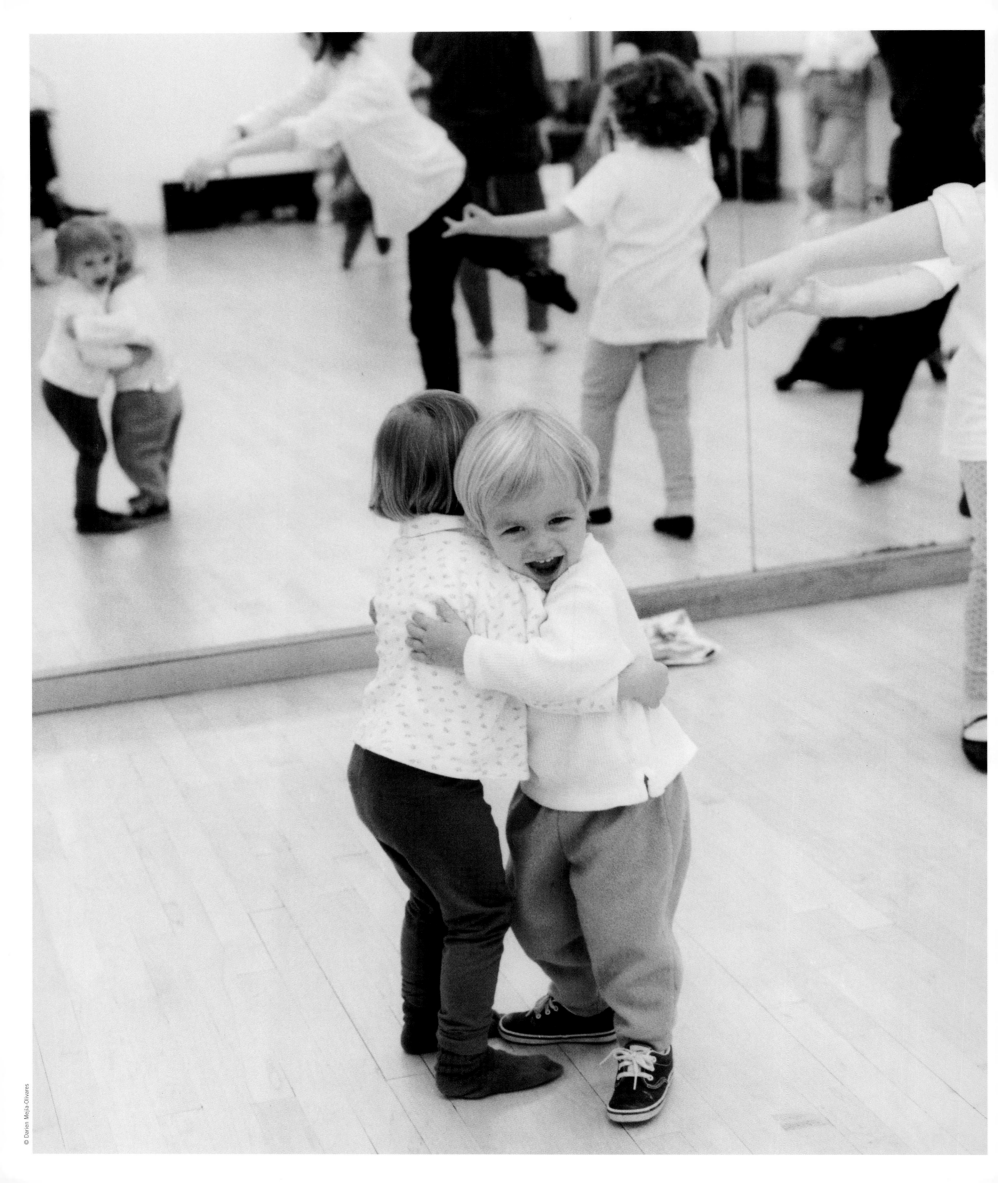

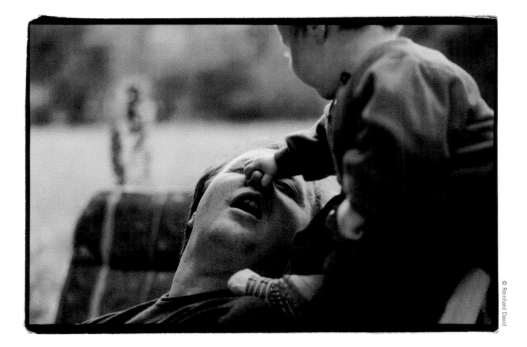

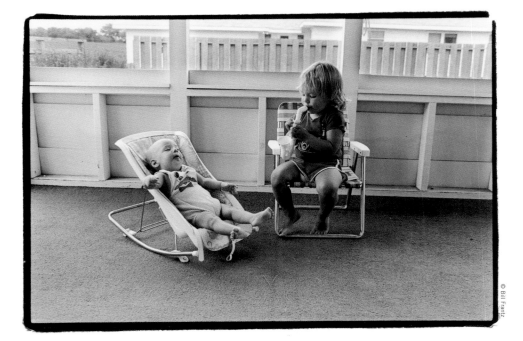

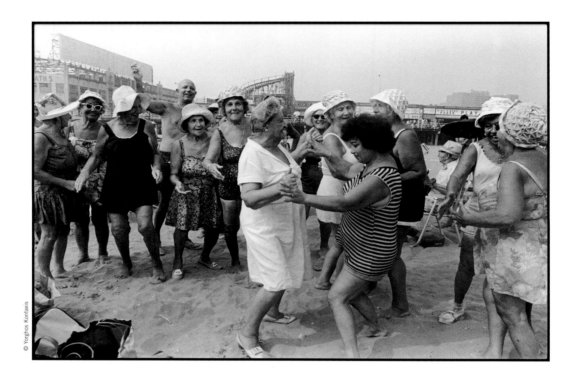

© Yorghos Kontaxis

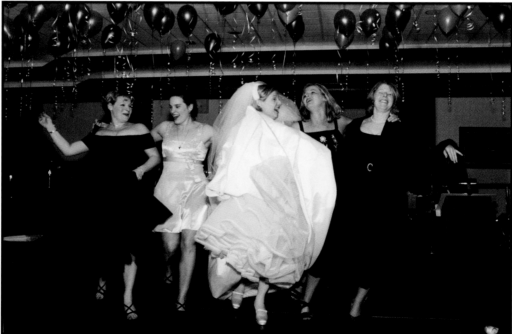

© Katherine Fletcher

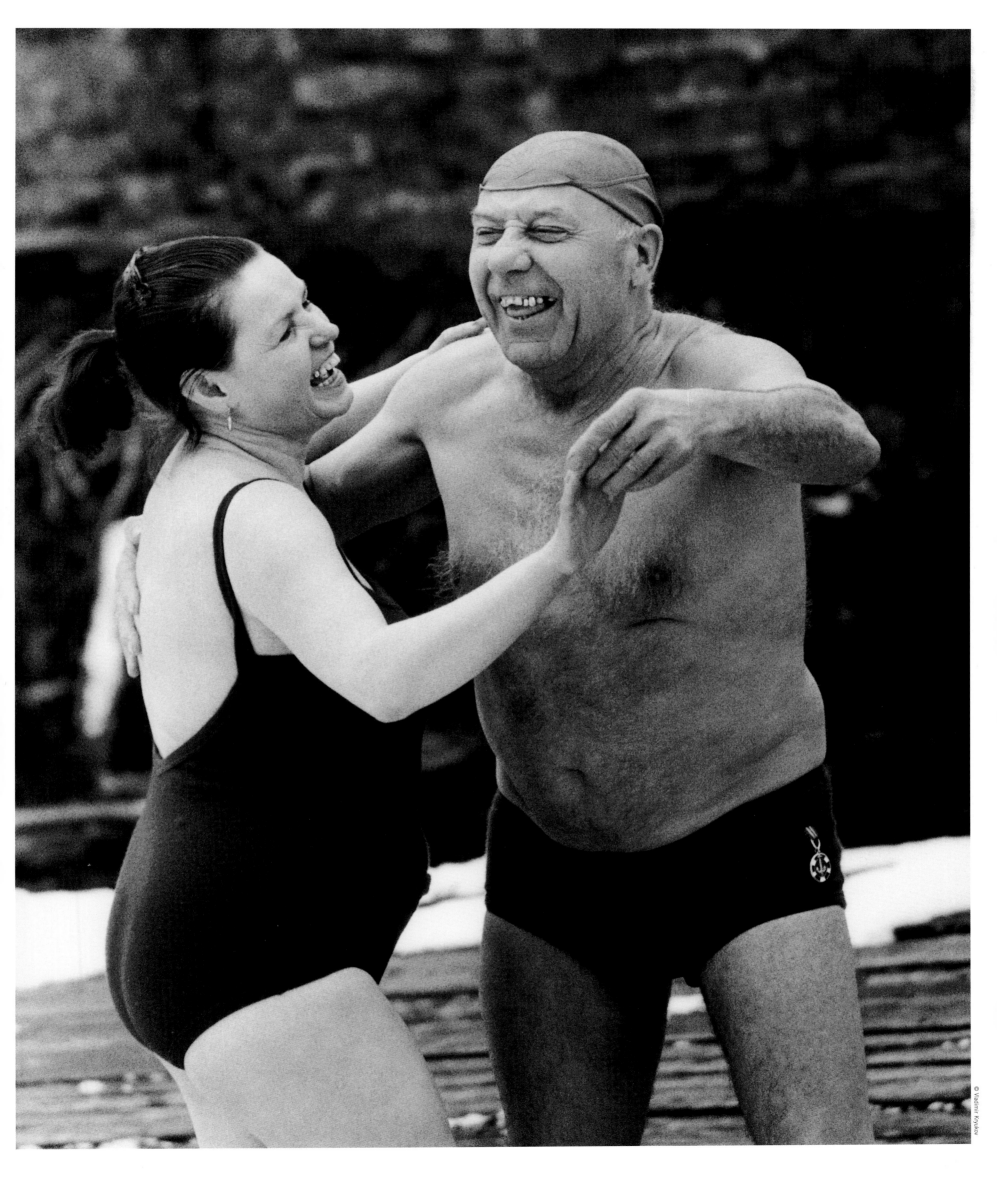

Real friends are those who, when you've made a fool of yourself, don't feel that you've done a permanent job.

[ERWIN T. RANDALL]

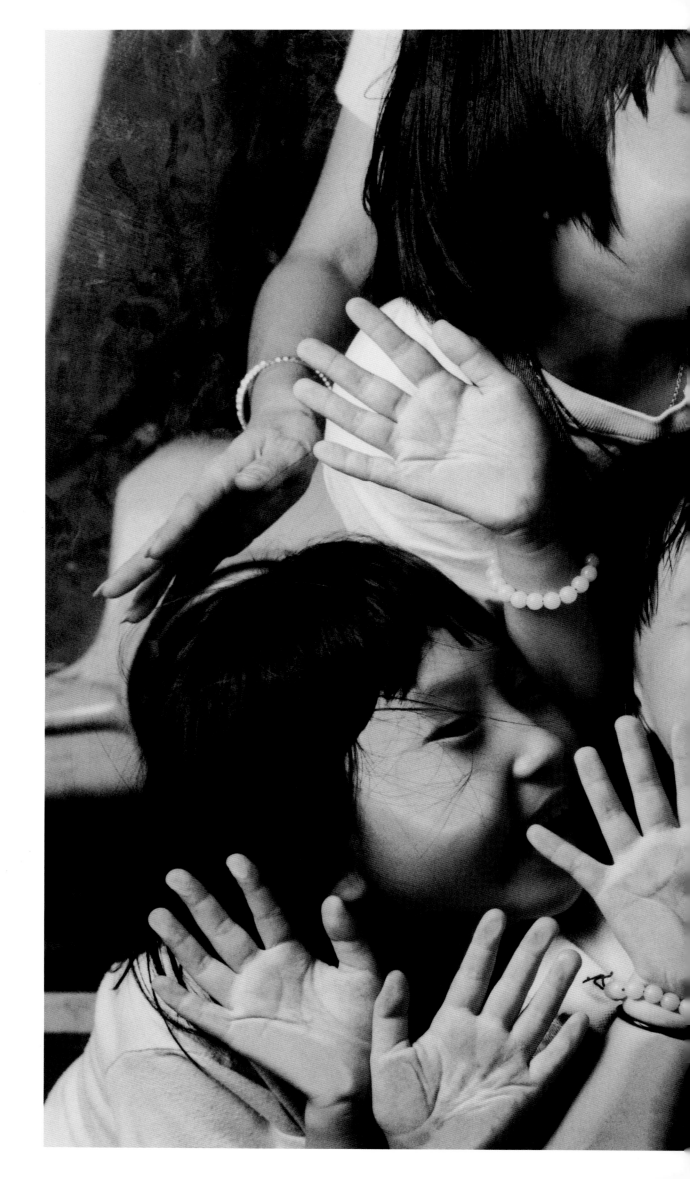

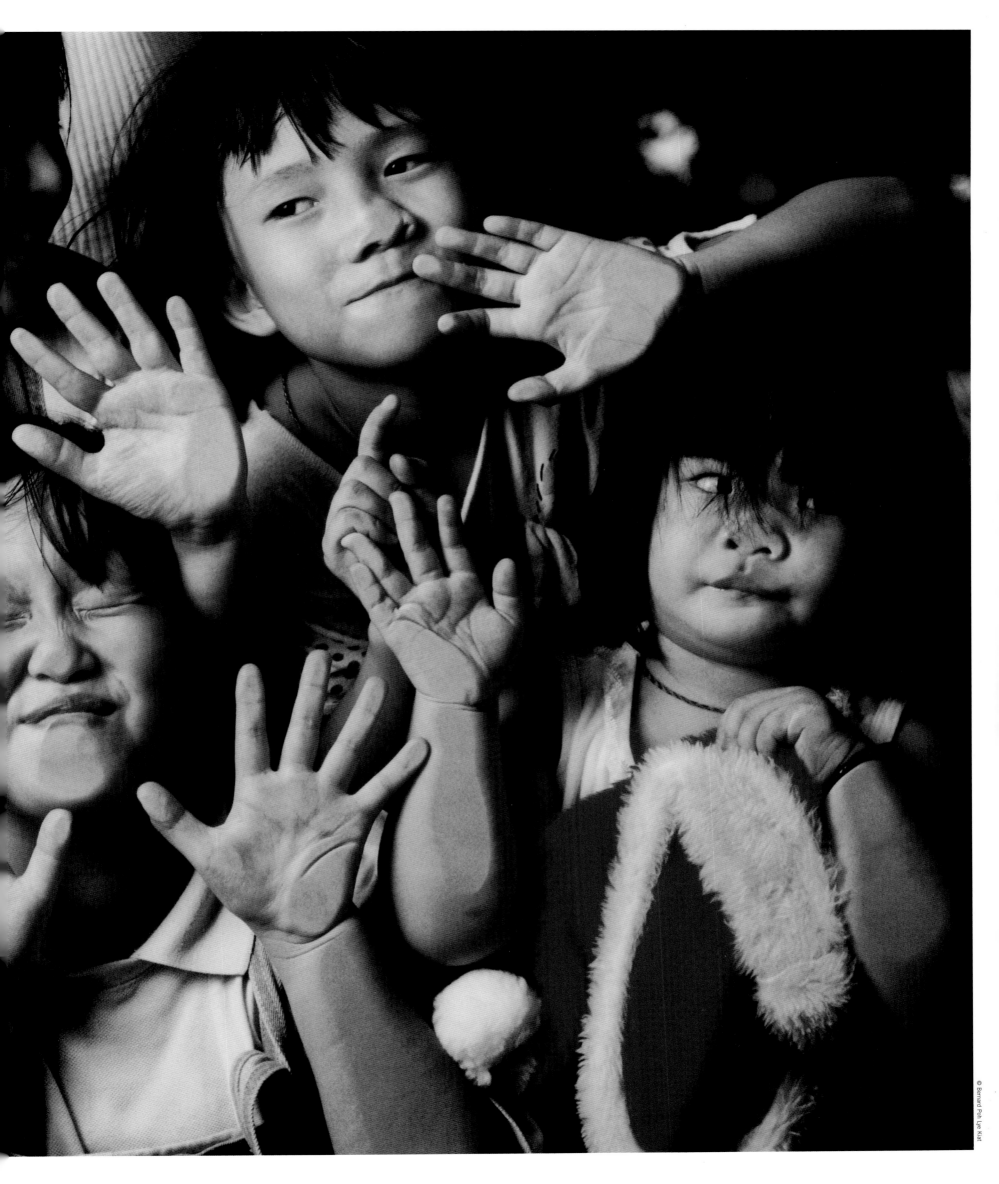

© Bernard Poh Lye Kiat

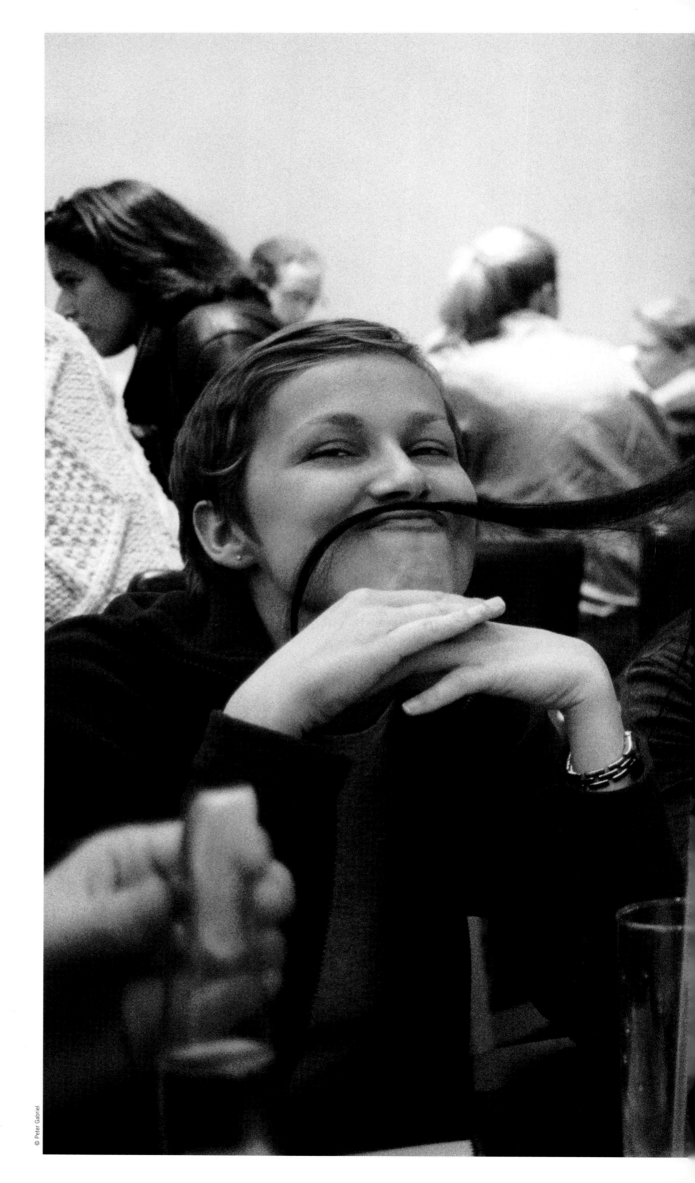

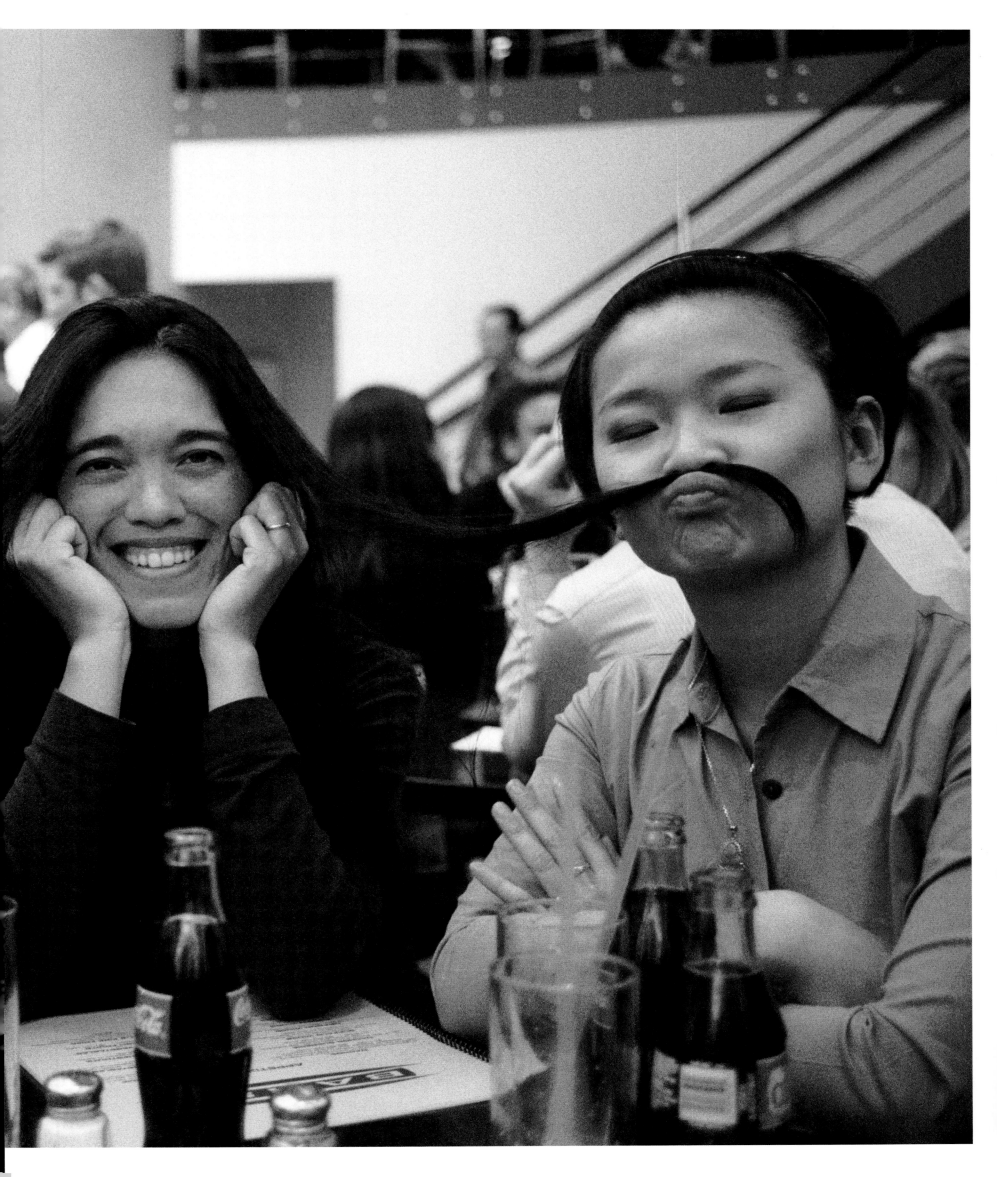

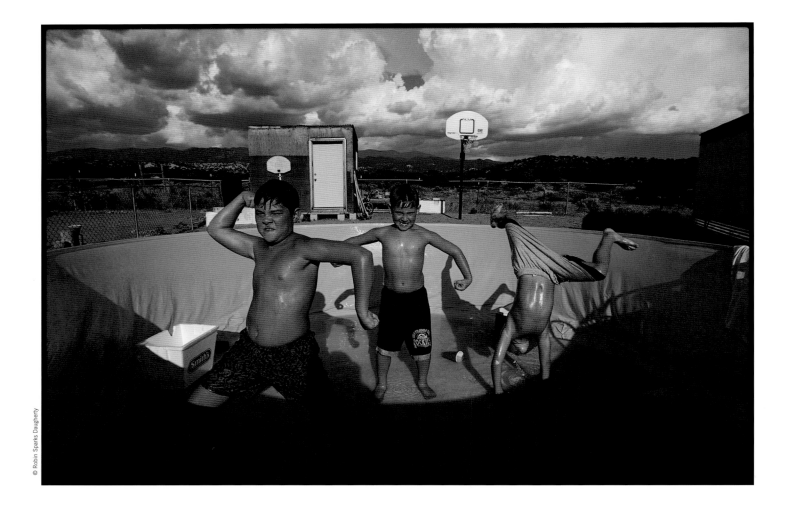

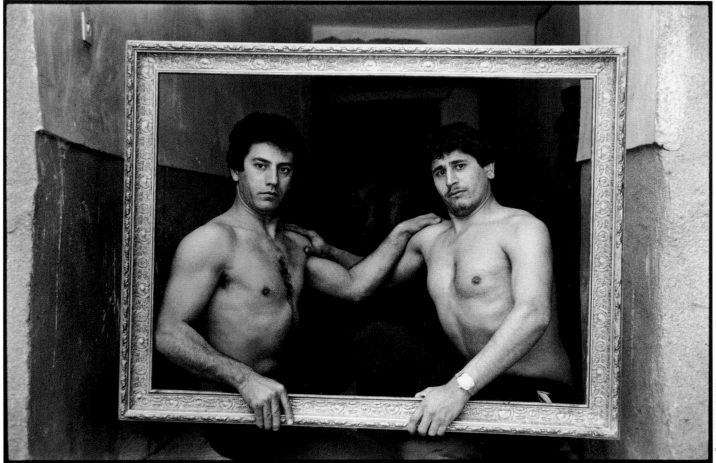

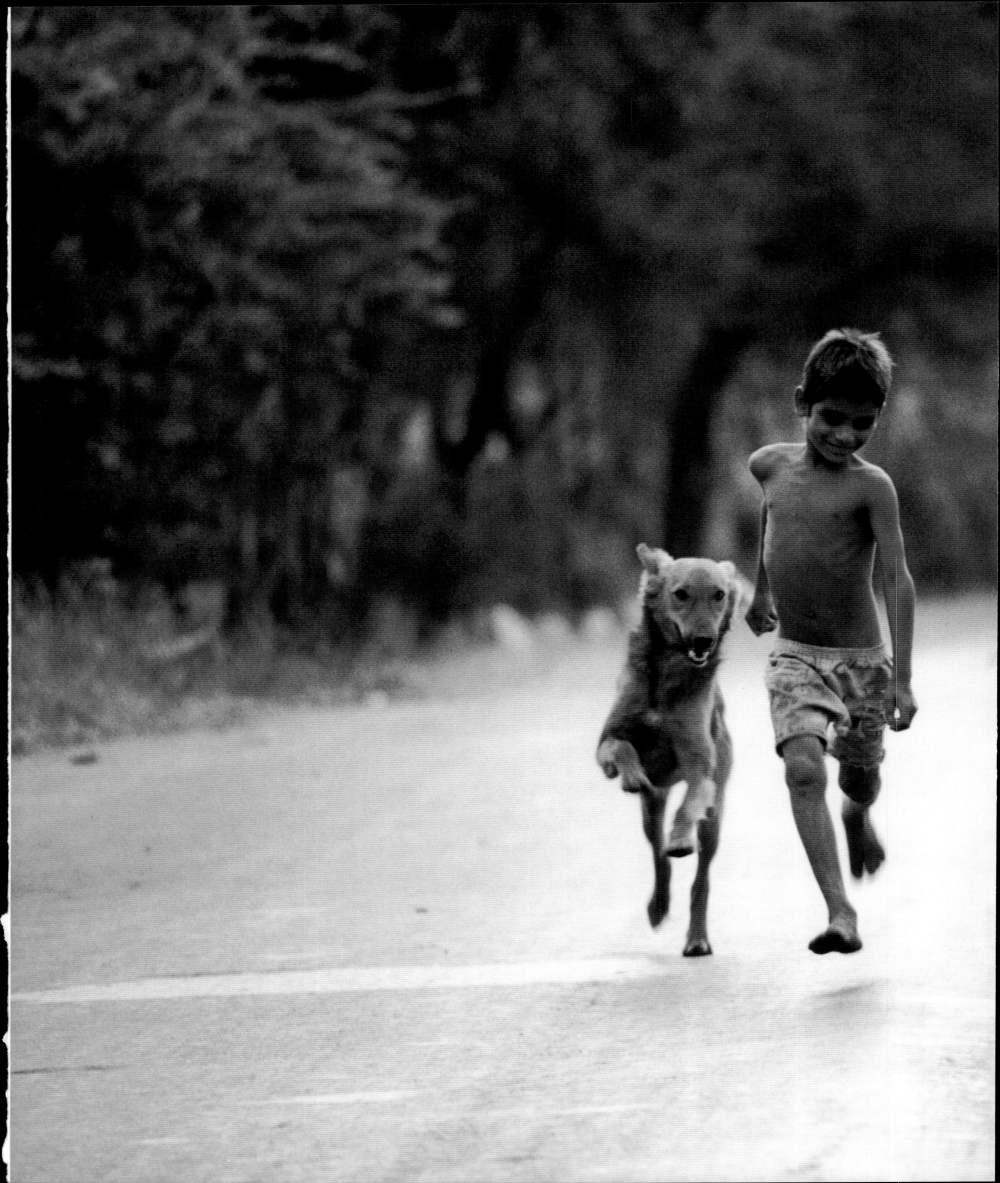

Joy is not in things, it is in us.

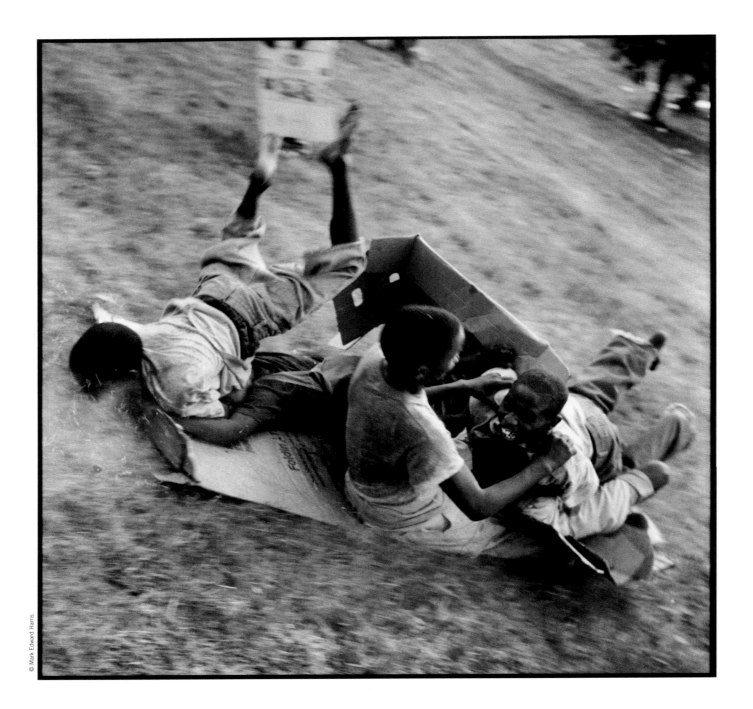

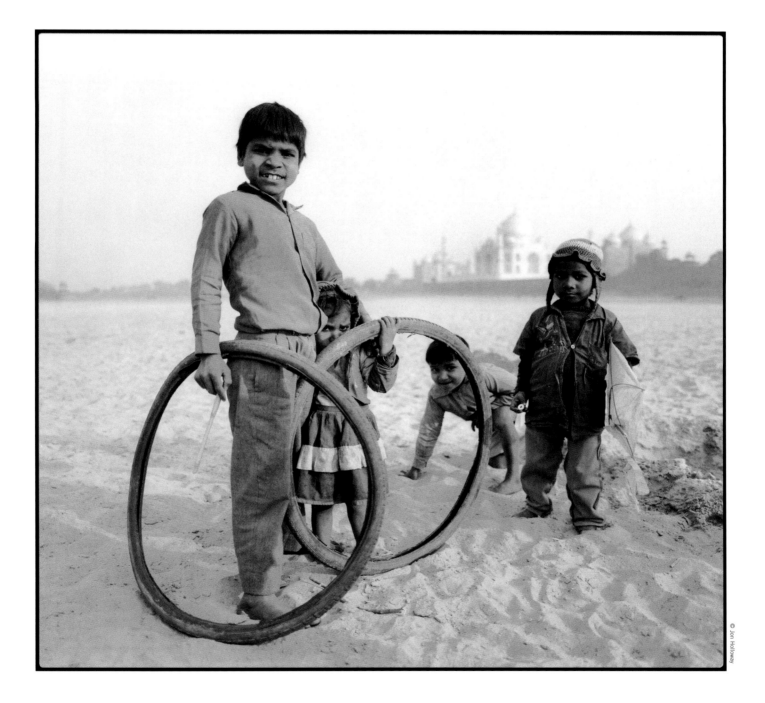

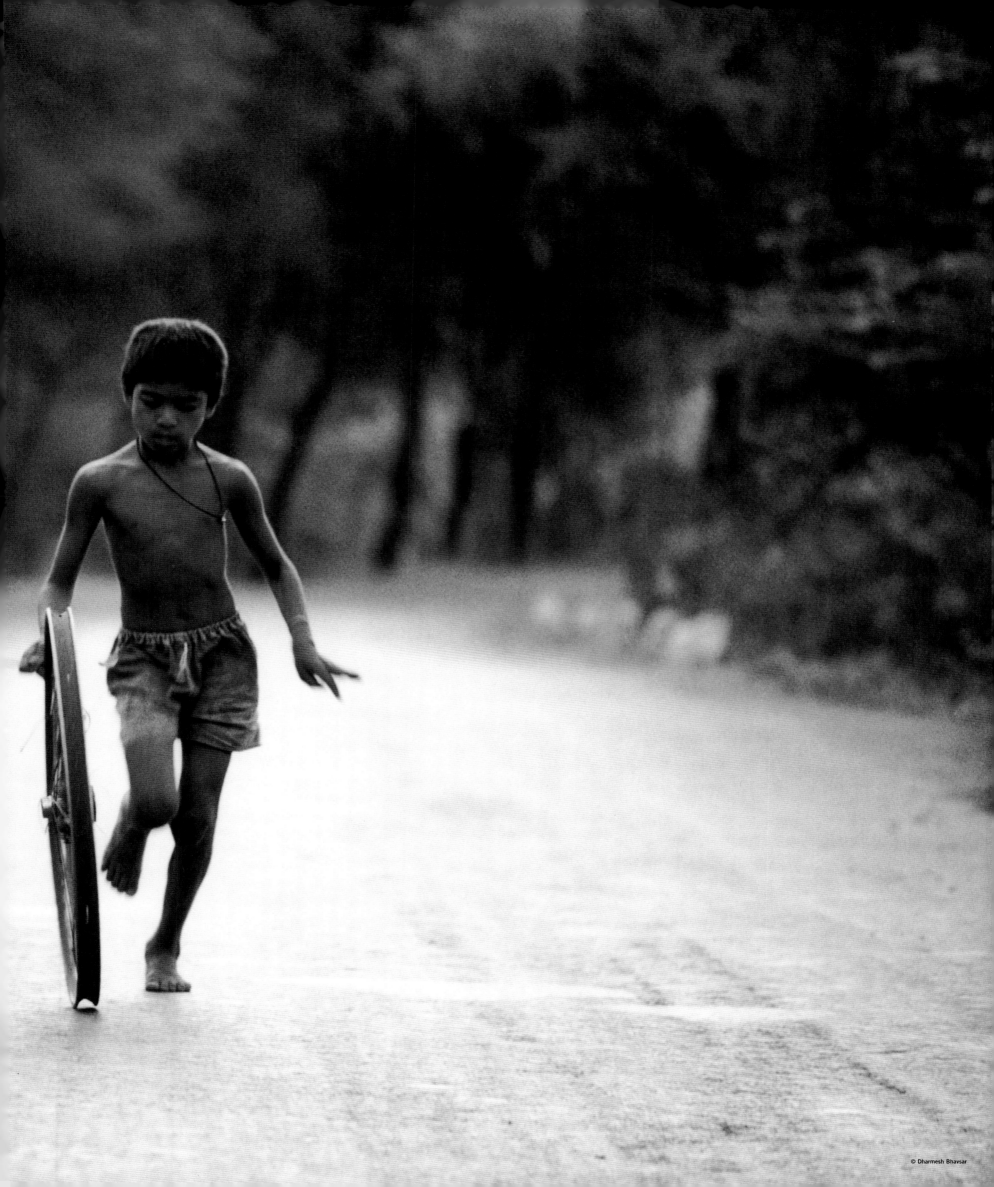

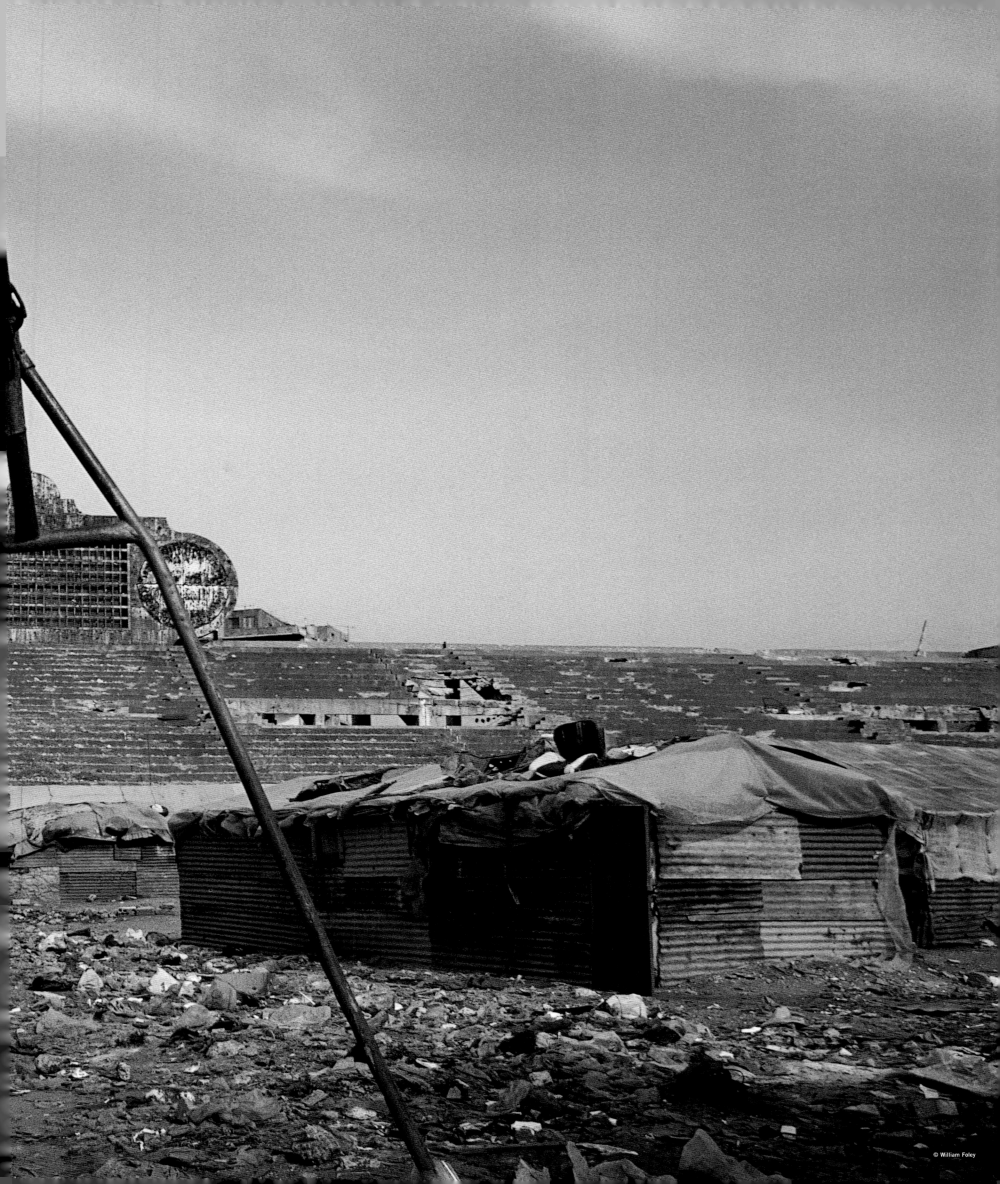

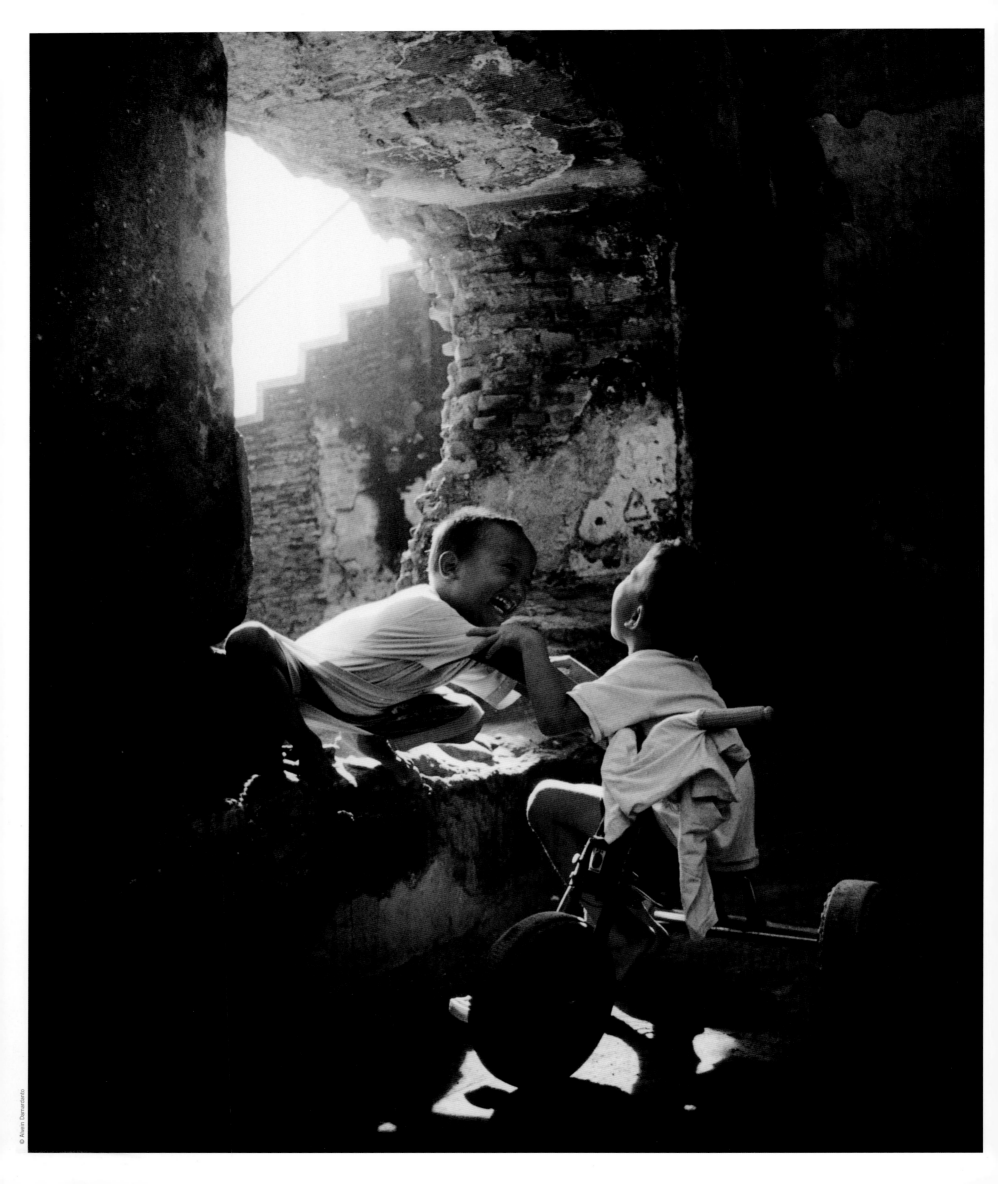

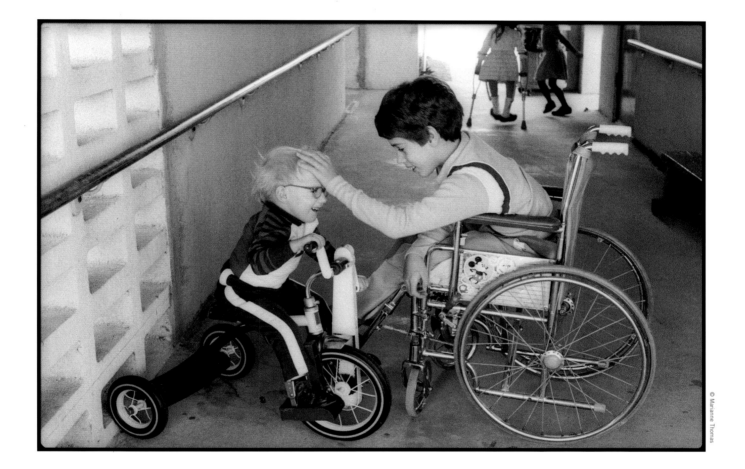

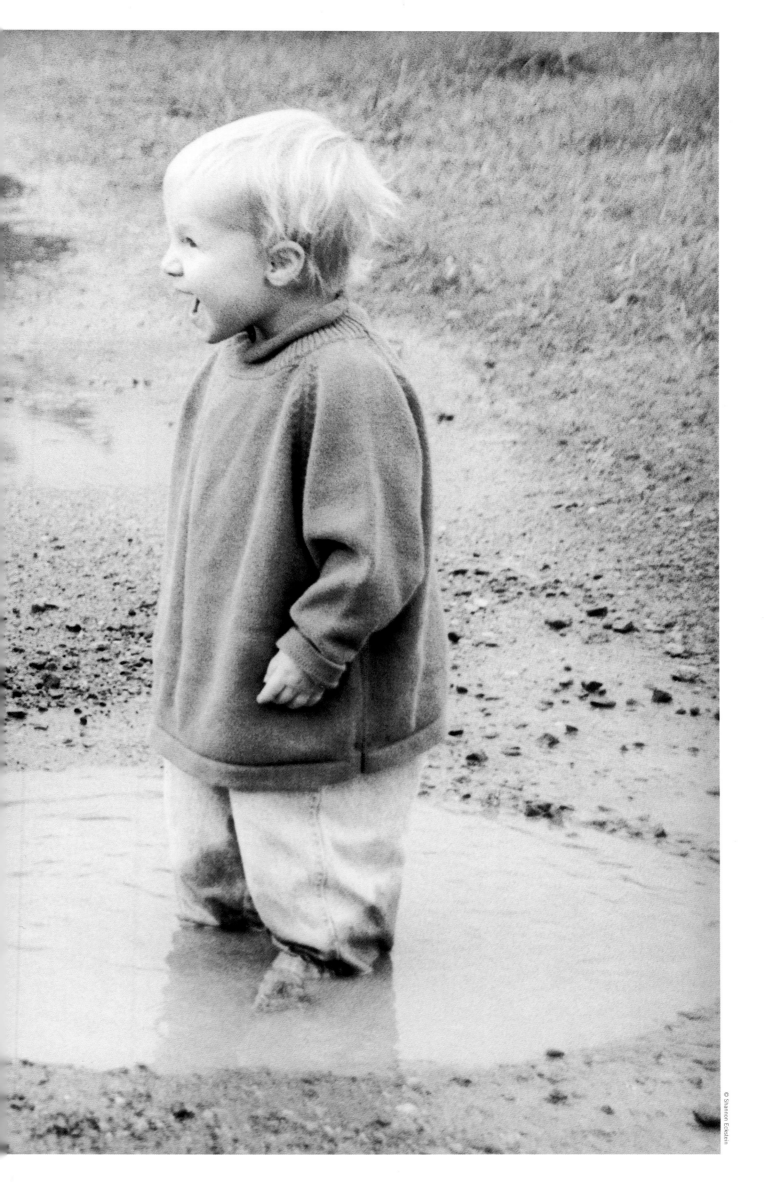

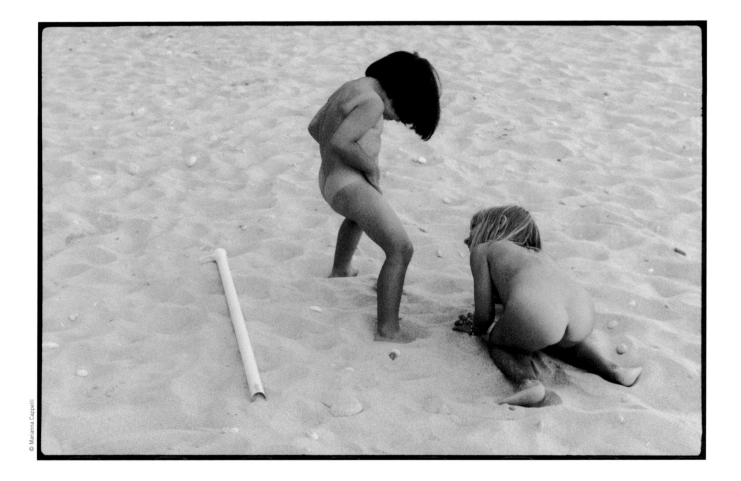

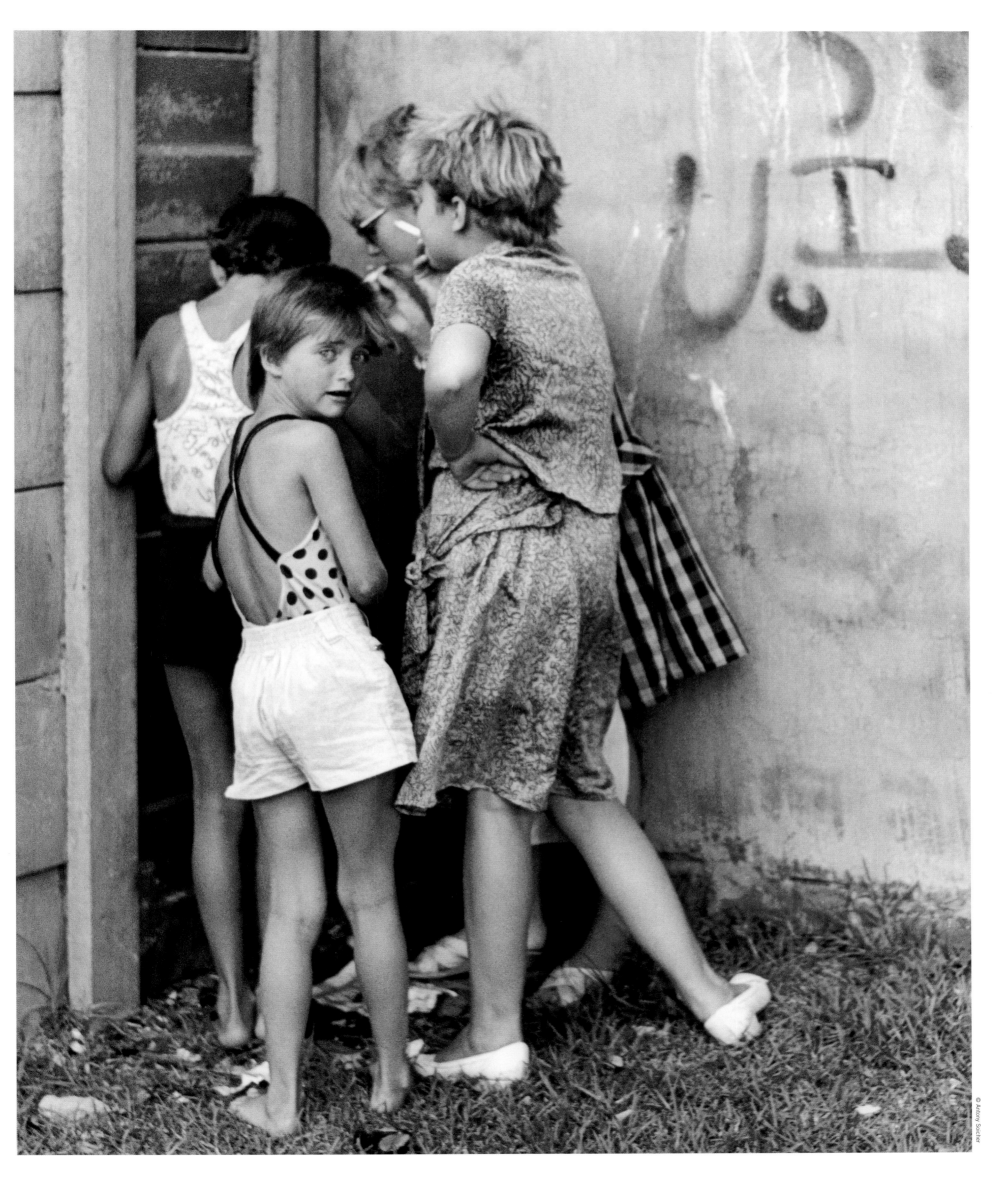

SHADOWS

FALL BEHIND YOU.

[MAORI PROVERB]

TURN YOUR FACE TO THE SUN AND THE

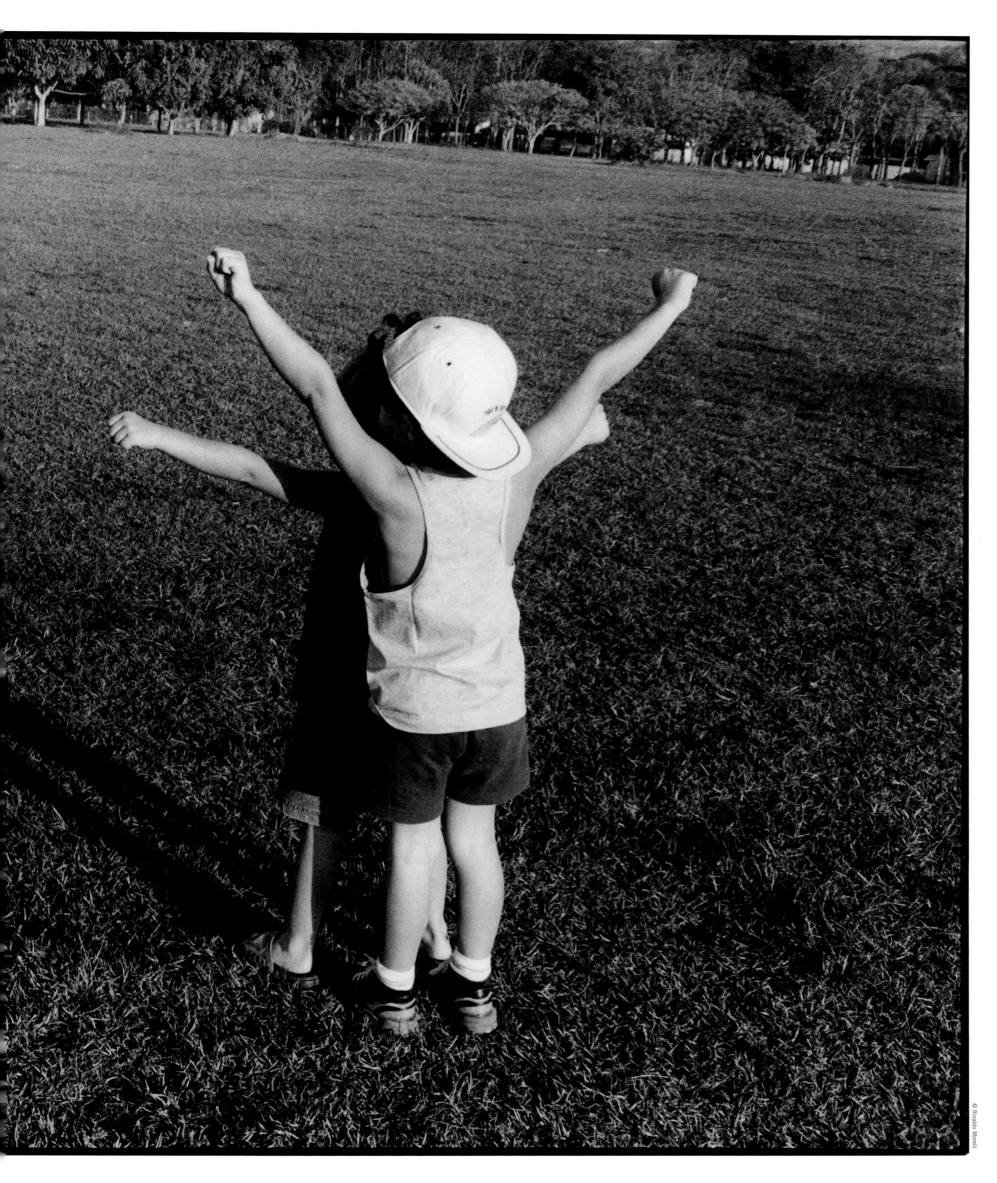

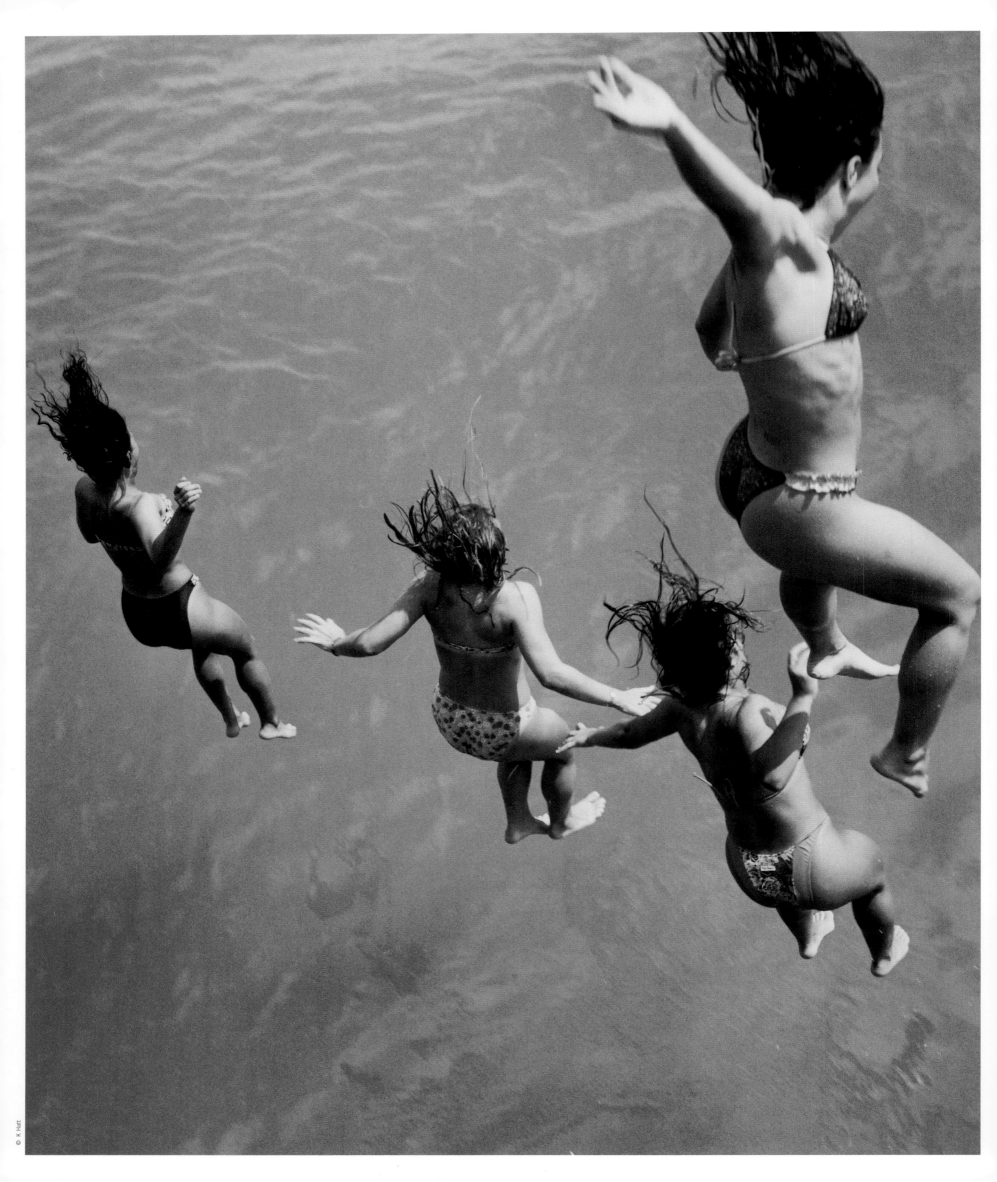

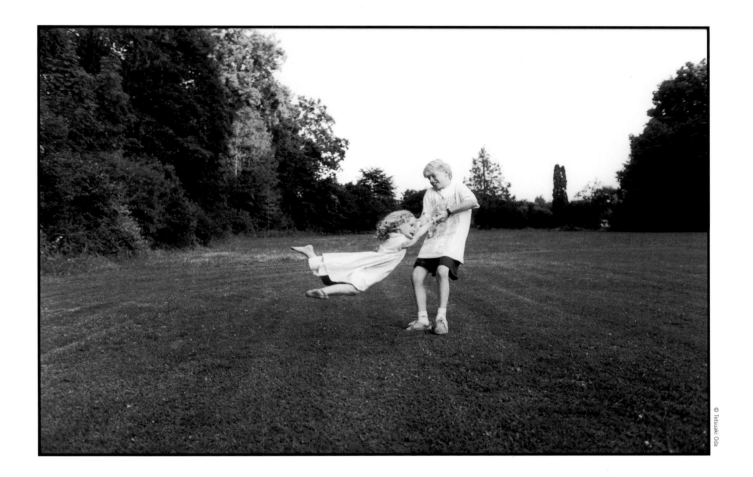

The best and most beautiful things in the world

cannot be seen or even touched. They must be felt with the heart.

[HELEN ADAMS KELLER]

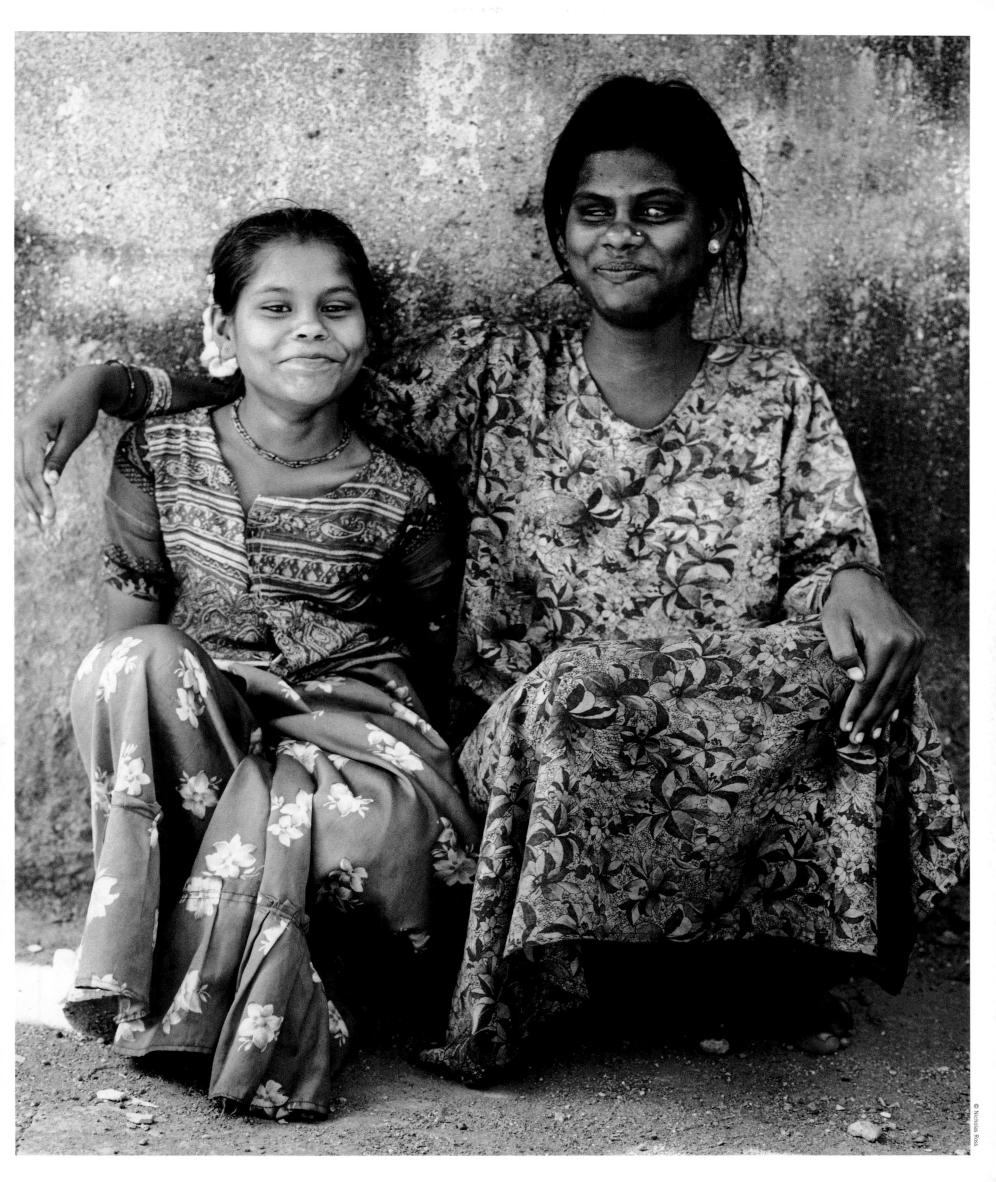

© Nicholas Ross

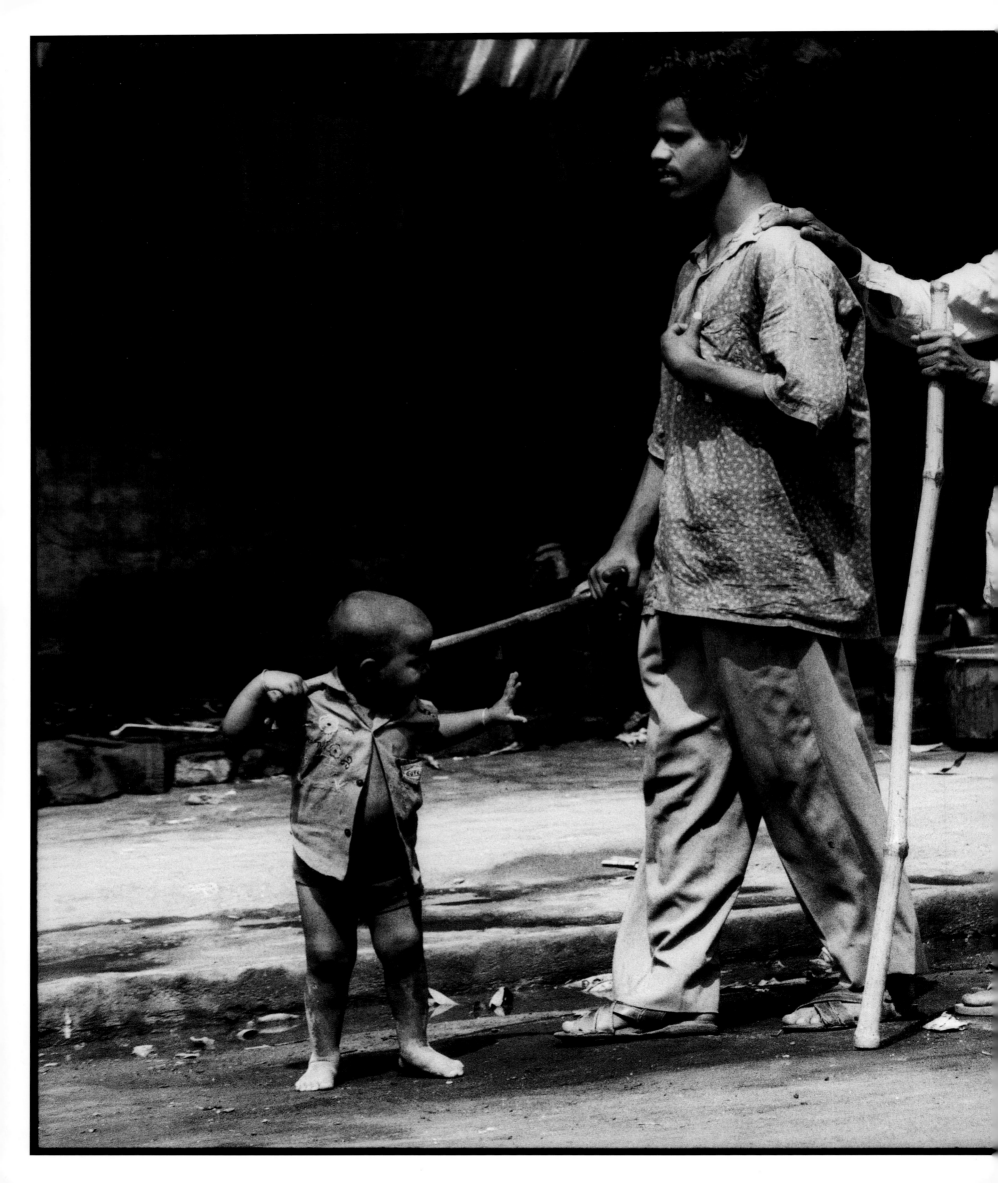

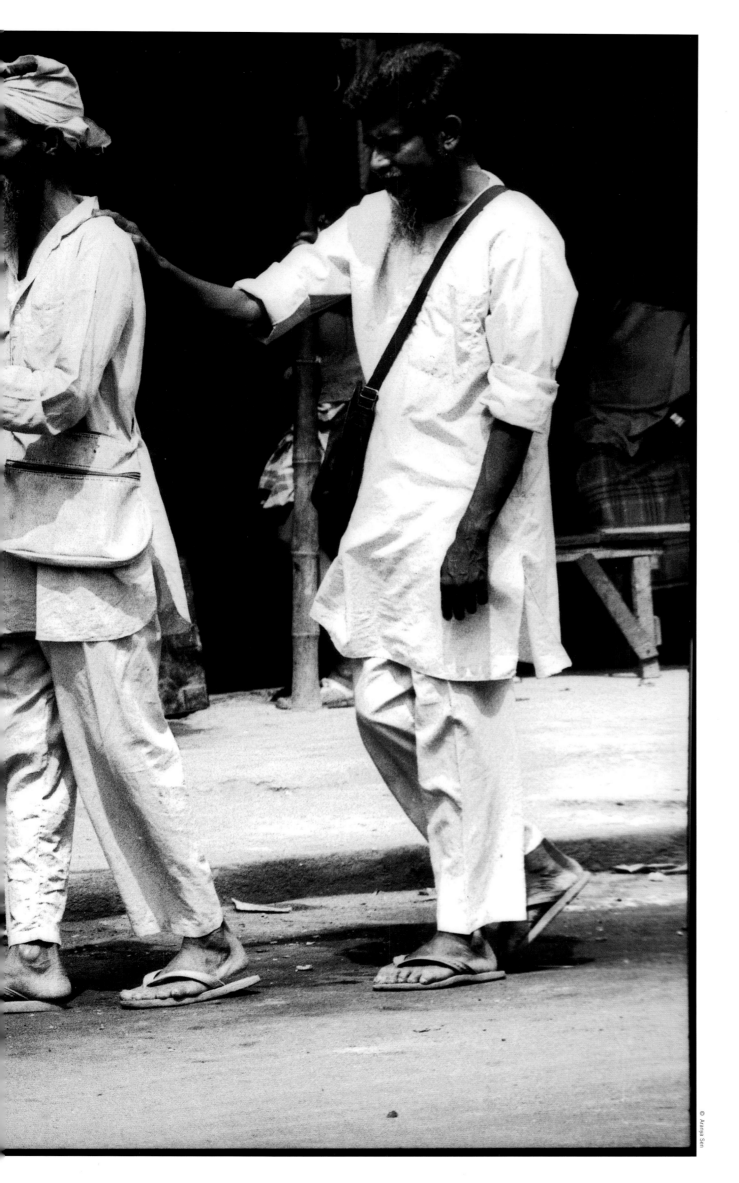

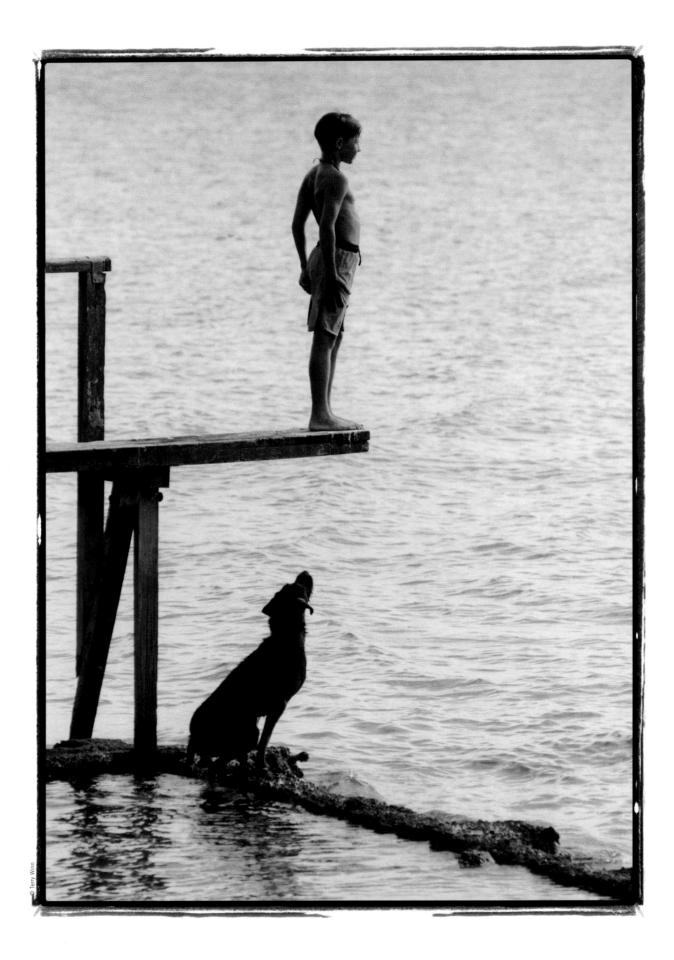

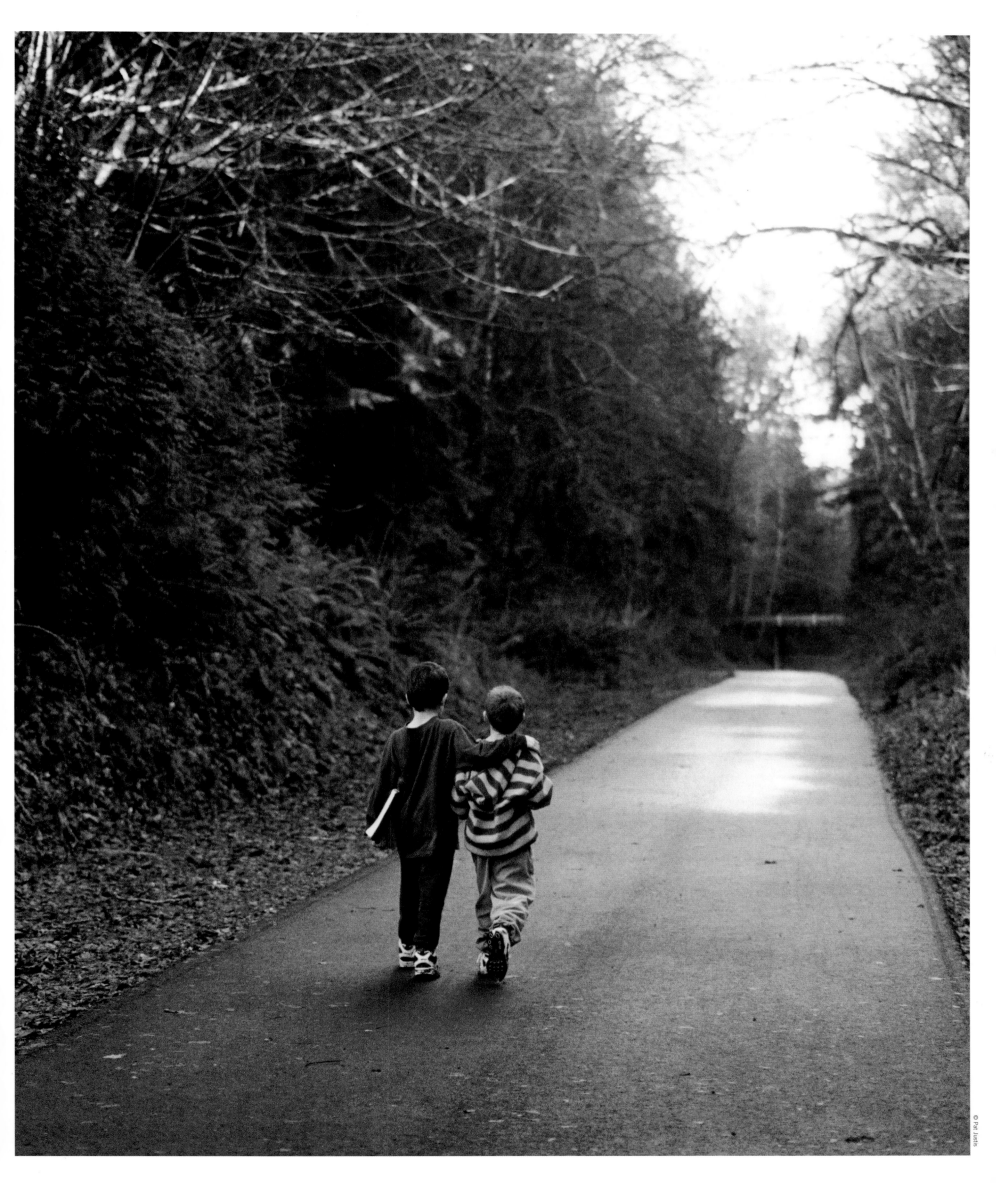

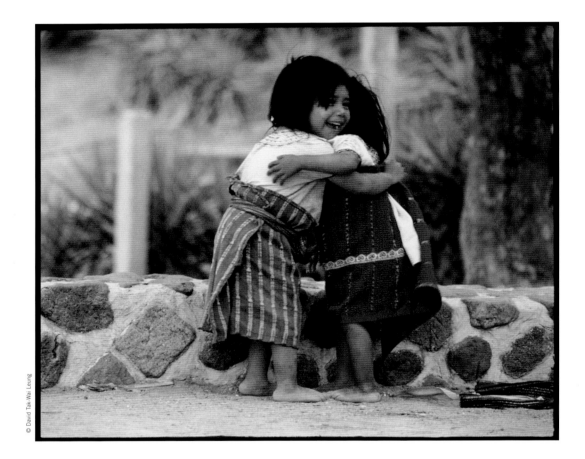

Hold a true friend with both your hands.

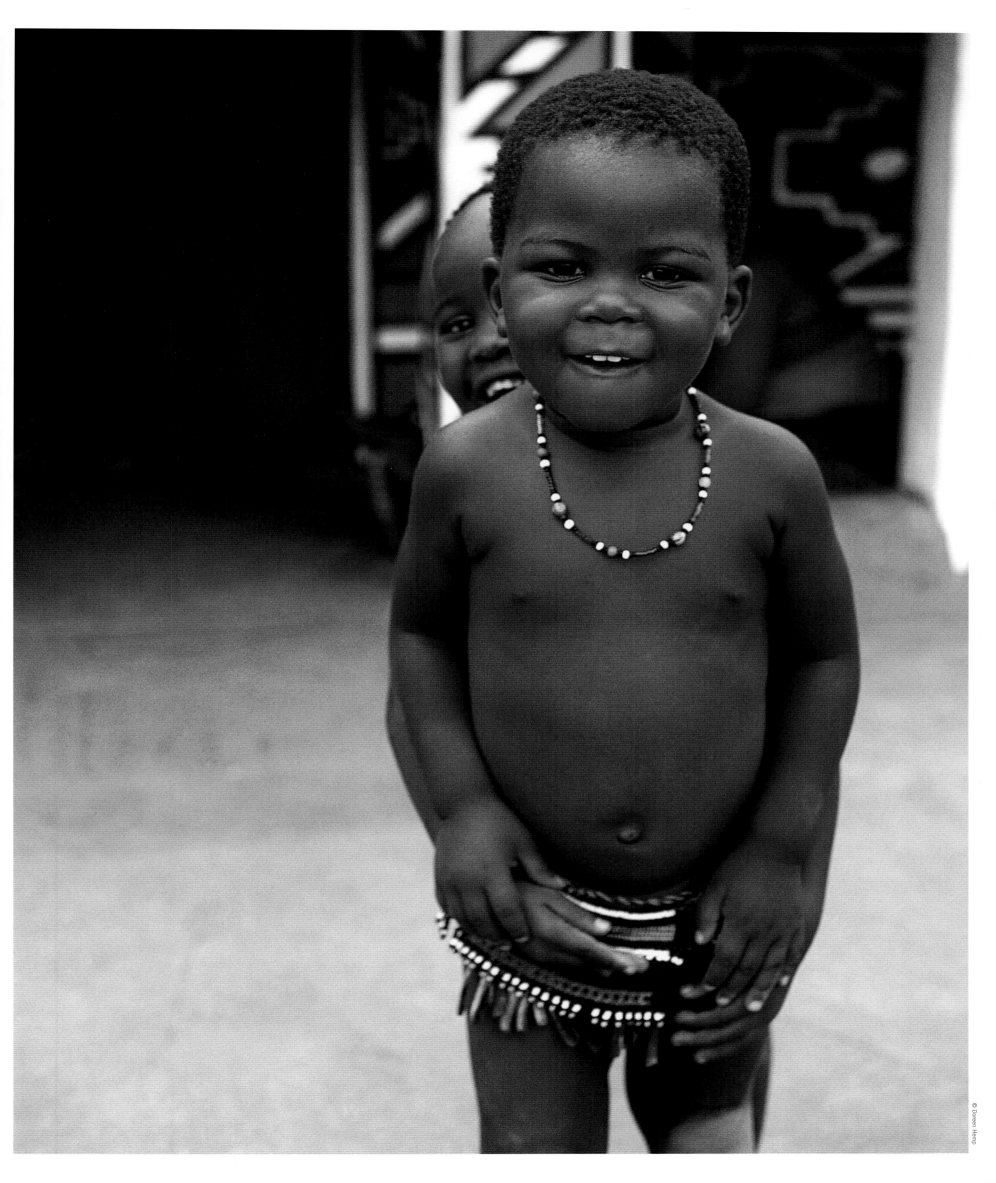

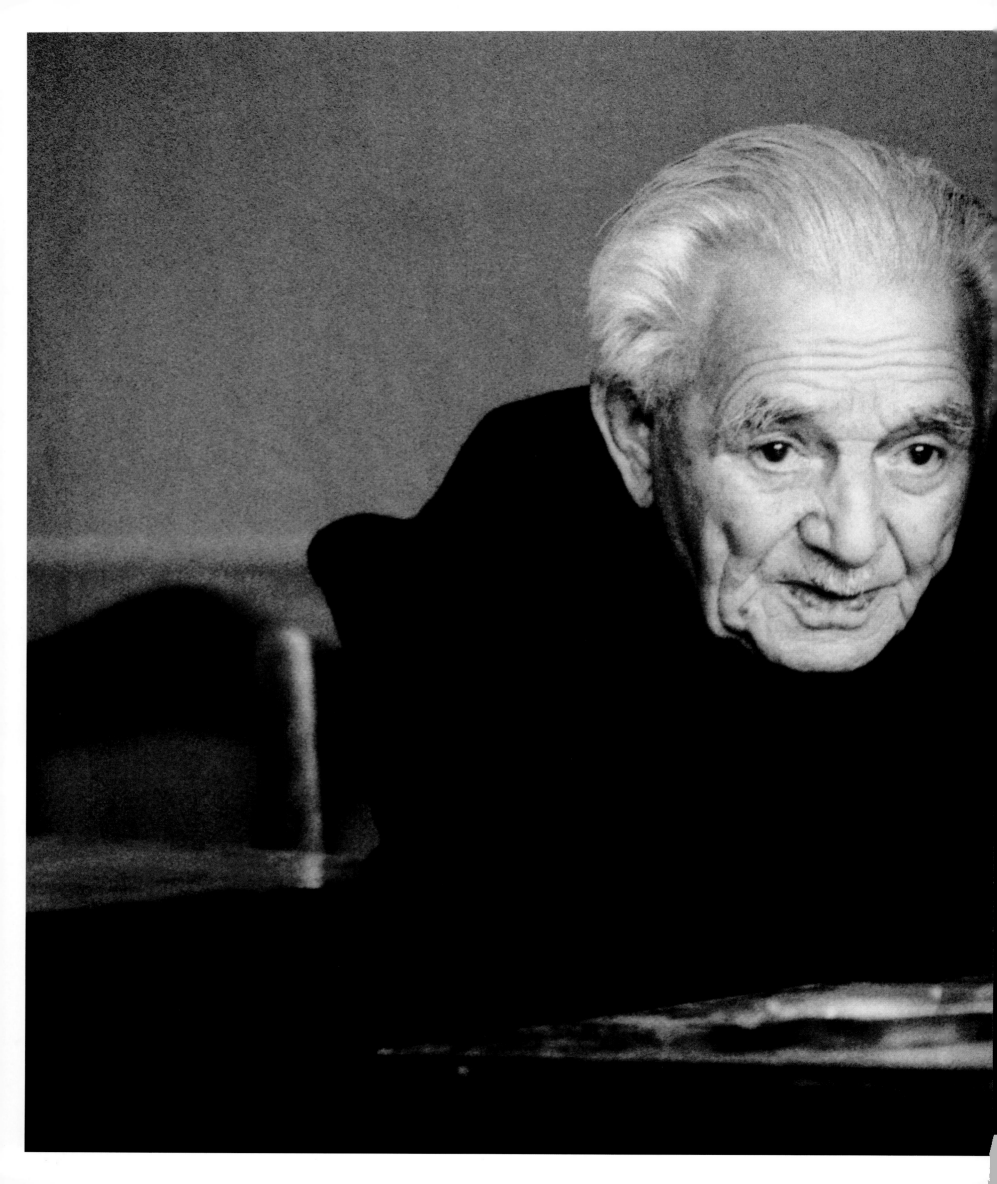

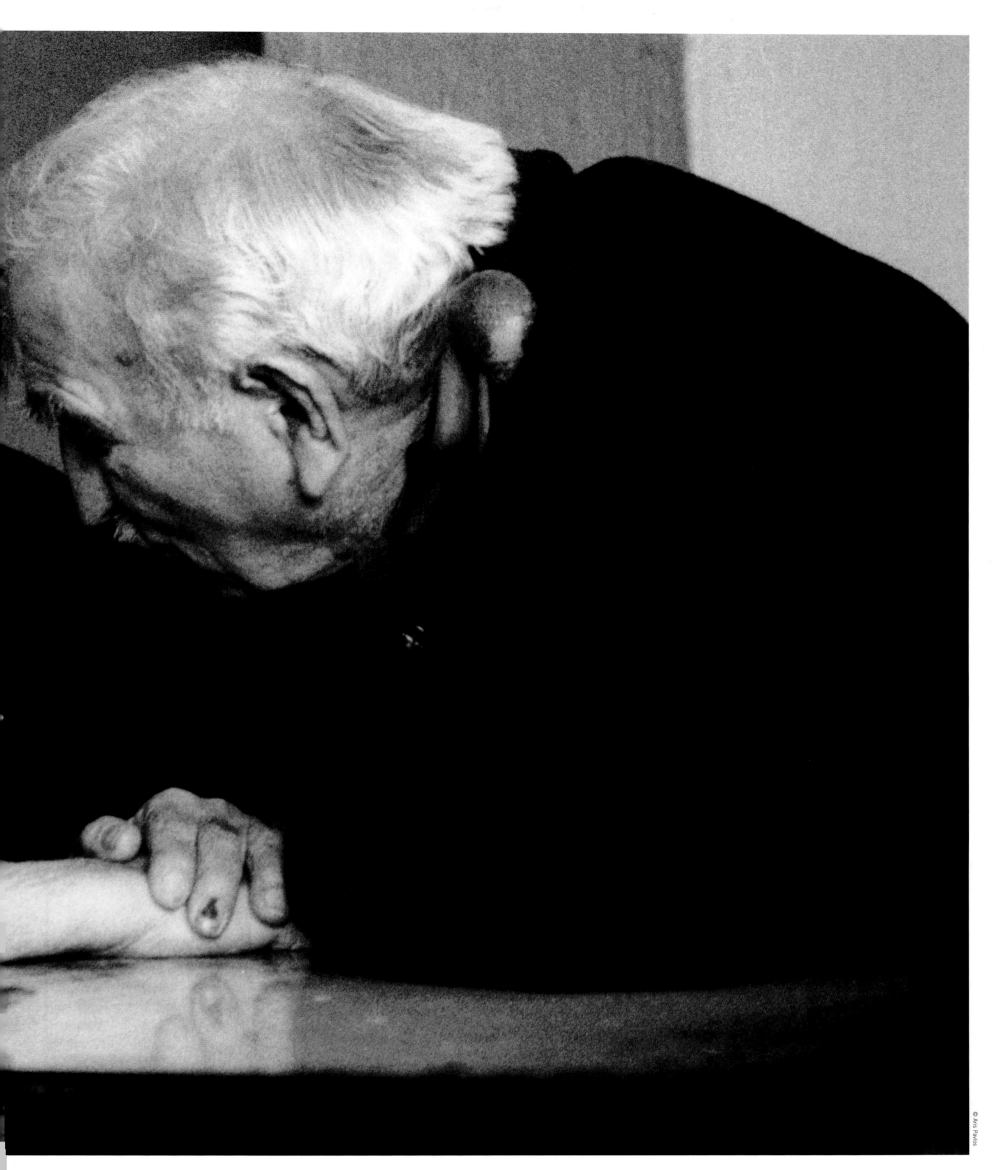

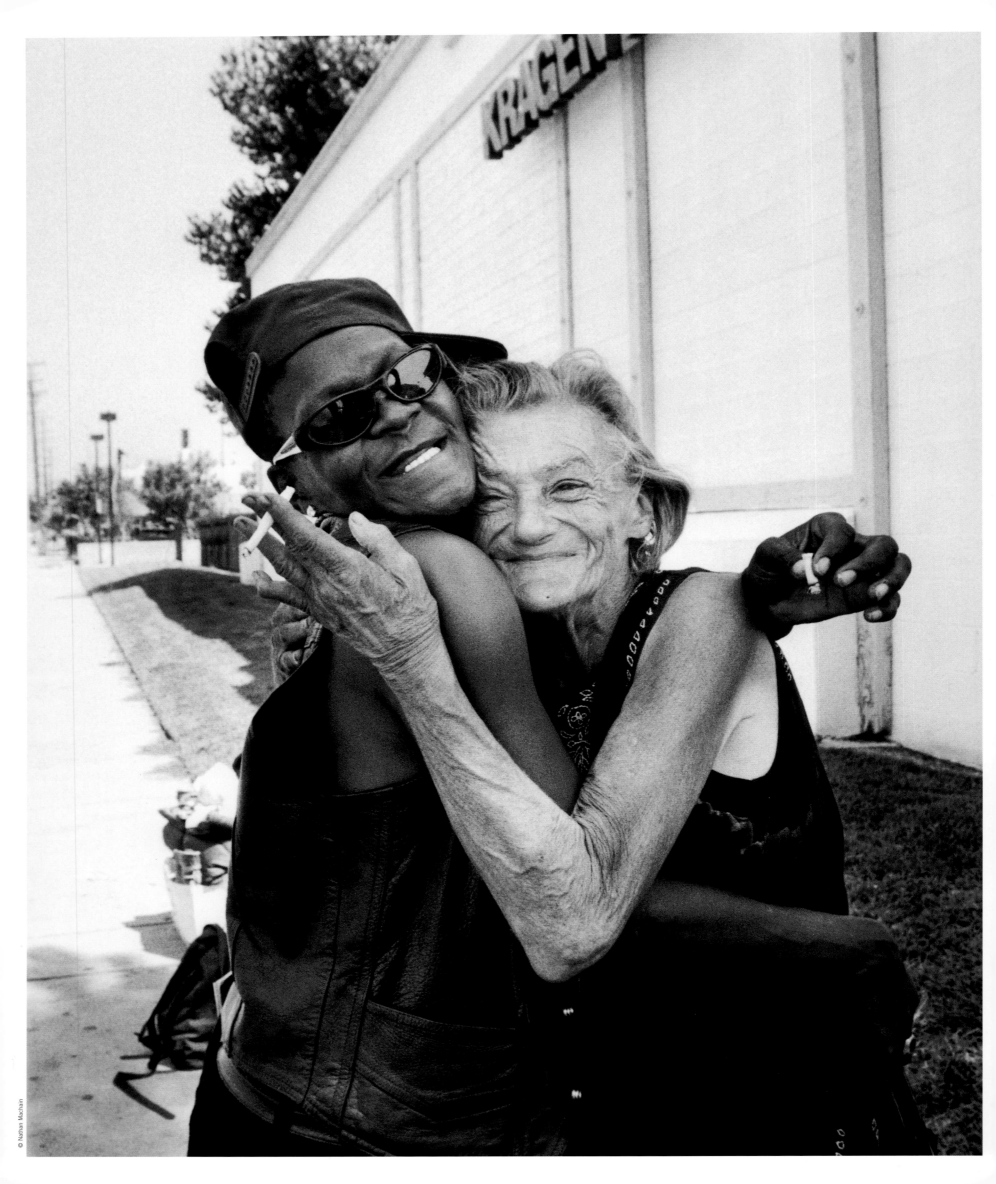

Don't walk in front of me, I may not follow.
Don't walk behind me, I may not lead.

Just walk beside me

and be my friend.

[ALBERT CAMUS]

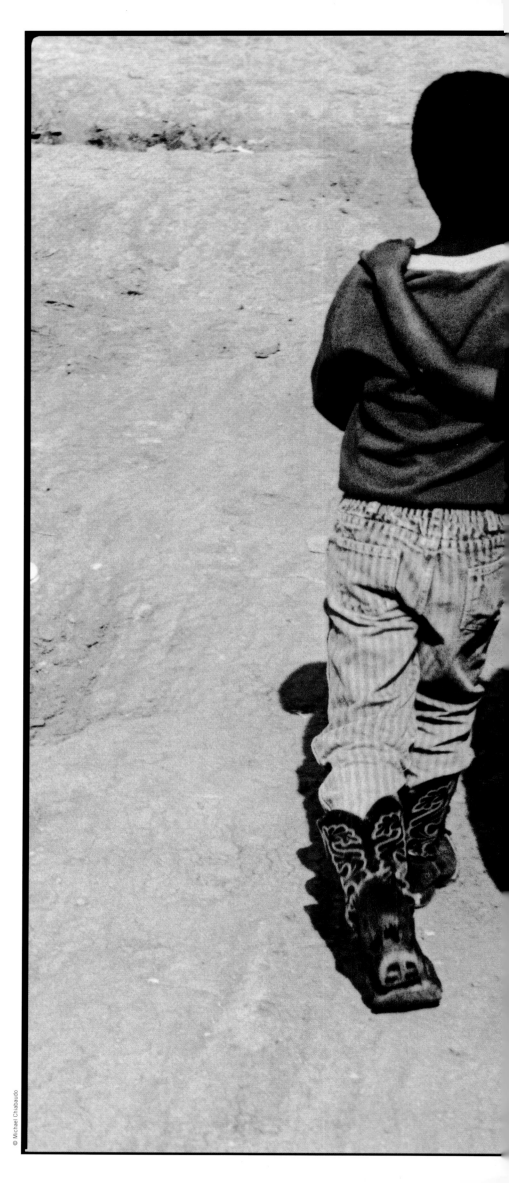

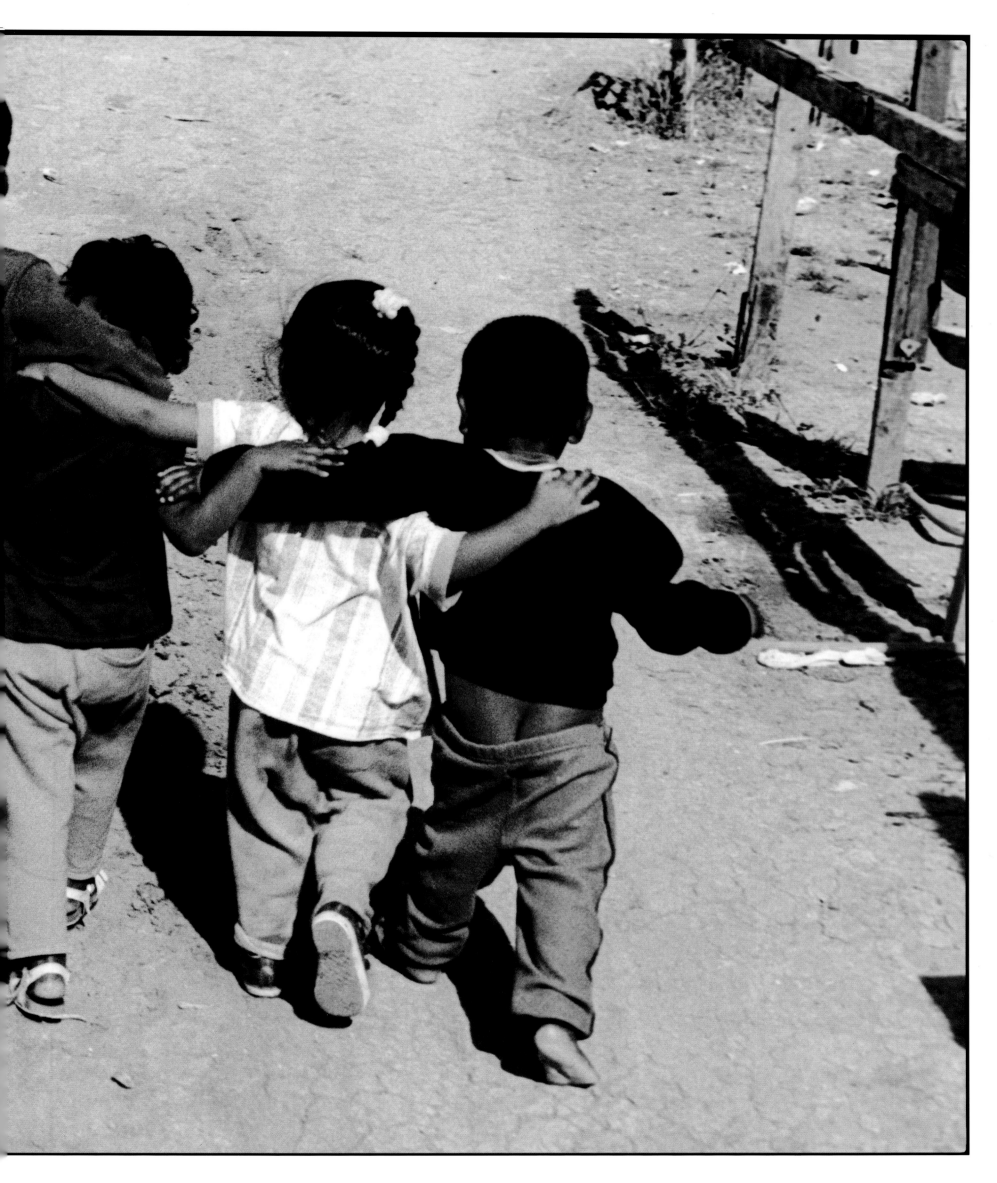

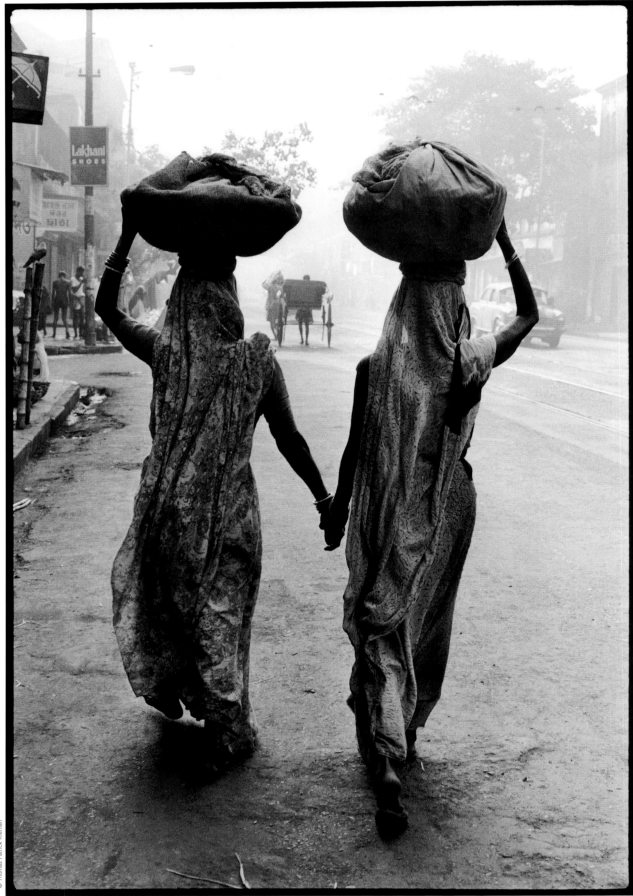

I have often wished that I could photograph

for ever something as wonderful and enriching as friendship,

so it is a joy to sit and leaf through picture after picture

by those who have done so.

(MAEVE BINCHY)

PHOTOGRAPHER BIOGRAPHIES

PHOTO CAPTIONS

Krassimir Andonov
BULGARIA

Krassimir Andonov was born in Bulgaria and studied at the National Academy of Theater and Film Arts in Sofia. He now works as an assistant in photography at the Academy and is also a professional member of the Union of Bulgarian Cinematographers. Krassimir was awarded first prize in the Declic Photo Competition in Paris in 1995 and first prize in the Coca-Cola Bulgaria Photo Competition in 1998.

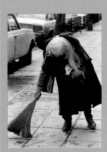

© 1997 Krassimir Andonov

The human touch – an old woman gently shelters a homeless dog from the frosty morning as she sweeps a pavement in Sofia, Bulgaria.

Nikon EM, 100 mm, Kodak T-max/135, Exp. f4.5-1/60

Kostas Argyris
GREECE

Kostas Argyris studied at the Aristotle University of Thessaloniki, Greece, where he became interested in photography and television production. Since 1986 he has been a full-time freelance photographer. He spent five years as resident photographer in the monastic state of Mount Athos and was the curator of the photographic archive there. Kostas is a founder member of the Greek photo agency Phaos.

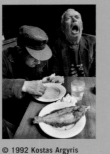

© 1992 Kostas Argyris

A Greek lunch companion can't disguise a yawn after a fishy repast in Thessaloniki.

Contax 167 MT, Kodak Tri-X/135, Exp. f5.6-1/60

Amit Bar
THE NETHERLANDS

Amit Bar was born on a kibbutz in Israel and went on to study creative art at the University of Haifa. He is now a freelance photographer and artist based in the Netherlands.

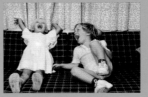

© 1986 Amit Bar

A comfortable sofa is the ideal spot for three-year-olds Allon and Tom to share laughter and play. The young friends live at the Kfar Hamaccabi Kibbutz in Israel.

Nikon FA, 35–70 mm, Ilford/135, Exp. N/A

Dharmesh Bhavsar
CANADA

Dharmesh Bhavsar has been a professional photographer for over 15 years. Originally based in India, he migrated recently to Canada and now lives in Ontario. He has participated in exhibitions around India and has won five international awards from UNESCO, Asahi Shimbun and Canon. Dharmesh has also contributed work to a book on street children for UNICEF.

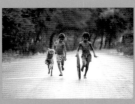

© 1999 Dharmesh Bhavsar

Free wheeling – a rolling wheel leads an energetic race for three companions on a deserted road in Baroda, India.

Nikon F3 HP, 4/80–200 mm, Kodak/135, Exp. N/A

Felix Bialy
ARGENTINA

Felix Bialy is a self-taught photographer living in Buenos Aires, Argentina. Since 1991 he has won more than 40 first or second prizes in national competitions. In 1996 he was awarded the El Condor FAF, the most prestigious photographic prize awarded by the Argentine Photography Federation. In 1997 he won first prize in the Sigma/Foto magazine competition in Spain and, in 1998, became an artist of FIAP, the International Federation of Photographic Art.

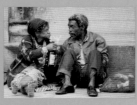

© 1982 Felix Bialy

Sharing a pavement and a bottle in Rio de Janeiro, Brazil.

Nikon F3, 80–200 mm, Fuji/135, Exp. f5.6-1/60

Gay Block
USA

Gay Block's photographic career began in 1975 and culminated in her landmark work with writer Malka Drucker, *Rescuers – Portraits of Moral Courage in the Holocaust*. This work was published as a book and also became a traveling exhibition which visited over 30 venues in the USA and around the world.

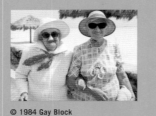

© 1984 Gay Block

In the bright sunshine of Miami, Florida, two friends make sure their noses are well protected as they stroll arm in arm along South Beach.

Pentax 6x7, 90 mm, Kodak VPS/220, Exp. f8-1/60

Romano Cagnoni
ITALY

Romano Cagnoni was born in Italy but moved to London, England, to study with photojournalism expert Simon Guttman. Romano was the first photographer admitted to North Vietnam in 1965 and since then has documented many world events for a range of international magazines. He has won the USA Overseas Press Award and numerous other prizes. Harold Evans, the former editor of the *Sunday Times* in London, mentions Romano among the seven most famous photographers in the world, in his book *Pictures on a Page*.

© 1985 Romano Cagnoni

High spirits on the road to Pietrasanta, Italy, as two teenage friends ride to the beach.

Leica 2M, 50 mm, Kodak/135, Exp. f8-1/125

Marianna Cappelli
ITALY

Marianna Cappelli was born in Naples, Italy. She now lives in Novaro where she pursues her interest in photography and the arts.

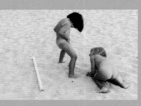

© 1996 Marianna Cappelli

The natural curiosity of the photographer's four-year-old daughter Martina and her friend Esther brings new discoveries on a beach in Sardinia, Italy.

Canon EOS 600, 35–70 mm, Ilford HP5 Plus/135, Exp. N/A

Lori Carr
USA

Lori Carr was born in the USA and began her photography career taking pictures for her high school yearbook. After studying at Columbia University in Chicago, she moved to California to freelance as a professional photographer. Currently Lori is based in Los Angeles where she photographs celebrities for the music, film and television industries.

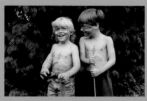

© 1991 Lori Carr

Body paint and childhood imagination bond young warriors Billy and Shaun in San Rafael, California, USA.

Leica M4, 50 mm, Kodak Tri-X/135, Exp. N/A

Mara Catalán
USA

Mara Catalán was born in Madrid, Spain. Today she lives in New York, USA, but travels widely with her photography. She has worked for, among others, the Spanish magazine *El Europeo*, the Chilean magazine *Cosas*, and Magnum Photos in New York. Mara has also worked as a photographer on numerous film projects and as a photo archivist at a museum in Chiapas, Mexico.

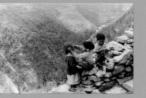

© 1998 Mara Catalán

High above the Annapurna Valley in Nepal, three children enjoy the simple pleasures of friendship. Perched on a precipice, the two young girls decorate their hair with freshly picked flowers.

Nikon F, 28 mm, Kodak Tri-X 400/135, Exp. N/A

Michael Chiabaudo
USA

Michael Chiabaudo is a full-time photographer from the USA. He is based in New York but travels regularly with his work. He is currently compiling a book of images he has photographed around the world.

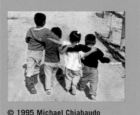

© 1995 Michael Chiabaudo

As his friends stride out along a dusty village street near Tijuana, Mexico, a young boy – and his trousers – try to keep up.

Nikon N90S, 28 mm, Kodak Tri-X/135, Exp. N/A

Claude Coirault
TAHITI

Claude Coirault was born in Guadeloupe in the French West Indies. He studied math, physics and languages at university in Paris before concentrating on his interest in photography. Claude has worked as a photographer in many different countries on a range of subject matter. Currently he is based in Papeete, Tahiti.

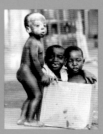

© 1975 Claude Coirault

A young boy – his face smeared with local medicine – soon forgets his illness when his friends arrive with their new toy, a cardboard box. This scene was captured on film in Abidjan in the Ivory Coast region of Africa.

Canon F1, 200 mm, Kodachrome/135, Exp. f5.6-1/125

Alvein Damardanto
INDONESIA

Alvein Damardanto was born in South Sumatra, Indonesia, and studied photography at the Modern School of Design in central Java. He has won several awards for his work in Indonesia and was nominated for the Bali International Photo Contest in 1999. Alvein also works as an independent documentary film-maker.

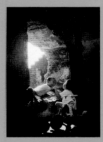

© 1999 Alvein Damardanto

After a game of soccer, two young players relive the moments of the match as they sit in the window of an old castle in Jogjakarta, Indonesia.

Nikon EM2, 28 mm, Kodak/135, Exp. N/A

Robin Sparks Daugherty
USA

Robin Sparks Daugherty began her career as a photographer in 1978 working on newspapers. Today she is a travel columnist, taking photographs and writing for the on-line magazine *EscapeArtist*. Robin's pictures and feature stories have appeared in over 50 magazines and newspapers, and her award-winning images have been shown in galleries throughout California. A permanent exhibition of her work is displayed at the Carson Valley Medical Center in Nevada, USA.

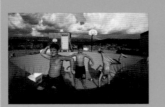

© 1994 Robin Sparks Daugherty

Bathing bravado – during a summer drought in New Mexico, USA, three friends prove that there is still fun to be had with only two inches of water in the pool.

Canon EOS 630, 20–35 mm, Kodak/135, Exp. f11-1/125

Reinhard David
AUSTRIA

Reinhard David was born in Vienna, Austria, and became interested in photography while studying at university. He now works as a freelance photographer and concentrates particularly on the themes of the Middle East, Africa and South-East Asia.

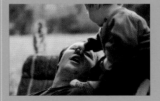

© 1999 Reinhard David

Young Jakob makes a memorable first impression when he is introduced to his Uncle Christian at a family party near Vienna, Austria.

Contax G2, 90 mm, Kodak T-max/135, Exp. f2.8-1/60

Thierry Des Ouches
FRANCE

Thierry Des Ouches is a self-taught freelance photographer based in France. He has developed a very personal photographic collection, notably through numerous exhibitions and books, including *Requiem*, *Femmes* and *Vaches*. Recently he has been working on a new publication, *France*, and pictures from this collection will be displayed in the National Library of France.

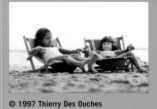

© 1997 Thierry Des Ouches

This is the life – young sun worshippers Diane and Audrey take it easy on the beach in Noirmoutier, France. Their photographer father captures the scene.

Canon EOS 1, 2.8/300 mm, Kodak/135, Exp. N/A

Duc Doan
VIETNAM

Duc Doan was born in Cam Pha, Vietnam. He is still based in the same town and has worked as a photographer for over 20 years.

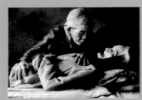

© 1993 Duc Doan

A fond farewell as an 88-year-old Vietnamese woman says goodbye to her childhood friend, close to death at the age of 92. This moment was captured on film in Ha Long city in the Quang Ninh province of Vietnam.

Minolta H-matic 7S, 45 mm, Cbema Poto 64/135, Exp. f5.6-1/30

Shannon Eckstein
CANADA

Shannon Eckstein was born in Canada and spent seven years traveling around the world before returning to Vancouver. In 1998 she set up her own company, Silvershadow Photographic Images, which specializes in innovative black and white photography for a wide range of clients.

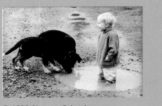

© 1998 Shannon Eckstein

The rain has stopped in Chilliwack, British Columbia, Canada, and 18-month-old Kiana can't wait to explore a new puddle with the help of her puppies, Tasia and Belle.

Nikon F90X, 70–200 mm, Kodak Tri-X 400/135, Exp. f5.6/8-1/200

Paz Errázuriz
CHILE

Paz Errázuriz is a self-taught photographer from Santiago, Chile. She studied education at the Catholic University in Santiago and, after graduation, worked as a primary school teacher. After leaving the teaching profession, she became an independent photographer for magazines and Fundacion Andes. She was awarded a Guggenheim Fellowship in 1987, and has had two books published.

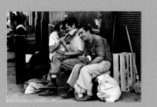

© 1991 Paz Errázuriz

Outside Santiago market in Chile, three cigarette sellers find that old crates make excellent seats when you want to catch up with friends.

Nikon F2, 80 mm, Kodak Tri-X/135, Exp. f8-1/60

Katherine Fletcher
USA

Katherine Fletcher holds a Bachelor of Fine Arts degree in photography. She runs her own business, Unforgettable Images, in Omaha, Nebraska, specializing in journalistic wedding photography.

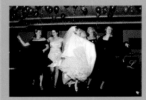

© 1999 Katherine Fletcher

Wedded bliss in Omaha, Nebraska, USA – inhibitions are shed as new bride Stephanie and her friends get into party mood.

Canon A2, 28–70 mm, Kodak/135, Exp. f8-1/90

William Foley
USA

William Foley is a Pulitzer Prize winning photojournalist. After studying at Indianapolis University in the USA, he worked for the Associated Press and *Time* magazine in Cairo, Egypt, and in Beirut, Lebanon. He won the Pulitzer Prize for Spot News photography in 1983 for a series of images taken in Beirut, and his work has been published in every major publication around the world. After working in 48 different countries, William is now based in New York where he works as a freelance photographer.

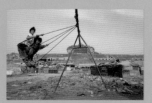

© 1993 William Foley

The sky's the limit for two young girls in Beirut, Lebanon. Their playground is an old sports stadium which became home to hundreds of refugees following the Israeli invasion of 1982.

Canon T90, 35 mm, Fuji/135, Exp. f5.6-1/250

Pepe Franco
USA

Pepe Franco's interest in photography began when he bought his first camera with money he earned as a bricklayer. After studying sociology at college, he decided to follow a career in photography. He has been a professional photojournalist since 1984, working mainly in Spain, but with recent assignments in Mexico and the USA.

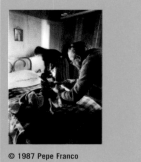

© 1987 Pepe Franco

Trusted companion – in Madrid, Spain, an elderly man sings to his devoted dog while a social worker continues quietly with her chores.

Canon F1, 28 mm, Kodak/135, Exp. N/A

Bill Frantz
USA

Bill Frantz studied at the Arts Institute of Chicago, USA. After graduation, he worked as an associate staff photographer and studio manager on *Playboy* magazine for seven years. He then moved to Wisconsin and became a freelance photographer. Currently he works as a product/industrial photographer but also undertakes wedding and general commercial photography.

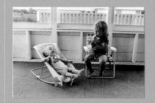

© 1981 Bill Frantz

Music to the ears – budding saxophonist Sarah, aged two, entertains her baby sister, Leslie, in Wisconsin, USA.

Bronica ETRS, 2.8/75 mm, Kodak Vericolor/120, Exp. N/A

Peter Gabriel
USA

Peter Gabriel was born in South Korea and later moved to Austria with his family. He studied medicine in Vienna and then traveled to the USA where his interest in photography began. Peter now works as a photographer based in New York.

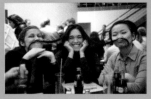

© 1999 Peter Gabriel

A fashion-conscious trio discover the perfect accessory as they sit in a café in New York.

Contax T2, 38 mm, Ilford Delta 400/135, Exp. f4-1/15

David M Grossman
USA

David M Grossman is a freelance photographer based in New York. He specializes in photographing people and has worked for a range of clients including magazines, the advertising industry, and the health care sector. David's work is represented in public and private collections.

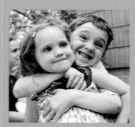

© 1998 David M Grossman

Brother and sister – six-year-old Ethan gives four-year-old Emory an enthusiastic hug at a birthday party in Brooklyn, New York.

Canon T90, 28 mm, Kodak Tri-X/135, Exp. N/A

Mikolaj Grynberg
POLAND

Mikolaj Grynberg trained as an education psychologist before becoming a professional photographer in 1990. Currently he specializes in taking photographs for the advertising industry in Warsaw, Poland. Mikolaj was awarded first prize in the 1993 Polish Press Contest, as well as first and second prizes in the 1995 Ilford photographic competition.

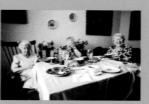

© 1999 Mikolaj Grynberg

In Warsaw, Poland, Madame Falk's 90th birthday provides the perfect excuse for a tea party. Old friends Madame Malik, 89, and Madame Krauze, 80, share in the celebrations.

Leica M6, 21 mm, Ilford HP5/135, Exp. f2.8-1/30

Mark Edward Harris
USA

Mark Edward Harris graduated with a Master of Arts degree from California State University, USA, and is now a photographer, writer and teacher based in Los Angeles. He has won many awards. His work has appeared in publications including *Time*, *Life*, *Vogue* and *People*. His book *Faces of the Twentieth Century: Master Photographers and Their Work* won Photography Book of the Year at the New York Book Show in 1999.

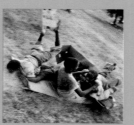

© 1999 Mark Edward Harris

Downhill racers – a cardboard box provides thrills and spills for a group of friends on a hillside in Memphis, Tennessee, USA.

Nikon N90S, 35 mm, Kodak Tri-X/135, Exp. f4-1/60

Gail Harvey
CANADA

Gail Harvey of Toronto, Canada, was one of the first women to be hired by United Press as a staff photographer in the late 1970s. After completing a critically acclaimed photo book on Terry Fox, a one-legged runner who ran across Canada, she worked as a freelancer for various Canadian and international magazines. At the same time, Gail pursued her own photographic projects and has held 10 solo gallery exhibitions.

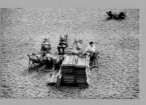

© 1979 Gail Harvey

Circle of friends – on a cold day on the beach at Brighton, on England's south coast, a group of pensioners warm to each other's company.

Canon A1, 85 mm, Kodak Tri-X/135, Exp. f5.6-1/250

K Hatt
USA

K Hatt was born in London, Canada, and became interested in photography in high school. He moved to New York, USA, and worked as a photo assistant for a number of popular fashion photographers before launching his own career in fashion and portrait photography.

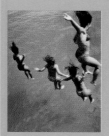

© 1993 K Hatt

Free fall – four bikini-clad friends leap off a pier into the water below in Miami, Florida, USA.

Fuji 645S, 75 mm, Kodak Tri-X/120, Exp. f8-1/250

Linda Heim
USA

Linda Heim lives in Delmar in Albany, USA, and was trained as a physical education teacher. She is a serious amateur photographer and enjoys capturing a range of subject matter on film.

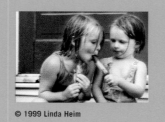

© 1999 Linda Heim

Taste testing in Averill Park, in New York state, USA – five-year-old Abigail is curious to see whether Samantha's lollipop has a different flavor from her own.

Canon T90, 28–200 mm, Kodak/135, Exp. N/A

Doreen Hemp
SOUTH AFRICA

Doreen Hemp is a photographer based in South Africa. She holds a Masters Degree in fine arts and often incorporates photography into her artwork. Her photographs have appeared in a variety of South African books and magazines.

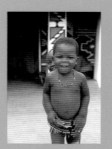

© 1993 Doreen Hemp

Two of a kind – dressed in the traditional beaded loincloths and necklaces of their tribe, two Ndebele children play outside their home in Kwandebele, South Africa.

Pentax K1000, 50 mm, Fujichrome/135, Exp. f5.6-1/60

Andreas Heumann
UK

Andreas Heumann was born in Germany and educated in Switzerland. Andreas's images are in the collections of the Victoria and Albert Museum in London, the Kodak Museum of Photography in Rochester, USA, and numerous private collections. He has won many awards including Agfa Picture of the Year 1994, Communications Arts Award of Excellence 1994 and six Gold Awards from the Association of Photographers UK.

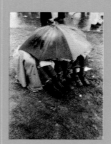

© 1972 Andreas Heumann

Taking cover – three young friends share the shelter of an umbrella as they wait patiently for an open-air rock concert to begin in London, England.

Leica M4, 35 mm, Kodak/135, Exp. N/A

Philip Hight
USA

Philip Hight was born in Tennessee, USA, and is a graduate of the Middle Tennessee State University. He works as a commercial photographer based in Nashville.

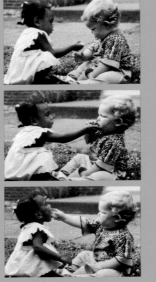

© 1992 Philip Hight

Pass the ice – young playmates, Precious and Alex, find that sharing ice cubes is the perfect way to keep cool on a hot summer day in Nashville, Tennessee, USA.

Pentax SF1, 35–70 mm, Kodak T-max/135, Exp. N/A

Jon Holloway
USA

Jon Holloway is a Master of Fine Arts graduate and a professional photographer based in South Carolina, USA. His work has been featured in over 30 solo exhibitions and he has received many awards, including prizes from *Nature* and *National Geographic* magazines.

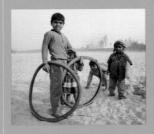

© 1998 Jon Holloway

The future and the past – Indian children turn old tires into new toys as they play, with the historic Taj Mahal visible in the background.

Pentax 67, 55 mm, Ilford FP4/120, Exp. N/A

John A Hryniuk
CANADA

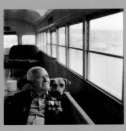

John A Hryniuk began his freelance photography career by working for Reuters News Agency and the Canadian daily newspaper the *Toronto Star*. Currently he works as a location portrait photographer based in Toronto and his images have appeared in publications including *Stern*, the *New York Times* and *Reader's Digest*.

© 1998 John A Hryniuk

A retired Canadian war veteran shares a pensive moment with a close companion, near Ottawa, Ontario, Canada. Home is an old school bus which he shares with 15 energetic dogs.

Hasselblad 500, 4/80 mm, 120, Exp. f4-1/15

Faisal M D Nurul Huda
BANGLADESH

Faisal M D Nurul Huda works as an administration officer at the European Commission Food Security Unit in Bangladesh. He graduated with an English language degree and has been an enthusiastic amateur photographer since 1991.

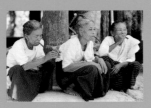

© 1998 Faisal M D Nurul Huda

To celebrate their reunion after six years, cousins from the Marma tribe in Bangladesh smoke traditional hand-made cigars. The youngest woman made the cigars especially for this occasion – to share as a time-honored token of friendship and love.

Nikon F3, 105 mm, Fuji Neopan SS/135, Exp. f5.6-1/125

Roy Hyrkin
USA

Roy Hyrkin was a public relations photographer at the State University of New York in Middletown, USA, and now works as a fine art photographer. His vintage prints are included in the George Eastman House International Museum of Photography in Rochester, New York state, and the New York Public Library, as well as in private collections throughout the USA.

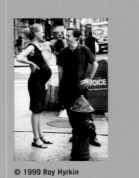

© 1999 Roy Hyrkin

Friends meet on a street in New York.

Canon EOS 1N, 28–105 mm, Kodak T-max 400/135, Exp. f6.3-1/125

Davy Jones
UK

Davy Jones was born in Liverpool, England, and studied politics, Russian and Soviet studies at the city's university. He moved to London to work as a photographer's assistant for four years and is now a professional photographer specializing in reportage.

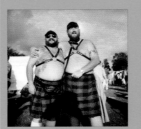

© 1997 Davy Jones

Two kilted friends stand out from the crowd at the Gay Pride Festival in London, England.

Rolleiflex T, 80 mm, Ilford HP5/120, Exp. N/A

Lance Jones
USA

Lance Jones was born in Seoul, Korea. He graduated with an arts and photography degree from Earlham College in Richmond, USA, and currently works as a freelance photographer based in West Rutland, Vermont, USA.

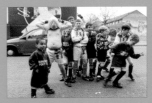

© 1997 Lance Jones

Friendship means playing on the same side – a young soccer team in Belfast, Northern Ireland.

Canon EOS, 35–80 mm, Kodak TMY/135, Exp. N/A

Damrong Juntawonsup
THAILAND

Damrong Juntawonsup studied at Ramkhumheang University in Thailand where he graduated with a Master of Education Technology degree. Today he is the director of a stock image business and a freelance photographer based in Bangkok, Thailand.

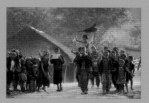

© 1999 Damrong Juntawonsup

Hail the hero – in a rural village in the Chiangrai province of Thailand, children cheer home the winner of a running race.

Canon EOS 1N, 70–100 mm, Fuji Velvia/135, Exp. f5.6-1/125

Pat Justis
USA

Pat Justis is a self-taught photographer and writer based in Olympia, Washington, USA. Her work has appeared in publications including *Shots*, *Hope* and the *Sun*, as well as in the Northwest International Exhibition of Photography and several solo shows.

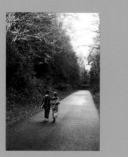

© 1999 Pat Justis

A country lane in Olympia, Washington, USA, becomes an adventurous path for childhood friends Keegan, aged six, and Graeme, seven.

Pentax P30T, 90 mm, Ilford Delta 400/135, Exp. N/A

Sombut Ketkeaw
THAILAND

Sombut Ketkeaw is a professional photographer based in Phanatnikhom Chonburi in Thailand. He works as the manager of a studio which specializes in wedding, portrait and family photography, as well as photo bank images. Sombut has participated in several photographic exhibitions in his home country.

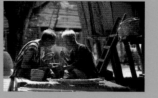

© 1999 Sombut Ketkeaw

Uncle Yoo, 67, and Uncle Song, 72, unwind over a pot of "uh" – a traditional alcoholic drink – after a long day's work in the countryside of Nakornpanom, Thailand.

Canon EOS 1N, 70–200 mm, Fuji Velvia/135, Exp. f5.6

Thomas Patrick Kiernan
IRELAND

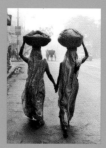

Thomas Patrick Kiernan was born in Ireland and developed an interest in photography after seeing Cartier-Bresson and Kertesz exhibitions in New York. In between summer jobs, Thomas pursues his passion for photography by working in India and Egypt.

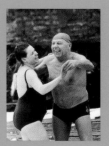

© 1996 Thomas Patrick Kiernan

Graceful under a heavy load – two Indian women walk side by side as they carry vegetables to market in Calcutta, India.

Olympus OM 1N, 1.8/50 mm, Kodak Tri-X 400/135, Exp. f11/16-1/250

Paul Knight
NEW ZEALAND

Paul Knight is a lecturer in Japanese at Massey University in Palmerston North, New Zealand. A keen photographer, he traveled to Japan on a UNESCO grant in 1960, a move which stimulated a fascination with capturing the Japanese culture on film. He has since spent a five-year period in Japan with the resulting photographs appearing in exhibitions and as part of a national tour.

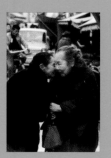

© 1967 Paul Knight

In the small, bustling town of Wajima in Japan, a local resident is eager to pass on the latest news to her friend.

Asahi Pentax, 105 mm, Kodak Tri-X/135, Exp. N/A

Viktor Kolar
CZECH REPUBLIC

Viktor Kolar has been a freelance photographer since 1984, and in 1991 he won the *Mother Jones* International Photography Award. Since 1994, he has been working as lecturer in documentary photography at FAMU Academy of Performing Arts in Ostrava, Czech Republic.

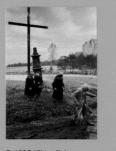

© 1992 Viktor Kolar

Church-goers make their way carefully to mass in Karvina, Czech Republic. Their nearby church gradually sank 27 meters following long-term mining in the town. The five women, all over 70, have been part of the congregation for over 40 years. They always stop to pray at this cross, erected in 1989 after the Velvet Revolution.

Leica M4, f35, Kodak Tri-X/135, Exp. f11-1/250

Yorghos Kontaxis
USA

Yorghos Kontaxis is a fine arts graduate from the School of Visual Arts in New York, USA. As well as 13 years of stage acting experience in Greece, he has had a varied photographic career in the USA. Yorghos has held many solo and group exhibitions in the USA. He is also recipient of the Award of Excellence from *Newsweek* magazine, the Award of Merit from *Time/Life* magazine and the Artistic Achievement Award from the International Syros Rotary Club.

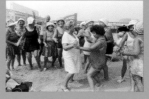

© Yorghos Kontaxis [Date N/A]

Coney Island in New York, USA – six friends turn a sandy beach into a dance floor to the delight of their enthusiastic audience.

Nikon FM2, Nikkor 24 mm, Kodak Tri-X/135, Exp. f8-1/125

Vladimir Kryukov
RUSSIA

Vladimir Kryukov was born in Moscow, Russia, and studied journalism at the Moscow State University. After graduation, he worked as staff photographer on the *Soviet Union* magazine for nine years and then set up his own company in 1990. Vladimir won the grand prize in the Golden Lens Award in Belgium in 1989 and has held two personal exhibitions in Moscow. He is founder of the Russian professional photography website "Photodome."

© 1998 Vladimir Kryukov

After a swim in the chilly waters of a Moscow river, a Russian couple steal the show with a display of affection.

Nikon FM2, 2.8/300 mm, 135, Exp. f5.6-1/250

Martin Langer
GERMANY

Martin Langer was born in Gottingen, Germany, and today lives in Hamburg. He studied photojournalism and photographic design in Bielefield and currently works as a freelancer for newspapers and publishing companies.

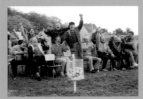

© 1995 Martin Langer

In Germany, joy and relief unite supporters of the Marienborn soccer team after a goal is scored.

Nikon F2A, 85 mm, Kodak/135, Exp. f4-1/90

David Tak-Wai Leung
CANADA

David Tak-Wai Leung has been an enthusiastic amateur photographer for over 30 years. His interest in photographing nature and the survival of ancient cultures has encouraged him to travel widely, including visits to Tibet, China, Central America and Micronesia.

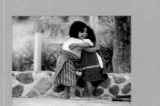

© 1999 David Tak-Wai Leung

Two Mayan children share laughter and cuddles in Panajachel, Guatemala.

Canon Elan IIe, 75–300 mm, 135, Exp. f5.6-1/60

Thanh Long
VIETNAM

Thanh Long developed his first film over 35 years ago and is still a professional photographer in Nha Trang City, Vietnam. He has won gold medals at the Asahi Shimbun International Photographic Salon of Japan in 1988, 1995, 1997 and 1999. His work has been exhibited through Europe, Asia and North America.

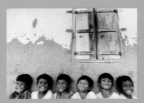

© 1995 Thanh Long

The faces of six young friends as they take a break from lessons at their school in Phan Rang city, Vietnam.

Nikon F2, 28 mm, 135, Exp. f5.6-1/30

Tim Lynch
USA

Tim Lynch has been a photographer for over 20 years and has worked in 27 countries as well as most states of the USA. He considers himself a photography generalist and works on location as well as in the studio. Currently Tim is working in Boston, Massachusetts, as a digital photographer for World Wide Web companies.

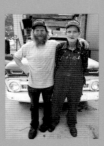

© 1998 Tim Lynch

The best of friends – Leon and his father, Johnny, take a break from collecting the trash in Jasper, Indiana, USA.

Nikon F3, 24 mm, Kodachrome/135, Exp. N/A

Simon Lynn
NEW ZEALAND

Born in New Zealand, Simon Lynn has degrees in anthropology and Oriental medicine. He also studied for part of a photographic diploma before choosing instead to gain experience as a photographer's assistant. Simon has worked n corporate, fashion and editorial photography and currently works internat onally as a commercial photographer.

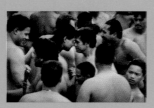

© Simon Lynn [date N/A]

On the shore of Lake Rotorua in New Zealand, two Maori brothers are engaged in a "hongi" – an exchange of breath as a form of greeting. The group are all members of an extended family – they have just come ashore after a canoe race celebrating Waitangi Day, New Zealand's national day.

Canon EOS 5, 200 mm, Kodak T-max/135, Exp. f5.6-1/125

Nathan Machain
USA

Nathan Machain lives in southern California, USA. He has been a keen photographer for three years, with a particular interest in documentary photography and photojournalism. Currently he works as a freelancer for a local San Bernardino County newspaper, the Sun.

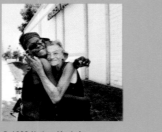

© 1999 Nathan Machain

Home is where the heart is – on a street in San Bernardino, California, two homeless women clasp each other in an affectionate embrace.

Canon A2, 28–105 mm, Kodak Tri-X/135, Exp. f9.5-1/250

Francesca Mancini
ITALY

Francesca Mancini was born in Rome, Italy, and studied psychology at the city's university. Recently she began to concentrate on photography as her career, focusing particularly on the plight of Kosovan refugees in Italy. She now works as a freelance reporter and photographer for press agencies in Rome.

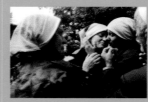

© 1999 Francesca Mancini

United in grief – a moment of solidarity as a young Kosovan woman embraces her friend whose husband has been killed by a mine.

Nikon F100, 35 mm, Kodak Tri-X/135, Exp. N/A

Jinjun Mao
CHINA

Jinjun Mao studied photography while he attended a military academy in China and became a photographer-reporter for an armed forces magazine, Renmin Qianxian. Returning to civilian life, he became a professional photographer and a member of the Chinese Photographers Association. He has contributed to numerous publications and exhibitions in and beyond his home country. Currently Jinjun works as a photographer at the Ah Mao Photography Studio in Songyang, China.

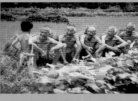

© 1998 Jinjun Mao

In Shuinan village, China, the mischievous antics of a five-year-old visitor amuse and delight his grandfather and friends.

Canon AE1, 50 mm, Konika/135, Exp. f5.6-1/125

José Martí
CUBA

José Martí was born in Havana, Cuba, and has been a professional photographer for over 30 years. His images have been displayed in exhibitions, galleries and personal collections around the world including Cuba, Germany, Spain and Italy. José has also won many national and international awards for his photographs.

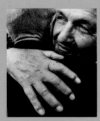

© 1999 José Martí

An emotional reunion as Estevan Cortiza Rabina, 81, embraces his 77-year-old brother, Juan. After many years in Spain, Juan has returned to his native Cuba to retire. It is the first time the brothers have met in 40 years.

Nikon F3, 28 mm, Agfa APX 100/135, Exp. f8-1/30

Darien Mejía-Olivares
USA

Darien Mejía-Olivares was born in Mexico and went on to study journalism and photography at college. In 1996 she moved to New York, USA, and became an enthusiastic photographer, taking courses at New York University and the School of Visual Arts. Darien was a finalist in the 1998 Photographers Forum magazine competition.

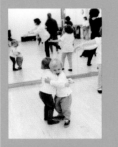

© 1998 Darien Mejía-Olivares

Dancing partners – as two-year-old toddlers Harry and Margaret take to the floor in New York, USA, they can't resist giving each other a hug.

Minolta Maxxum 7000 AF, 50 mm, Kodak T-max 400/135, Exp. N/A

Bernard Mendoza
USA

Bernard Mendoza began his photography career in the 1960s and attracted many top international clients to his studios in London, Amsterdam and Houston, Texas. His work has been displayed by the National Portrait Galleries of England and Scotland, the Royal Photographic Society, the Museum of Modern Art in Houston, Texas, and the Denver Art Museum. His images have also been included in the Smithsonian on-line collection.

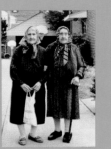

© 1999 Bernard Mendoza

An inseparable pair – elderly Ukrainian sisters caught on film during a visit to Cleveland, Ohio, USA.

Nikon, 80 mm, Kodak Tri-X/135, Exp. f11-1/125

Rinaldo Morelli
BRAZIL

Rinaldo Morelli has been a photographer for over 15 years. Based in Brazil, he has had three individual photographic exhibitions and is currently studying for a Master of Arts and Technology degree at the University of Brasília. Rinaldo is a founding member of the Brazilian group of photographers "Ladrões de Alma" (Thieves of the Soul).

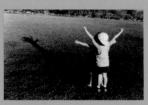

© 1995 Rinaldo Morelli

Me and my shadow – during a visit to the zoo, young Brazilians Pietro, aged four, and Yuri, five, are inspired to create their own weird and wonderful animals.

Nikon F3, 24 mm, Ilford/135, Exp. f11-1/60

P Kevin Morley
USA

P Kevin Morley graduated from the University of Missouri-Columbia, USA, with a degree in journalism. Since 1984 he has worked as a staff photographer at the *Richmond Times-Dispatch* in Virginia. He is also an instructor in photojournalism at the University of Richmond.

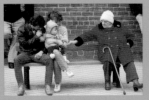

© 1987 P Kevin Morley

A gentle touch – an elderly stranger reaches out to baby Jeffrey, 15 months, as they wait for a bus in Richmond, Virginia, USA.

Nikon F3, 2.8/300 mm, Kodak Ektachrome/135, Exp. N/A

Aris Munandar
INDONESIA

Aris Munandar lives in Indonesia. He became interested in photography through national magazines which captured the spirit of his home country. He bought his first camera while he was a student and now spends most of his spare time pursuing his interest in photography.

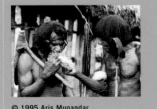

© 1995 Aris Munandar

Amid the hustle and bustle of Wamena town in Indonesia, two Dani tribesmen find time to relax. Dressed in traditional clothing and holding home-made axes and spears, they come to Wamena to trade and socialize.

Nikon F90, f5.6, Fuji/135, Exp. 1/60

Jana Nosekova
CZECH REPUBLIC

Jana Nosekova trained at the school of photography in Bratislava, Slovakia, and after graduation joined the Czechoslovak news agency, CTK. Currently she is based in Prague, Czech Republic, and works as a news photographer on the leading Czech newspaper *DNES*. Jana was an award winner in the 1997 Czech Press Photo Competition.

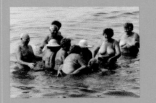

© 1998 Jana Nosekova

Fun and games in the water for a group of bathers in Constanze, Romania.

Nikon F5, 2.8/35-70 mm, Fuji 400/135, Exp. f11-1/125

Tetsuaki Oda
JAPAN

Tetsuaki Oda graduated from Jiyu Gakuen College in Tokyo, Japan, in 1967. He began his career as a professional photographer in his father's photo business before setting up his own photography shop. In 1995, the shop was completely destroyed by the Kobe city earthquake and Tetsuaki is now working as a freelance photographer.

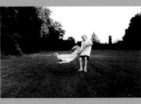

© 1995 Tetsuaki Oda

Open-air entertainment – two children are happy to amuse themselves during the interval of an outdoor music concert in Linköping, Sweden.

Leica M6, 1.4/35 mm, Kodak TMY/135, Exp. f8-1/500

Dilip Padhi
INDIA

Dilip Padhi lives in Orissa, India, and has been a keen amateur photographer since 1980. He is a licentiate of the Royal Photographic Society in England and a member of the Photographic Society of America. Dilip is particularly interested in nature, landscapes and portraits, and his work has been displayed in a number of national and international galleries.

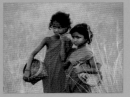

© 1999 Dilip Padhi

In a small village near Sambalpur, India, two young companions share a pensive moment.

Nikon F801S, Nikkor 70–210 mm, Kodak/135, Exp. f8-1/125

Amelia Panico
USA

Amelia Panico graduated from the Pratt Institute in New York, USA, with a fine arts degree specializing in photography. Today she works as a professional medical photographer, and as a studio and location freelancer. Amelia's work has been exhibited in the USA, France and Australia, and her medical research photography has appeared in leading international journals.

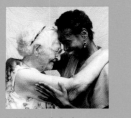

© 1996 Amelia Panico

In New York, a compassionate and loving moment is shared between a young nurse, Susan, and her 97-year-old patient, Carolina.

Hasselblad 500C, 120 mm, Kodak Tri-X/120, Exp. f8-1/60

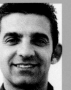

Aris Pavlos
GREECE

Aris Pavlos was born in Greece and studied photography at Athens Technical College. He has taught photography in amateur groups and in a rehabilitation center and is now focusing on a career in documentary photography.

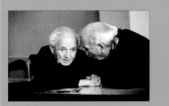

© 1998 Aris Pavlos

The wisdom of age – old friends Blionas, 92, and Tsigaras, 90, are absorbed in each other's conversation as they sit in their overcoats in a chilly café in Grevena, Greece.

Nikon F3, 135 mm, Ilford HP5/135, Exp. f25

Cristina Piza
GERMANY

Cristina Piza was born in Costa Rica and has spent time working in the UK and Berlin. Most recently her photographic work has concentrated on Cuba and its people, resulting in numerous exhibitions and commissions plus awards for her images.

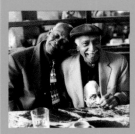

© 1998 Cristina Piza

Musicians and old friends Ruben and Ibrahin celebrate the release of their new CD at a café in Madrid, Spain.

Hasselblad 500C, 80 mm, Kodak/120, Exp. N/A

Bernard Poh Lye Kiat
SINGAPORE

Bernard Poh Lye Kiat is a Chinese photographer living in Singapore. After graduating from a SAFRA photographic course – and receiving the award for best overall student – he now runs his own photo shop business. Bernard has won more than 20 first prizes in various competitions, including the "Leisure in Singapore" competition run by the Straits Times, the Photo Fair '92 Model Photographic Contest organized by Nikon and the Canon Members Photo Contest.

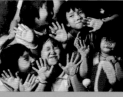

© 1998 Bernard Poh Lye Kiat

Christmas in Singapore – as the photographer gets his shop window ready for the festive season, his cheeky young relatives do their best to distract him.

Nikon F90X, 35–90 mm, Fuji/135, Exp. f11-1/30

Ted Polumbaum
USA

Ted Polumbaum graduated with a degree in history. He worked as a journalist on a daily newspaper and in television before turning to a career in photography. He has worked as a photographer for a range of corporations and publications including Life magazine. Ted has also published photographic books such as the highly praised Today is Not Like Yesterday: A Chilean Journey which documents his experiences of life in Chile.

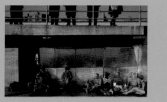

© 1965 Ted Polumbaum

Members of the "Polar Bear Club" aren't worried by the cold temperatures as they soak up the winter sun on Coney Island, New York. The onlookers don't share the same dress code.

Leica M3, 35 mm, Kodachrome/135, Exp. N/A

Romualdas Požerskis
LITHUANIA

Romualdas Požerskis studied electrical engineering at Kaunas Polytechnic Institute, Lithuania, and went on to work at the Photography Art Society of Lithuania. He has been a freelance photographer since 1980 and is a university lecturer in the history and aesthetics of photography. Romualdas was the 1991 winner of the Lithuanian National Award for cultural achievement and, in 1994, he became an artist of FIAP, the International Federation of Photographic Art.

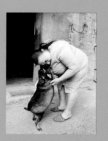

© 1981 Romualdas Požerskis

An enthusiastic greeting for a Lithuanian woman on the streets of the old town of Kaunas.

Minolta xD-11, 24 mm, Svema 400/135, Exp. f8-1/250

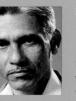

Surendra Pradhan
INDIA

Surendra Pradhan works as a high school teacher in India and has had a serious interest in photography since 1972. He became an associate of the Royal Photographic Society in England in 1984, and an artist of FIAP, the International Federation of Photographic Art, in 1995. His work has been displayed in many national and international galleries.

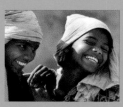

© 1984 Surendra Pradhan

Amid the paddy fields of rural India, the faces of two young workers are illuminated by laughter and friendship.

Pentax Spotomatic II, 135 mm, Ilford/135, Exp. f8-1/125

Greta Pratt
USA

Greta Pratt began her photography career by traveling through the midwestern states of America taking pictures of county fairs – these images were later published in a book. Her work has appeared in a variety of magazines including the *New York Times* magazine, the *New Yorker* and *Harpers*. Her photographs are also displayed in permanent collections in the National Museum of American Art, the Smithsonian Institution, The Museum of Fine Art in Houston and the Minneapolis Institute of Art.

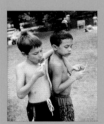

© 1999 Greta Pratt

Summer in New Jersey, USA – best friends Axel and Colby take a break from swimming to cool off with an ice cream.

Fuji 645, 60 mm, Kodak T-max/120, Exp. f5.6-1/60

Jennifer Prunty
USA

Jennifer Prunty began her photographic career working on a high school newspaper. She went on to become photography editor of her college yearbook and, after graduation, worked as a freelance photographer. In 1995 she returned to college to study for a Master of Fine Arts degree specializing in documentary photojournalism.

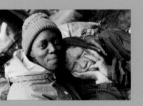

© 1997 Jennifer Prunty

A friendly shoulder – distraught at being unable to collect her social security check, "Mama Sue" is comforted by her companion, Dee. Both women belong to a group of homeless people, "The Family," who live together in a park in San Francisco, California, USA.

Nikon 2000, 50 mm, Kodak Tri-X/135, Exp. f5.6-1/60

Minh Qúy
VIETNAM

Minh Qúy studied at the Fine Arts Teacher Training University in Vietnam. He works as a professional photographer and has owned his own studio in Ho Chi Minh City since 1987.

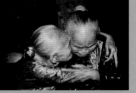

© 1991 Minh Qúy

An affectionate embrace as two sisters, both over the age of 80, share a private moment in Binh Duöng province, Vietnam.

Nikon FM2, 35–135 mm, Konica/135, Exp. f5.6-1/60

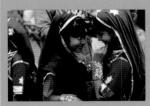

Rogério Ribeiro
BRAZIL

Rogério Ribeiro lives in Brazil and has been interested in photography since he was given his first camera at the age of seven. He went on to study photography as part of a plastic arts course at the Federal University of Rio Grande Do Sul, Brazil. Currently Rogério is pursuing his interest by studying the history of photography and developing a project on family portraiture.

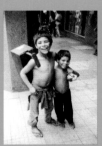

© 1982 Rogério Ribeiro

The breadwinner – with a box of shoe-shining equipment on his shoulder, a Brazilian boy extends a protective arm to his younger brother on the streets of Porto Alegre, in Brazil.

Yashica FX, 38 mm, Kodak Tri-X/135, Exp. f5.6-1/60

Malie Rich-Griffith
USA

Malie Rich-Griffith lives in Kailua, Hawaii. Her fascination with photography began in 1994 when she took a trip to East Africa and, since then, she has traveled extensively to pursue her interest.

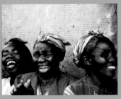

© 1997 Malie Rich-Griffith

Laughter is infectious for three friends from Mgahinga village, Uganda.

Canon EOS 1N, 28–135 mm, Kodak E100S/135, Exp. f5.6-1/125

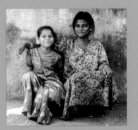

Simon Roberts
UK

Simon Roberts is a London-based photographer who is represented by creative talent agency Growbag. His work has been published in magazines such as *Life*, the *Sunday Times* magazine and *Stern*. He has won several national awards including the Ian Parry Award for the young photographer of the year, sponsored by the *Sunday Times* newspaper in London.

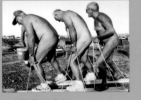

© 1999 Simon Roberts

An active retirement – three American "snowbirds" after their winter migration to the warm, southern states of the USA. These men belong to a nudist group who meet to play games and enjoy the sunshine and freedom of the Arizona desert.

Bronica ETSRI, 85 mm, Ilford FP4 Plus/120, Exp. f8-1/250

Nicholas Ross
UK

Nicholas Ross is a professional engineer involved in mineral exploration. He is a keen amateur photographer and always takes his camera with him when he travels around the world with his engineering work.

© 1999 Nicholas Ross

Smiling through – on a dusty pavement in the slums of Bombay, India, friendship blossoms for 12-year-old Indou and her blind companion, Mala.

Rolleiflex 6008, 75 mm, Kodak/120, Exp. f5.6-1/125

Janice Rubin
USA

Janice Rubin is a photographer based in Texas, USA. Since 1976, her work has appeared in publications throughout the USA and Europe including *Newsweek*, *Fortune*, *Rolling Stone* and the *New York Times*. She has exhibited in Canada, the USA and Holland, and her work has been included in the permanent collection of the Museum of Fine Arts in Houston, Texas.

© 1993 Janice Rubin

Smiles of encouragement – six-year-old dancers Natasha and Mitalee look to each other for confidence before performing in front of a capacity crowd at the Houston International Festival, Texas, USA.

Canon F1, 85 mm, Fuji RDP/135, Exp. N/A

Mike Ryan
USA

Mike Ryan was born in California, USA, and went on to serve with the US Peace Corps in the 1960s. During that time, he pursued his interest in photography by building a darkroom and practicing his craft on a remote Marshall Islands atoll. In 1968 Michael traveled around South-East Asia, compiling a portfolio which launched his career in professional photography. Today he works as a still-life photographer involved in advertising and fine art work in Massachusetts, USA.

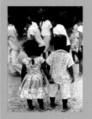

© 1968 Mike Ryan

On the Marshall Islands of the Pacific Ocean, a young toddler stays close to her friend. Together they watch the older children dancing in an annual festival of celebration.

Nikon F, 50 mm, Kodak/135, Exp. N/A

Seifollah Samadian Ahangar
IRAN

Seifollah Samadian Ahangar lives in Iran. He graduated with a degree in English translation and began his photography career in 1970. Currently he lectures in photojournalism at Tehran University and is the publisher and editor-in-chief of *Tassuir*, a monthly magazine for the visual arts. His photographs have been exhibited in France and Switzerland, as well as the Tehran Museum of Contemporary Arts in Iran.

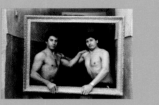

© 1989 Seifollah Samadian Ahangar

A portrait of friendship – friends Asadollah and Mohammad strike the traditional and historic pose of Iranian athletes for this photograph in Orumieh, Iran.

Nikon Nikormat, 24 mm, Kodak/135, Exp. f8-1/60

Aranya Sen
INDIA

Aranya Sen was born in Calcutta, India. After studying for a degree in journalism, he worked as a freelance press photographer for a variety of different newspapers as well as *Soviet Land* magazine and the Russian news photo agency Novosti. Currently Aranya works on the newspaper *Kalantar* in Calcutta.

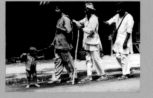

© 1999 Aranya Sen

A helping hand – six-year-old street urchin Babloo holds up his tiny hand to stop an oncoming car as he helps three blind friends to cross the road to their school in Calcutta, India.

Nikon 801S, 80–200 mm, Nova/135, Exp. f11.5-1/125

Pisit Senanunsakul
THAILAND

Pisit Senanunsakul is a professional photographer based in Thailand. He is the managing director of a studio specializing in wedding photography, personal portraits and photographic services.

© 1999 Pisit Senanunsakul

Two elderly friends share a joke as they go about their daily work in Chiang Rai, Thailand. They are drying native grass to be made into brooms.

Canon EOS 1, 70–200 mm, Fuji ISO 50/135, Exp. f8

Antony Soicher
SOUTH AFRICA

Antony Soicher was born in Johannesburg, South Africa, and studied photography at high school. His work concentrates particularly on documentary and street photography, capturing the themes of intimacy and humor. He has published four limited edition photographic books on these subjects.

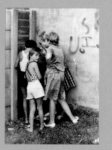

© 1991 Antony Soicher

Caught in the act – young smokers meet in the corner of a park in Johannesburg, South Africa, to enjoy a secret cigarette.

Leica M3, 50 mm, Kodak T-max 400/135, Exp. N/A

Kailash Soni
INDIA

Kailash Soni was born in India and his photographic images have been published in newspapers and magazines in his home country. He was a winner of the America's Photography Award Top 10 of the World in 1995, and received first prize in the PAI All India Salon of Photography awards in 1998.

© 1999 Kailash Soni

Conversation comes easily to two old friends as they relax opposite the Shiv Temple of Bilawali in Dewas, India.

Nikon FM2, f1.7, Pro Kodak/135, Exp. f8-1/125

Serena Stevenson
NEW ZEALAND

Serena Stevenson studied photography at the Unitech Design School in New Zealand. After graduating, she worked as an assistant for three years before becoming a professional freelance photographer. She currently undertakes assignments for many of New Zealand's top magazines and advertising agencies, and specializes in photographing people.

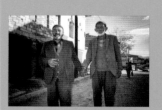

© 1998 Serena Stevenson

Hand in hand – two elderly friends hold tightly to each other for support as they take a stroll through the cobbled streets of Göreme, a village in the Cappadocian valleys of Turkey.

Nikon 28 TI, 28 mm, Optimia 400/135, Exp. N/A

Guy Stubbs
SOUTH AFRICA

Guy Stubbs trained in South Africa for five years and is now an internationally published photographer. Much of his work is based in South Africa, documenting the hopes and aspirations of the country's people. He has also worked in India to photograph water and sanitation projects in the poorer areas.

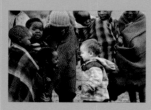

© 1996 Guy Stubbs

New faces – these young Basotho children are fascinated by 16-month-old Joshua, the first white child they have seen in their village of Bokong, Lesotho Highlands.

Nikon F4, 75–300 mm, Kodak T-max/135, Exp. N/A

Joan Sullivan
CANADA

Joan Sullivan is the daughter of a photographer and spent 10 years as a nutritionist before devoting herself full-time to photography. She is based in Quebec, Canada, but often travels to remote parts of the world to pursue her interest.

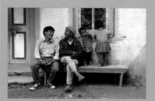

© 1989 Joan Sullivan

The babysitter – in the foothills of the Himalayas, a Nepalese grandfather looks after his two grandchildren while he catches up on news brought from Kathmandu by a young porter.

Nikon FM, 35–105 mm, Kodachrome 64/135, Exp. f8-1/125

Noelle Tan
USA

Noelle Tan was born in Manila, Philippines. After moving to the USA with her family, she studied for a photography degree at New York University. After graduation, she worked at the city's Museum of Modern Art and then became the manager of a photographic business. Her work has appeared in exhibitions in the USA.

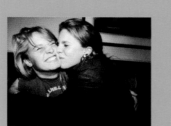

© 1990 Noelle Tan

Bonnie's enthusiastic greeting is matched by a delighted smile from friend Nancy in Washington DC, USA.

Nikon F3 HP, 35 mm, Kodak/135, Exp. N/A

Tran Cong Thanh
VIETNAM

Tran Cong Thanh was born in Vietnam and has been a professional photographer since 1983. He is a member of the Vietnam Art Photographic Association and, in 1999, won second prize in the Binh Thuan province Environment Photographic Competition.

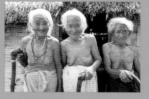

© 1998 Tran Cong Thanh

Good neighbors – three Vietnamese women, whose friendship spans over 50 years, enjoy visiting each other every morning in their mountain village in the Binh Thuan province.

Nikon Nikkormat, 28–70 mm, Kodak Gold/135, Exp. f8

Hank Willis Thomas
USA

Hank Willis Thomas is a professional photographer based in Washington DC, USA. His interest in photography was fueled by his mother's research into the history of African American photographers. He studied photography and Africana Studies at New York University and his work has been exhibited in New York and Washington DC.

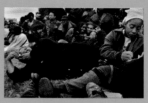

© 1997 Hank Willis Thomas

Three friends compose their own picture within a picture at a Million Women March in Philadelphia, Pennsylvania, USA.

Pentax 6x7, 75 mm, Fuji NPH/120, Exp. N/A

Marianne Thomas
USA

Marianne Thomas studied journalism at Syracuse University, USA, and photography at Daytona Beach Community College. After spending time as a Peace Corps volunteer in Venezuela, she pursued her career working as a reporter, staff photographer and photo editor on a number of different publications. Since 1992 Marianne has been working as photo editor at the *San Francisco Chronicle*, California.

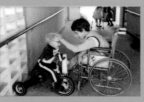

© 1981 Marianne Thomas

John David Bethel gives Eric Hinze, his "little buddy," an affectionate pat. The boys are both sufferers of spina bifida, a disease of the spinal cord. They play together while their parents attend a support group meeting in Florida, USA.

Nikon, Kodak Tri-X/135, Exp. N/A

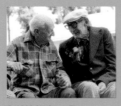

© 1983 Marianne Thomas

Close companions – William Bossidy listens attentively to his friend John Noonan, a fellow resident at their nursing home in Florida, USA.

Nikon, Kodak Tri-X/135, Exp. N/A

Dỗ Anh Tuâń
VIETNAM

Dỗ Anh Tuâń has been a photographer since 1991 and is also an active musician and painter. He is a member of the Hanoi Artistic Photography Association and the Vietnamese Artistic Photography Association.

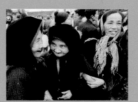

© 1996 Dỗ Anh Tuâń

Arm in arm – smiles light up the faces of three old friends when they are reunited at a festival in Bac Ninh town, Vietnam.

Nikon F3 HP, 2.0/24 mm, Ilford Pan 400/135, Exp. f5.6-1/250

Charley Van Dugteren
SOUTH AFRICA

Charley Van Dugteren lives in South Africa and received a diploma in photography from the Peninsula Technikon in Cape Town. She worked as a photographer's assistant during her studies and, after graduation, became a professional photographer working mainly on magazines. Currently she is concentrating on portrait, food and travel work and is completing a book on the winelands of South Africa.

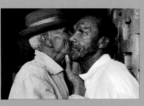

© 1997 Charley Van Dugteren

Two companions get close to make themselves heard in a noisy shebeen – a local pub – in Cape Town, South Africa.

Nikon F3, 35 mm, Ilford Delta 400/135, Exp. f2.8-1/8

Ann Versaen
BELGIUM

Ann Versaen lives in Strombeek-Bever in Belgium where she works as a nurse. She studied photography at evening classes and some of her images now appear in exhibitions in her home country.

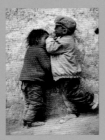

© 1994 Ann Versaen

Two young friends on the streets of the Tibetan town of Xigatse.

Canon EOS 1000, 35–80 mm, Kodak Gold/135, Exp. N/A

Alison Williams
USA

Alison Williams graduated with a Bachelor of Fine Arts in photography from the Rochester Institute of Technology in the USA. After her degree, she joined the Peace Corps in Mali, West Africa, giving her the opportunity to pursue her interest in documentary photography in a new environment.

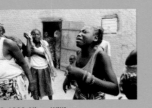

© 1998 Alison Williams

Tears mark the end of childhood camaraderie. In Mali, West Africa, a new bride is taken from her home to her fiancé's village 20 kilometers away. Her girlfriends bid her farewell in an emotional scene.

Nikon FM2, 24 mm, Kodak Tri-X/135, Exp. f11-1/60

David Williams
UK

David Williams is a professional, exhibiting photographer of a wide range of subject matter, from documentary to video art. Winner of the BBC Scotland 150 Years of Photography award, he is currently Head of Photography at Edinburgh College of Art.

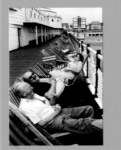

© 1984 David Williams

An English tradition – deckchairs on the pier provide a typical holiday setting for three friends taking a break in Brighton, in the south of England.

Nikon FM, 28 mm, Kodak Tri-X/135, Exp. f11-1/250

Terry Winn
NEW ZEALAND

Terry Winn has worked in photography since 1979 in Auckland, New Zealand. He and his wife operate a studio which undertakes private portrait assignments as well as publishing books, calendars and greeting cards. Terry is a fellow of the New Zealand Institute of Professional Photographers.

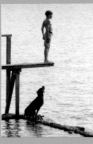

© 1993 Terry Winn

A boy's best friend – nine-year-old Jonathan prepares to take the plunge at his favorite swimming spot in Auckland, New Zealand. His dog Harry won't be far behind.

Hasselblad CM, 150 mm, Kodak Plus-X/120, Exp. f8-1/125

King Tuang Wong
MALAYSIA

King Tuang Wong works as a salesman in Sarawak, Malaysia. He is a keen amateur photographer and his occupational travels provide many opportunities to pursue his interest. He is secretary of the Photographic Society of Sibu in Sarawak.

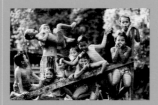

© 1999 King Tuang Wong

In Rumah Bilar in Sibu, Malaysia, young friends spend an evening making their own fun by the riverside.

Nikon F90, 2.8/80–200 mm, Kodak/135, Exp. f4-1/250

WINNER OF THE "FRIENDSHIP" CATEGORY IN THE M.I.L.K. PHOTOGRAPHIC COMPETITION.

ACKNOWLEDGMENTS

**The following individuals, companies, and organizations
were significant contributors to the development of M.I.L.K.**
Ruth Hamilton, Ruth-Anna Hobday, Claudia Hood,
Nicola Henderson, Liz McRae, Brian Ross, Don Neely,
Kai Brethouwer, Vicki Smith, Rebecca Swan,
Bound to Last, Designworks, Image Centre Limited,
Logan Brewer Production Design Limited, KPMG Legal,
Lowe Lintas & Partners, Midas Printing Group Limited,
MTA Arts for Transit, Print Management Consultants,
Sauvage Design and Mary-Ann Lewis.

Special thanks also to:
David Baldock, Julika Batten, Anne Bayin, Sue Bidwill,
Janet Blackwell, John Blackwell, Susanna Blackwell,
Sandra Bloodworth, Sonia Carroll, Mona Chen, Patrick Cox,
Michael Fleck, Lisa Highton, Anne Hoy, C K Lau,
Liz Meyers, James Mora, Paddianne Neely, Grant Nola,
Ricardo Ordóñez, Kim Phuc, Chris Pitt, Tanya Robertson,
Margaret Sinclair, Marlis Teubner, Nicki White.

The publisher is grateful for permission to reproduce those
items below subject to copyright. While every effort has
been made to trace copyright holders, the publisher would
be pleased to hear from any not acknowledged here.

Back cover quotation from *The Art of Worldly Wisdom* by
Baltasar Gracian, translated by Joseph Jacobs, © 1993
by Shambhala Publications, Inc., reprinted by arrangement
with Shambhala Publications, Inc., Boston,
www.shambhala.com

Competition Chief Judge Elliott Erwitt

Design Lucy Richardson

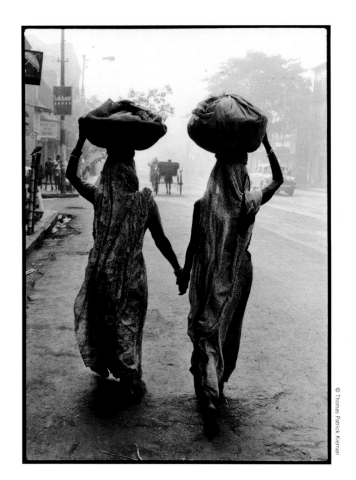

© Thomas Patrick Kiernan

M · I · L · K ™

Designed by Lucy Richardson. Color separations by Image Centre. Printed by Midas Printing Limited, Hong Kong.

FIRST U.S. EDITION

Library of Congress Cataloging-in-Publication Data

Friendship: a celebration of humanity.—1st U.S. ed.

p. cm.

ISBN 0-06-620970-6

1. Friendship—Pictorial works. 2. Friendship.

BF575.F66 F72 2001

779'.930234—dc21 00-051547

01 02 03 04 05 10 9 8 7 6 5 4 3 2 1